David Joselit Joan Simon Renata Salecl

Jenny Holzer

Φ

Publisher's Acknowledgements
Special thanks are due to **Amy
Whitaker**, New York. We would
also like to thank **Calder
Publications**, London for their
kind permission to reprint texts
and to thank the following for
lending reproductions: **Leo
Castelli Gallery**, New York;
Barbara Gladstone Gallery, New
York; **Metro Pictures**, New York;
The Museum of Modern Art, New
York; **Yvonne Rainer**, New York;
Martha Rosler, New York; **John
Weber Gallery**, New York. Special
thanks to the Jenny Holzer
Studio. Photographers: **Edward
Addeo, William Allen, Shigeo
Anzai, Erika Barahona Ede,
Patricia Blake, R. Burckhardt,
Harry Chambers, Paula Court, F.
Crepaz, Mike Glier, Gianfranco
Gorgoni, David Heald, Karin
Hessmann, Jenny Holzer, Maggie
Hopp, Eeva Inkeri, Hirohashi
Isao, Claude Joray, Lisa Kahane,
Hans-Dieter Klauge, Peter Köhl,
Larry Lame, Werner
Lieberknecht, Salvatore Licitra,
Tom Loonan, Herb Lotz, Attilio
Maranzano, M. Michalski,
Pelka/Noble, David Regen,
Beatrix Ruf, Alan Richardson,
Ritts Photography, Bernhard
Schaub, Mark Smith, Dan Soper,
Laurie Sparham, Squidds &
Nunns, Hayashi Tatsuo, Udo Titz,
Michael Tropea, Christian
Wachter, Stephen White, B.
Wojcik**

Artist's Acknowledgements
I would like to thank my staff –
Rachel Barenblat, Tory Bender,
Richard Berman, Joseph Campana,
Jerusha Clark, Mary Cross, Teri
Griffith, Brenda Phelps, Wendy
Williams and especially Amy
Whitaker, project manager and
research assistant for this book.
Also, special thanks to Mike Glier
and Lili Holzer-Glier, and to the
writers – Joan Simon, David
Joselit, Renata Salecl – and to my
contacts at Phaidon – Iwona
Blazwick, Gilda Williams, Ian Farr,
Clare Manchester, Clare Stent,
Stuart Smith and Veronica Price.
I want to thank Paul Miller, Merrick
Ketcham and Henry Appleton at
Sunrise Systems and John and
Janet Socinski at Rutland Marble
and Granite for many years of good
work. Virtual reality world
courtesy of Intel and Sense8.

All works are in private collections
unless otherwise stated.

Every effort has been made to
contact copyright holders prior to
publication.

Phaidon Press Limited
Regent's Wharf
All Saints Street
London N1 9PA

Phaidon Press Inc.
180 Varick Street
New York, NY 10014

www.phaidon.com

First published 1998
Reprinted 2003
© Phaidon Press Limited 1998
All works and artist's writings of
Jenny Holzer, including *Book
Report – A Response to Artist's
Choice*, are © Jenny Holzer.

ISBN 0 7148 3754 7

A CIP catalogue record of this
book is available from the British
Library.

All rights reserved. No part of this
publication may be reproduced,
stored in a retrieval system or
transmitted in any form or by any
means, electronic, mechanical,
photocopying, recording or other-
wise, without the written
permission of Phaidon Press Ltd.

Designed by SMITH
Printed in Hong Kong

cover, from **Arno**
1996–97
Nine 2-sided LED signs
1300 × 16 × 16 cm each
Permanent installation, Museo
Guggenheim Bilbao, Spain, 1997

page 4, from **Truisms**
1977–79
Electronic scoreboard
732 × 976 cm
Project, Candlestick Park, San
Francisco, 1987

page 6, Lili Holzer-
Glier*(foreground)* and Jenny
Holzer *(background)* at Christmas
1994
Hoosick, New York

page 40, from **Truisms**
1977–79
Carving on rock
Furka Pass, Switzerland, 1991

page 78, from **Lustmord** (detail),
collaboration with Tibor Kalman
1993–94
Photographs of handwriting in ink
on skin
32 × 22 cm each page
Project for *Süddeutsche Zeitung
Magazin*, No. 46, 1993

page 88, from **Survival** (detail)
1983–85
UNEX sign
284 × 77.5 cm
Collections, Whitney Museum of
American Art, New York; National
Gallery of Canada, Ottawa

page 144, Virginia Holzer with
Jenny Holzer
1954

Text works by Jenny Holzer which
are not reprinted in full or
extracted in the Artist's Writings
section are featured as follows:
Survival (1983–85), in Artist's
Choice: Elias Canetti, *Crowds and
Power* (extracts)
Laments (1988–89), in Artist's
Choice: Samuel Beckett, *Ill Seen,
Ill Said* (extract)
Lustmord (1993–94), in Focus:
Renata Salecl, *Cut-and-Dried
Bodies, or How to Avoid the Pervert
Trap*
Arno (1996–97), in Artist's
Writings: Jenny Holzer, *Book
Report – A Response to Artist's
Choice*

Contents

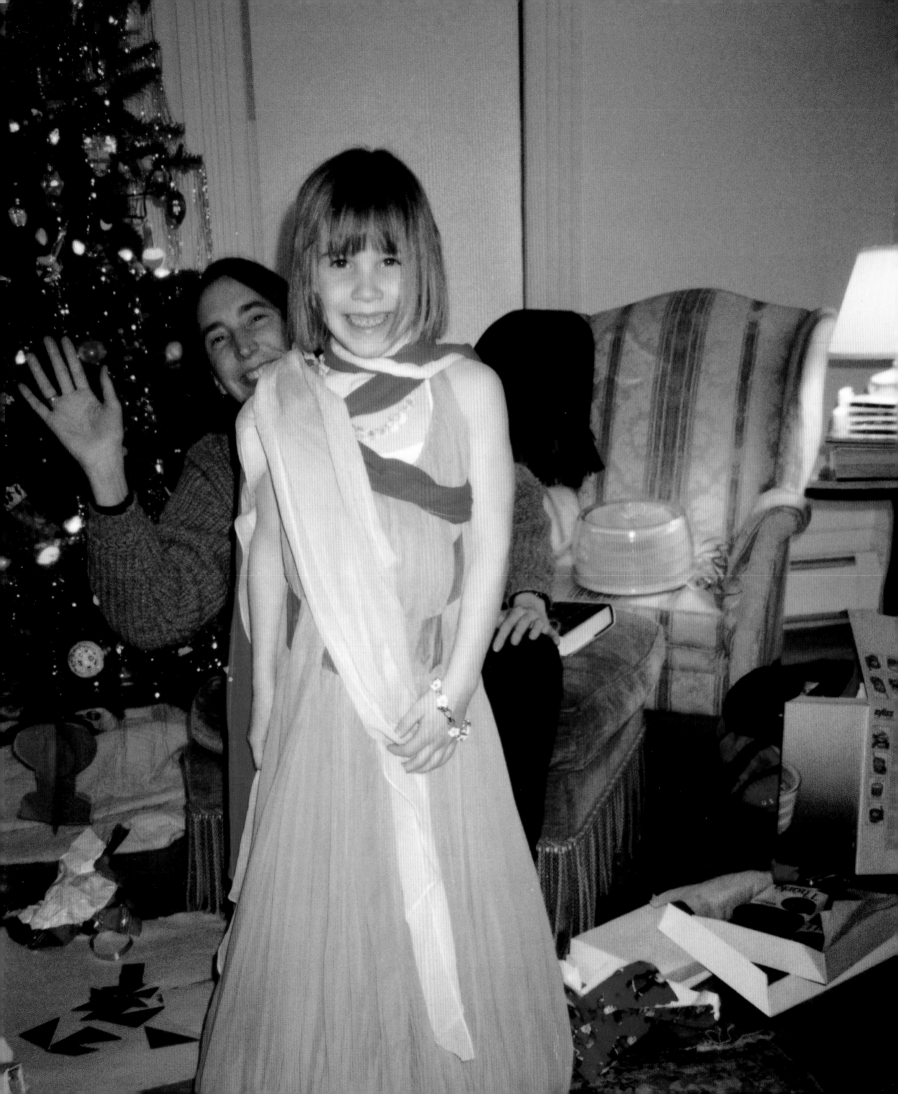

Contents

Joan Simon Why don't we start right in the middle of the public life of your work so far, if not quite at the chronological mid-point: the 1990 Venice Biennale?

Jenny Holzer **OK, so we're starting at the end.**

Simon The end of what?

Holzer **I'm not sure yet. Certainly some chapter.**

Simon You were, in 1990, the first woman to represent the US in a solo show in the then-almost one hundred-year history of the Biennale. Your show won the prestigious Leone d'Oro award – grand prize for best pavilion – and it high-lighted dramatic changes in your work. Some of the texts on paper posters that you left anonymously on New York streets in 1977, for example, turned up etched in marble fit for a palace, specifically, the palace of the Venetian Doges. Here your 'one-liners' were presented underfoot, carved in stone; they were also on electronic signs in a complex retrospective barrage of your writings, which one witness characterized as 'firestorms'. And while the show incorpo-rated the anonymous, genderless speakers of your earliest *Truisms* (1977–79), it also emphatically presented the anguished, distinctly female and personal voice of the *Mother and Child* (1990) texts. What did all this mean to you?

Holzer **Because I was the official representative, I was extremely self-conscious. I didn't want to be the first woman to bungle it. I was in a personal pickle because my baby was mad at me for being distracted and my husband was distraught. I was exhausted. Venice followed the Dia and Guggenheim shows in New York. Eventually, I was glad to have written about how it is to have a child, and I was privileged to walk Venice so often. I was happy to be able to complete the work.**

Simon How did you construct the show?

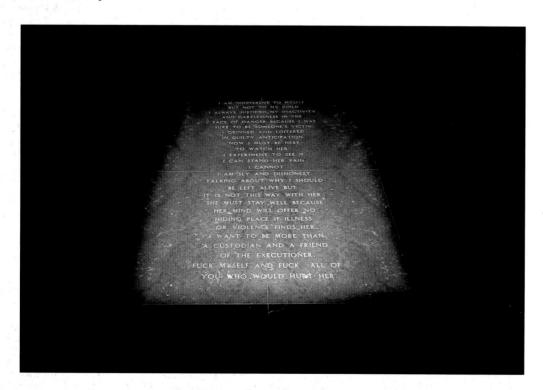

From **Truisms** and **Mother and Child**
Floor, Nero Marquina and Rosso Magnaboschi marble tile in diamond pattern with Biancone marble border
3 benches, Biancone marble tops, Rosso Magnaboschi marble legs
46 × 746 × 44 cm left bench
46 × 563 × 44 cm right bench
46 × 456 × 44 cm far bench
Installation, Gallery B, United States Pavilion, 44th Venice Biennale, 1990

left, from **Mother and Child** (detail)
1990
Floor, Biancone marble tile in diamond pattern, Rosso Magnaboschi marble tablet with Nero Marquina marble border in centre of room
Wall, Twelve 3-colour LED signs
390 × 14 × 10 cm each
Installation, Gallery A, United States Pavilion, 44th Venice Biennale

MOURIR ET REVENIR
DONNE UNE PERSPECTIVE
CONSIDERABLE

POLITIK DIENT
PRIVATINTERESSEN

LEBEN RUFEN
LEBEN GESCHICHTE
ANALYSIEREN

TODAS LAS COSAS
ESTÁN DELICADAMENTE
ENTRELAZADAS

ABUSE OF POWER
COMES AS NO SURPRISE

NO PUEDE SER COMPRADA
LA SALVACIÓN
NI VENDIDA

IL N'EST PAS
BON D'AVOIR TROP
D'ABSOLUS

IL DESIDERIO
DI RIPRODUZIONE E UN
DESIDERIO DI MORTE

VOS PARENTS SONT
L'EFFET DU HASARD

KEINE
HABEN IST E
AN DIE

ANY SURPLUS IS IMMORAL

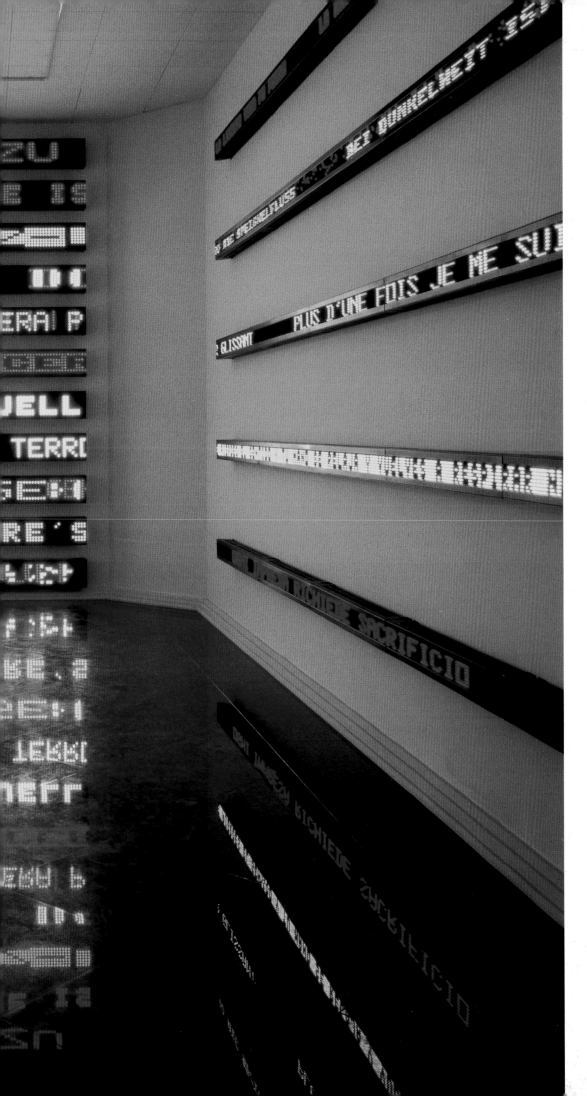

opposite and overleaf, from
Truisms, **Inflammatory Essays**,
Living, **Survival**, **Under a Rock**,
Laments, **Mother and Child**
Floor, Rosso Magnaboschi marble
tile in diamond pattern with Rosso
Magnaboschi marble border
Right wall, five 3-colour LED signs
14 × 609 × 10 cm each
Left wall, five 3-colour LED signs
14 × 609 × 10 cm each
Far wall, eleven 3-colour LED signs
24 × 447 × 11 cm each
Installation, Gallery E, United
States Pavilion, 44th
Venice Biennale, 1990

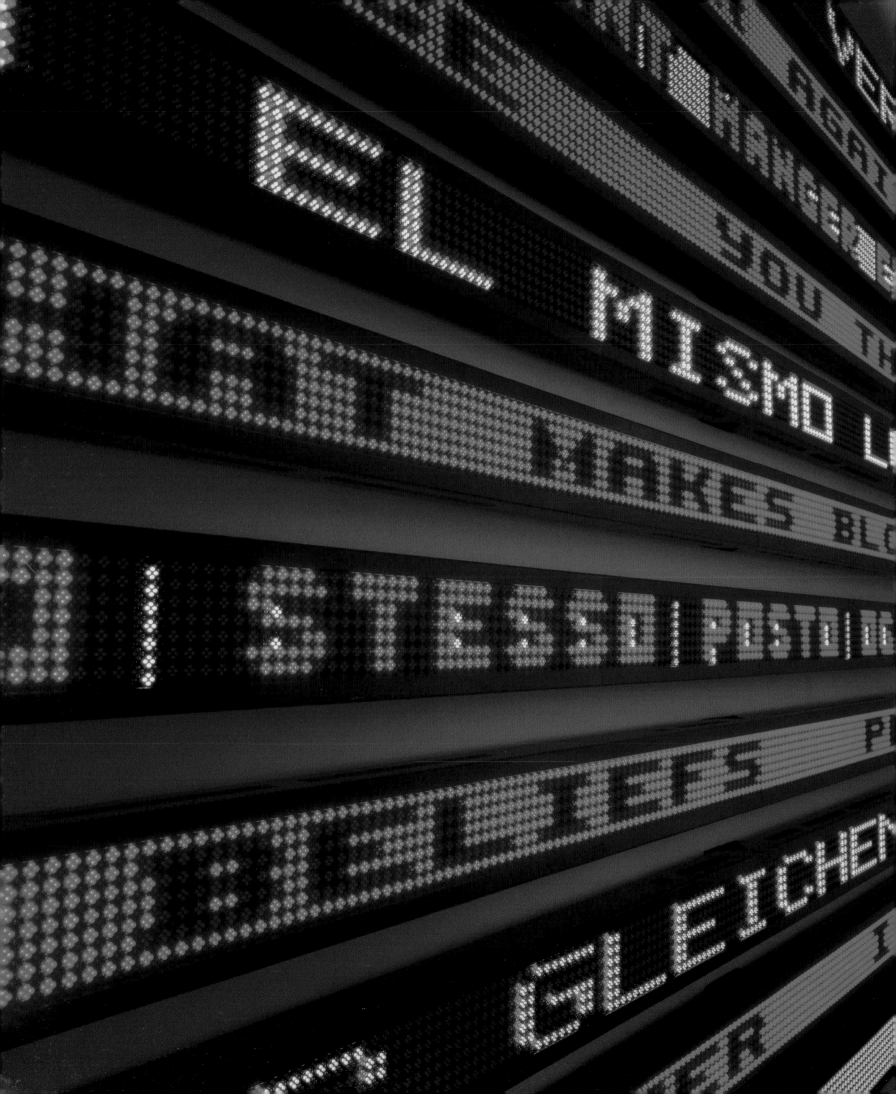

opposite, from **Truisms**,
Inflammatory Essays, **Living**,
Survival, **Under a Rock**, **Laments**,
Mother and Child (detail)
Installation, Gallery E, United
States Pavilion, 44th
Venice Biennale, 1990

below, from **Mother and Child**
1990
Floor, Biancone marble tile in
diamond pattern, Rosso
Magnaboschi marble tablet with
Nero Marquina marble border in
centre of room
Wall, twelve 3-colour LED signs
390 × 14 × 10 cm each
Installation, Gallery A, United
States Pavilion, 44th
Venice Biennale

Holzer There were public pieces, electronic signs, and there certainly was more stone than there had ever been before.

Simon You're referring, I think, to the texts cut into Italian marble of the floor and benches.

Holzer The stone was prominent because I was trying to make the piece Venetian, rather than trying to go over the top with materials.

Simon How so?

Holzer The beautiful red and white stone is asphalt there. I saw that red and white everywhere. I put polished marble floors in the pavilion so the signs would be reflected in them. The lagoon does the same for Venice.
I made marble benches in two of the pavilion's rooms, so that people could sit and await fate, as practised in the Doge's antechambers.

Simon You've often called yourself a 'public artist', and Venice is among the most public of art-world events.

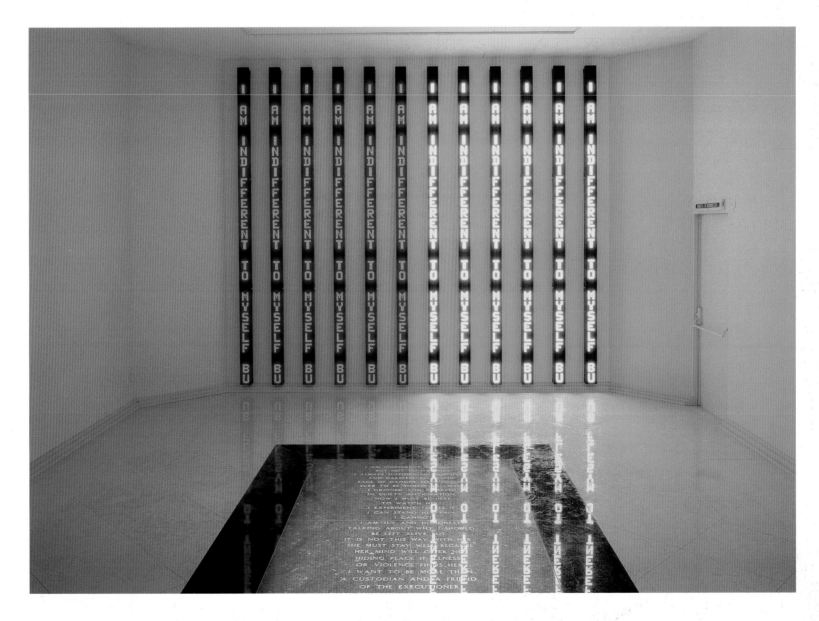

Holzer I thought the anonymous public pieces for Venice – the TV spots, the posters, the signs in the Mestre taxis and Venice's *vaporetti* – would take care of themselves, but I was terrified by the prospect of the American Pavilion. I was interested to watch the pavilion's audience. I put everything in the world into the 'toaster oven' room – the horizontal sign room – because I wanted it to be too much for the viewers. I also wanted to see the reactions to the *Mother and Child* work. There were strong responses. People stood very still. Some would cry and others would turn and walk out quickly. Many would tell me stories about children they had lost.

Simon Did people move easily between the two sections – the church-like sobriety of the vertical signs in the *Mother and Child* room and the delirious, disorienting, cacophony of messages on the horizontal signs in the other?

Holzer I can't give you an accurate answer, but my hunch is that the work tended to sort people into groups, the contemplative group in one room and then another gang. The thrill-seekers went to the 'toaster' room.

Simon Let's go back to the beginning. Where were you born, when and to whom?

Holzer Gallipolis, Ohio, 1950. In Holzer Hospital, to Richard and Virginia Holzer.

Simon Holzer Hospital?

Holzer My grandfather and grandmother founded it. He was a doctor and she a nurse. There were no hospitals in that area so they made one.

Simon How long were they in Ohio?

Holzer They were both born in Ohio. They met, and instead of wandering off, lived and died in Ohio.

Simon When did the family originally come to America?

Holzer I believe they came in the middle of the nineteenth century, with one of those waves of German folk.

Simon Wasn't your dad a Ford dealer?

Holzer And my grandfather, my mother's father.

From **Truisms**, **Living** and **Survival**
TV spots
Project, 44th Venice Biennale, 1990

From **Truisms** and **Survival**
Souvenirs
Project, 44th Venice Biennale, 1990

From **Truisms**
1977–79
Posters
Project, 44th Venice Biennale, 1990

Simon Why is the Midwest called the 'heartland'?

Holzer **I've never been sure. What seems credible is something about true and solid values.**

Simon Did you go to the public library when you were a little kid?

Holzer **A lot. My mother was determined to have that happen. Unlike some things she was set on, I liked to go to the library.**

Simon Were you a writer as well as a reader?

Holzer **More a reader, but I wanted to write ecstatic, fantastic things. I tried to imagine what it would be like to write on drugs. I'd heard of Coleridge.**

Simon What did you write?

Holzer **Anything; I wrote about light bulbs and insects. I tried to write as if I were mad, in some exalted state.**

Simon Did you read newspapers?

Holzer **I liked newspapers a lot. And novels. Probably Emily Brontë's *Wuthering Heights* scared me the most. There's a scene in which a lost child's ghost appears and frightens the sleeper. The child's arm is fearfully cut. (See *Wuthering Heights* excerpt, page 102.)**

Simon Even if the child is a vision, it's a terrifying image, not unlike those in your *Under a Rock* (1986) and *Lustmord* (1993–94) series.

Holzer **There is horror in those works.**

Simon When you were a child, what was Ohio like?

Holzer **I thought it was pretty grand. We lived in a new development on the edge of a town of 30,000 people. It had been an apple orchard, a wild abandoned apple orchard. I stayed until I was sixteen, and then went to Fort Lauderdale, Florida, to improve my image. I wanted to see if I could be less of a nerd.**

Simon Why did you think you were a nerd?

Holzer **Inner conviction. Tall. Too skinny. Approximately intelligent. Things like that.**

Simon Did you do any art when you were a kid?

Holzer **I did most of my art when I was a kid. I wish I still had the same rhythm and frequency. I drew.**

Simon Which you don't do any more?

Holzer **No. It went away. And I'm sorry.**

Simon What did you draw?

Holzer **Epics. No single-sheet stuff after I was five or six. Shelf-paper scrolls. Everything from Noah's ark up to the development of the automobile. I tried to get it all down.**

Simon Was anyone in the family an artist?

Holzer **My grandmother's sister, Audrey Donaldson Ruston, who did Grandma Moses-type paintings. Even better than an artist, she was a psychic. She could predict events and could find water with willow switches. The art and water-witching were a great combination.**

Simon Did you go to museums as a youngster?

Holzer **I went to the Metropolitan in New York once, for an hour.**

Simon Do you remember anything in particular from that visit?

Holzer **Rembrandt behind a rope. They had just bought one, and had it out. I think they even had the price by it. About a million dollars. It was something like what my father used to do to sell Fords.**

Simon Your work is so much about 'public voice', I'm curious to know if you remember any influential ministers, teachers, lawyers, politicians, newscasters? American newscasters and radio announcers often come from the Midwest.

Holzer **This probably sounds fake, but I did like that Times Square sign that had war news on it, that I'd seen in old news reels rebroadcast on TV in Ohio. It had reports from the front.**

Simon The one I remember from my childhood had only words. Was there another sign with moving pictures?

Holzer **My 'dream sign' of childhood was the text-only Times Square 'zipper'.**

Simon That news 'zipper' has been in operation since 1928. In fact, it is on the same Times Square building where you, in 1982, first worked with electronic signs on its Spectacolor board.
Were the Holzers church-goers, bible-readers?

Holzer **My father refused to go to church. Refused to have anything to do with it. My mother tried to have me attend for a while and then gave up. I had a religious spell. I was interested in rapturous writing.**

Simon What did you intend to study in college?

Holzer **I was trying to be normal, so I thought maybe I should be a lawyer. I wound up at Duke University in North Carolina on the suggestion of an**

alcoholic guidance counsellor. I was too timid to go where I wanted. That was Radcliffe. I had the notion there were interesting women there. I wanted to see what smart women did. At Duke the women were bright, but they didn't always let on.

Simon After studying liberal arts at Duke from 1968 to 1970, you changed schools a couple of times. Why did you transfer to the University of Chicago?

Holzer I was in love. He was going to graduate from Duke and I wasn't all that happy there. I felt becalmed but not enchanted. I wanted to go to a new place, a city. I was getting closer to admitting that I was, well, two things: useless for regular life and less ashamed about wanting to be an artist. I thought I could do art in Chicago.

Chicago was the best place I'd ever been. I loved the University and the city. It was very hard to leave. I would have stayed, but as a transfer student I would have had to study still more liberal arts. If I wanted to do studio, I couldn't remain. While there, I did manage a fair amount of print-making and a lot of drawing. I was happy to use my hands.

Simon Why did you choose Ohio University in Athens?

Holzer It was the time of the Vietnam War. My boyfriend, a conscientious objector, found a job at Holzer Hospital. See how we circle back? I wanted to concentrate on studio, and, from my summer school experiences, I knew there were a number of good people teaching at Ohio University. That was sufficient encouragement.

Simon When you graduated from Ohio University in 1972 with a degree in fine arts, did you want to keep doing art?

Holzer I wanted to, but I couldn't figure out how. In my childhood, the artist I knew most about was Picasso. I saw him in a magazine article with photos in which he was on the beach ogling a mistress. I knew I wasn't Picasso. I didn't know how to be an artist.

Simon What was your work like at this point?

Holzer Things that were found. Data. I had worked at Holzer Hospital in the claims department. I typed cards with information about what patients were suffering. For my artwork, I used all the cards ruined by my typos. I pasted the cards on a panel, in rows. I put them in lines, just had to organize them in tight, neat rows. I didn't show the piece to anybody.

Simon What did you do after graduation?

Holzer I went to Europe: Germany, France, Spain, Denmark; to Frankfurt, to Paris, to Madrid, to Barcelona. I saw many major museums for the first time. I looked at medieval and Renaissance art. The Goyas in the Prado sent me – his darkness and determination to look and show perfectly.

Simon And after the European stay?

Holzer I went home for a while. I tried to go back into the horse business. I made a run at it a couple of times. I gave riding lessons, worked at farms, galloped youngsters and walked hots. Not my talent.

Simon The horse business was your mother's work.

Holzer She was a riding teacher. I was no good at it. I gave up horses, went to Arlington, Virginia, got a job at People's Drugstore, and wasn't discovered. I started making some paintings, and I decided to go to Rhode Island School of Design for summer classes.

Simon You actually went to Rhode Island School of Design two different times. Was this the 1974 summer session when you took the 'painting alternatives' class?

Holzer Yes, that's the summer class.

Simon Some of the works you made that summer were the first of your public pieces.

Holzer I did paintings I didn't like. I was cutting them to ribbons and ripping them. After I had done that to a huge painting, I had all these painting shreds. I thought maybe I'd tie them up, tie them together. I started doing that and made a half mile-long painting. It was a really big bad painting, enormously labour-intensive, painted on both sides. I left it at the beach. I watched people walk by it and on it. Be around it and ignore it.

Simon What was the bread piece, *Pigeon Lines* (1975)?

Holzer Longing for order, I put bread out in geometric patterns. The pigeons had to eat in squares and triangles – sometimes they had to eat lines.

Pigeon Lines
1975
Bread, pigeons
Dimensions variable
Project, Providence, Rhode Island

Simon And the indoor environment, the *Blue Room* (1975)?

Holzer **That was one of the first pieces I did that felt right. Everything in the room was painted. The walls, floors and ceiling, the glass in the window, the door, were all done white. Then I went back and put a Thalo blue wash over the whole room. Where the paint would dry, all of the surface would have an irregular edge. The space was disorienting. The paint was rather lovely, especially that colour.**

I did the room instead of easel painting and presented it to the faculty and the students. I worked outside for the general public but didn't have the idea of inviting them inside. I was also working on plain painting then.

Simon What were those paintings?

Holzer **I made abstract paintings that were fairly traditional. The only somewhat unusual thing I did was to paint pieces of canvas and then superimpose them. The result was traditional abstract painting with literally overlapped fields. Then there were long, rectangular, found fabrics on which I began to write.**

Simon What did you write?

Holzer **This is a bit embarrassing, but one dark to light green material made me think of the depths of the ocean, so I wrote oceanographic information. That was lame, and it sent me to the Brown Library to find more subject matter: a return to the library. Next I did a blue fabric piece with text about time and space, and I began to draw the diagrams.**

Maybe this started with seeing the old boyfriend's physics diagrams. I thought they were great. I loved drawings of time. I also saw that trying to represent time was kind of absurd, kind of grand.

Untitled (Space – Time Text)
(detail)
1976
Ink on cotton cloth
122 × 762 cm

THE PAST, THE FUTURE AND A NO MAN'S LAND OR A NO SIGNAL'S REGION

Space-time diagram of the null cone with vertex at the origin

Two bodies run together, fuse, and then vanish

Simon You re-drew the diagrams you found in the library?

Holzer **Very carefully, and painfully, on paper. Hundreds of drawings. I would only try once. I had to draw perfectly the first time, and if I couldn't, I'd stop and start a new one. It was a horrible test. I tried to draw the diagrams free-hand just as they were in the books. Ridiculous. Straight lines. Hatch marks.**

Simon How were these discrete pieces of information organized?

Holzer **I made books and I stacked the drawings in boxes. Sometimes they were grouped by subject.**

Simon What did making an extremely precise copy of someone else's original (even one already mechanically reproduced in a book) mean for you? Contemporaries of yours, such as Sherrie Levine, made this a critical practice.

Holzer **It was a trial for me, a salute to the subjects and a study of representation. Eventually it was a fascination with the captions.**

Simon After summer school you stayed in Rhode Island.

Holzer **I met Mike (Glier) in the RISD 'painting alternatives' class, and after summer school, I found a studio in Providence. I decided, OK, I'm going to be an artist. A year later I went to graduate school there (1975–77). Before I went to graduate school, I worked as a model for RISD drawing and sculpture classes. Then I entered the painting program.**

Simon Put your clothes back on.

Holzer **Put my clothes on as a graduate student and taught some of the same kids for whom I'd modelled. That was a manoeuvre.**
 In the studio I was working hard. Some of the faculty rejected what I did. They hated my blue room and my videos.

Diagrams
1976
Ink on paper
15 × 11.5 cm each

Simon What were the videos like?

Holzer **Not great and somewhat autobiographical. Once, I went to my grand-parents' house and shot all around their farm. That's as close to autobiography as I ever came. I couldn't manage it.**

Simon What other art were you connecting with at this point?

Holzer **When I was working in summer school, Bruce Helander said the pieces looked like Nancy Graves'. By the time I got to graduate school, I ran into John Miller, who was interested in the art journal *The Fox*. He educated me.**

Simon How did you get from RISD, where you got your Masters of Fine Arts degree in painting in 1977, to the next stop, New York?

Holzer **Mike had been accepted into the Whitney Independent Study program, and I was desperate not to get tossed from RISD even though I didn't want to be there. Actually, it was better than that. I wanted to go to New York City to be an artist. I was in trouble with the RISD painting faculty. One of my videos was about alcoholism, which was in my family, and in the faculty. Someone asked me, 'You would expose your alcoholic aunt?', and a painting professor said, 'You would do anything. That is what is wrong with the twentieth century'. I considered suicide.**

Simon The alternative became New York.

Holzer **I applied to the Whitney program, and was accepted.**

Simon That was in 1977. What's discussed most often regarding your time at the Whitney program is the reading list which, you've often said, was a prompt to your writing the *Truisms*. Who assigned the list, and what import did it carry in the program?

Holzer **It was Ron Clark's list, and it was important.**

Simon Did the program focus more on theory than studio issues?

Holzer **There was a dose of theory, and they were quite willing and able to discuss studio. I thought the program was nicely balanced. They were hands-on when needed, hands-off when it was crucial. I liked that.**

Simon What artists were important to you at the time?

 Holzer **Yvonne Rainer fascinated me. I thought about the things she had done with the body and with words. They scared me to death but I wanted to find a way to her subjects. I couldn't see how. The way became clearer, and it had to do with language.**

Simon What was Rainer like as a teacher?

Holzer **A bit remote. Reserved, in a dignified, elegant sort of way. I appreciated**

her even if I mostly observed her. I didn't talk to many people in those days.

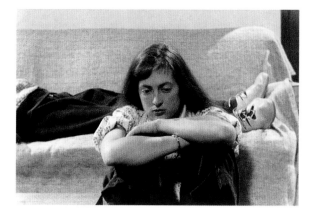

Simon The first work of Rainer's you had seen in person was the film *Kristina Talking Pictures* (1976).

Holzer **The first things of Rainer's that struck me were the pictures of her performing at Judson. I was amazed that she could be in motion with clothes off, being expressive that way. I didn't fully understand *Kristina Talking Pictures*, but what was clear – and I really can't explain this – is that the piece was hers. That she made it. It was the story of a woman.**

Simon *The Story of a Woman Who ...*, as another of her titles put it.

Holzer **Exactly. A woman working. Going back to the Picasso problem. Here was a woman's life, and she was deadly serious.**

Simon Any other artists?

Holzer **By the time I was part-way through undergraduate school, my art history went to Rauschenberg. I had a whiff of Joseph Kosuth by the time I was out of RISD. By the Whitney I was, maybe not up to speed, but something approaching that. Vito Acconci, Dan Graham and Alice Neel all talked at the Whitney.**

Simon When did you begin to write your texts down?

Holzer **Sometime in the first session of the Whitney program I tossed the painting with captions and started writing. Then I had to decide what to do with the writing.**

Simon For the first writings, what were your tools?

Holzer **Lined paper, and a Bic pen.**

Simon Why did you write the first *Truisms*?

Holzer **It's too neat to say it was just the Whitney reading list, but it was influential. I was intimidated by the list but wanted to address the subjects. I did the best I could with a number of one-liners.**

Simon Did everyone in the class address the list?

Holzer **Some people even read it (*laughter*). I read Sontag, and it was the first time I understood something of the difference between the critic and the artist. The distinction between writing about something and just plain writing. I didn't read much of the French stuff. Couldn't appreciate it. I read some of the Marxist offerings.**

Simon You worked on only the *Truisms* from 1977 to 1979?

Holzer **That was it, pretty much. I did one last painted gasp at P.S. 1 (1978).**

Yvonne Rainer
Kristina Talking Pictures
1976
92 mins., black and white
Film still

I painted the walls of a Project Room in different colours.

Simon How did you decide what form the *Truisms* should take?

Holzer **I was still at the Whitney when I did the first poster. I hate to give Mike all this credit, but he had the idea of doing a street poster. I was jealous immediately. The fact that he was going to do a poster was enough to make me print one.**

Simon What was to be printed on Mike's poster-to-be?

Holzer **A man falling through space.**

Simon What was your first poster?

Holzer **Thirty or forty of the best *Truisms*. I didn't alphabetize them – that change happened later. I typed, offset and pasted them on walls around town.**

Simon Then what?

Holzer **I just kept going. I didn't dare think of the reaction to them, but I hoped they would mean something to someone. At that stage I wanted to stay in motion, like tying the knots of the painting of a thousand cuts. I had to work and write a lot.**

Simon You finally did.

Holzer **A couple of hundred.**

Simon Not long after writing the *Truisms* you had three shows at three

From **Truisms**
1977–79
Photostats, audio tape, posters
Installation, Franklin Furnace,
New York, 1978, partially
destroyed

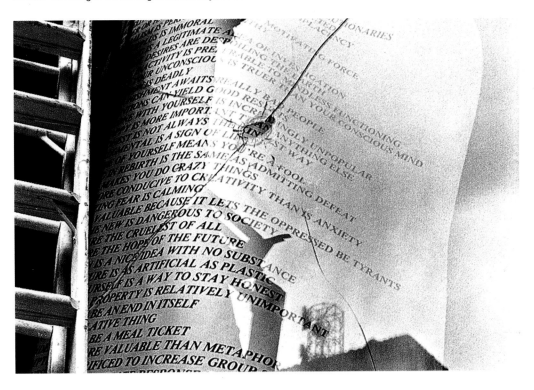

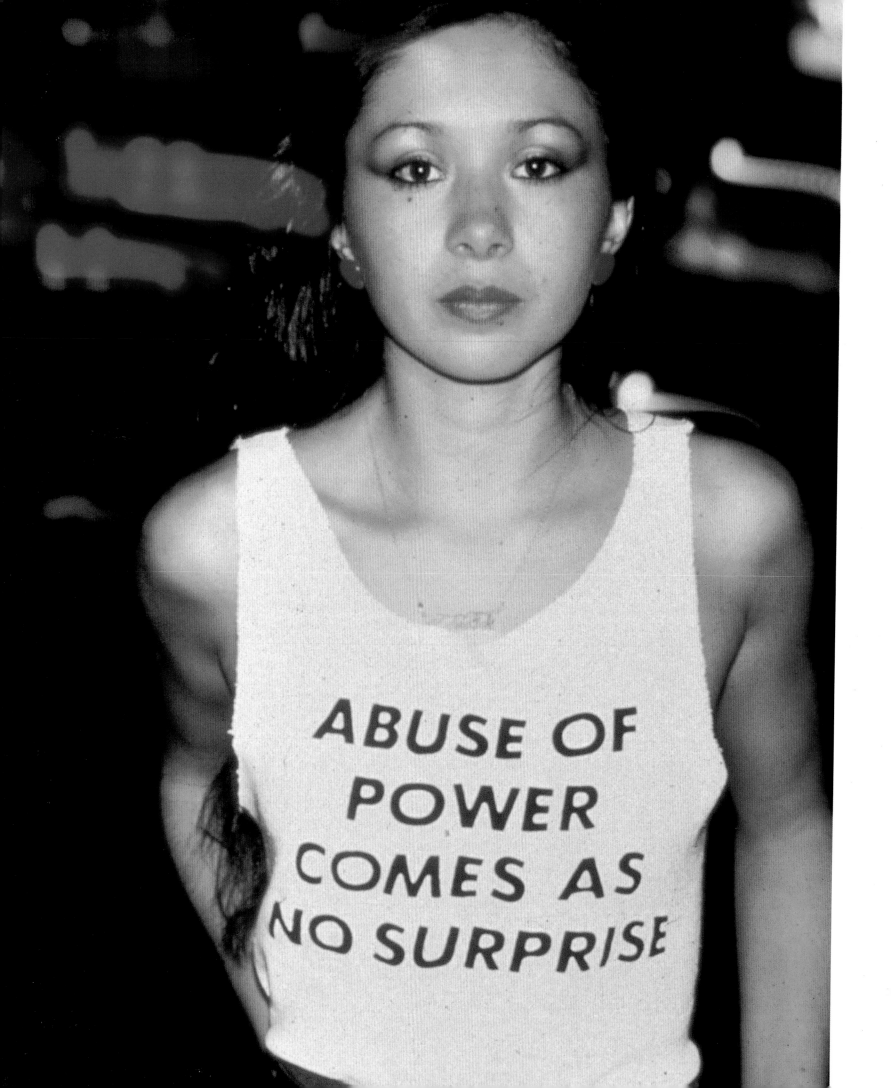

alternative spaces that were somewhat related: Franklin Furnace and Printed Matter in Lower Manhattan and Fashion Moda in the Bronx. These installations included audiotapes. Why, and at what point, did you jettison the live voice? Also, whose voice was on the tape?

Holzer **I didn't quite throw the voice away, but took a rest. Voices came back in the virtual reality *World II* (1994). I used other people's trained voices. I never had any interest in performing, even on tape. I used sound because it involves different body parts, plus you could hear the *Truisms* a block away.**

Simon It was that loud?

Holzer **In some places. I did one piece that was all audio: the *Truisms* in an elevator. It was in our loft at 515 Broadway. Sort of elevator music.**

Simon You've written eleven series in the past twenty years: *Truisms* (1977–79); *Inflammatory Essays* (1979–82); *Living* (1980–82); *Survival* (1983–85); *Under a Rock* (1986); *Laments* (1988–89); *Mother and Child* (1990); *War* (1992); *Lustmord* (1993–94); *Erlauf* (1995), and most recently *Arno* (1996–97). Since each set of writings flows into and sometimes integrates with the next, and as they are at times presented on the same kinds of signs or in assemblages, it

opposite, from **Truisms**
1977–79
T-shirt worn by Lady Pink
New York, 1983

above, from **Truisms**
1977–79
Coloured photostats, audio tape
Photostats 243 × 91 cm
Installation, Fashion Moda, Bronx,
New York, 1979, partially
destroyed

below, from **Truisms**
1977–79
T-shirt worn by John Ahearn
New York, 1982

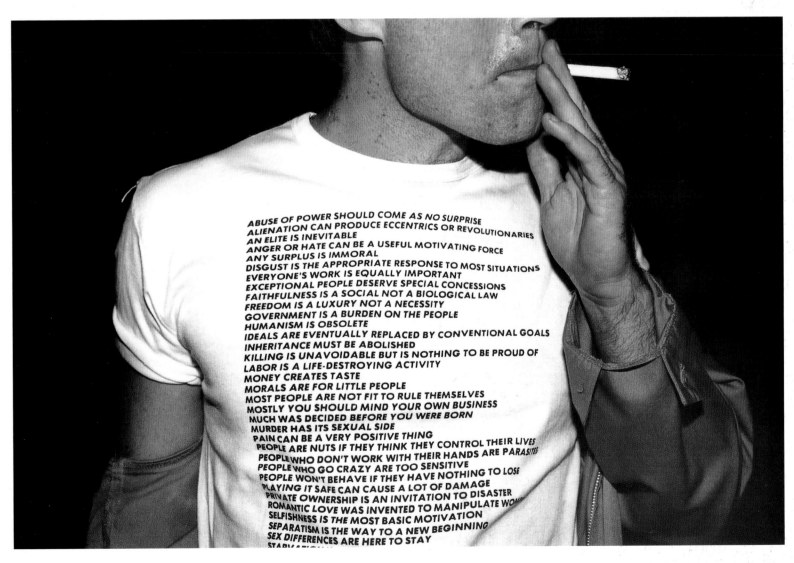

From **Inflammatory Essays**
(detail)
1979–82
Offset poster
25.5 × 25.5 cm
Project, New York, 1982, with
graffiti

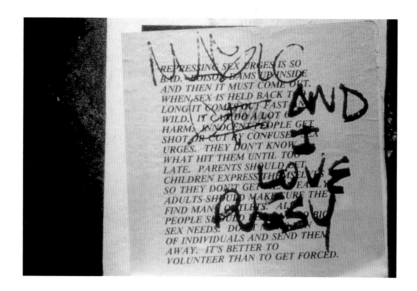

would be good to hear about each series specifically. I'm curious to know how,
in what forms and in what contexts, they were first made public.

Holzer **The *Truisms* are numberless one-liners written from multiple points**
of view. First they were on cheap offset street posters in Lower Manhattan,
and they have been in many forms and places since.

Simon On baseball caps, condoms, T-shirts, pencils, cash-register receipts, in
a dance performance, on electronic signs and on the Web, to name a few.

Holzer **The *Inflammatory Essays* were also street posters. Each poster was a**
different colour – a change of colour would announce the appearance of a
new text. The essays had exactly 100 words in twenty lines; the inspirational
literature was the writing of Emma Goldman, Rosa Luxemburg, Mao, Lenin,
et. al. *Living* was shown on cast bronze plaques and hand-lettered metal
signs. The bronze stood in contrast to the underground posters. The subject
matter is everyday life with a twist. The tone of the writing is matter-of-fact.
***Survival* was the first series written for electronic signs. It appeared on UNEX**
signs, made by the same company that created the Spectacolor board at One
Times Square. *Survival* is more urgent than *Living*.

Simon Working on the Spectacolor board in Times Square in 1982 was the first
time you used any of these electronic signs – what did it offer you?

Holzer **Memory. It let me show the material I had in Times Square for a good**
stretch of time. It let me program. That was interesting – to decide where to
place emphasis, when to make something fly, and how to stop.

Simon This was different from typesetting, which was a paying job for you in
the late 1970s and early 1980s.

Holzer **The fingers were on the keyboard again, but this time I was setting**
words in motion.

Simon What working materials do you use preliminary to making an electronic
sign? You say you don't draw anymore. But what are those things that look like

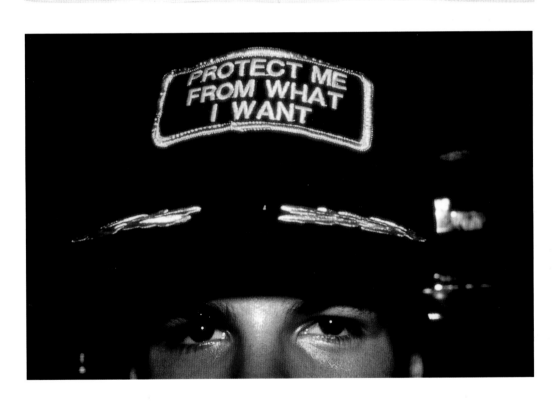

left, from **Survival**
1983–85
Latex condoms
5.5 × 10.5 cm

below, left, from **Survival**
1983–85
Cloth baseball cap
Approx. ø 16 cm

below, from **Truisms** and **Survival**
Cash register receipts
Dimensions variable
Project, London, 1988

bottom, from **Truisms**
1977–79
Wooden postcard
9 × 14 cm

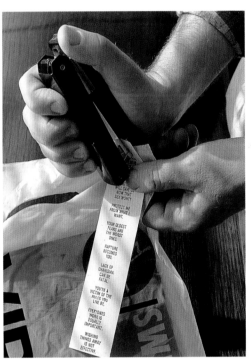

TORTURE IS BARBARIC

drawings or mock-ups for panels on the UNEX, for example, and how do they relate to some of the photos you took for the same images?

Holzer **There are only images on the UNEX signs and the UNEX are no more. Those weren't drawings – those were aberrations! I did shoot photos to make the aberrations. The diagrams were the last drawings.**

Simon Your words appear in stone for the first time in *Under a Rock*.

Holzer ***Under a Rock* was written after I moved to the country. The texts are somewhat desperate. The work appeared as a number of inscribed granite benches and electronic signs. People could occupy the benches and read the signs. *Under a Rock* was the first complete interior installation. I worked with Paul Miller at Sunrise Systems for this show. He has helped me realize all the major exhibitions that have electronic signage, including the hair-raising Guggenheim show.**

Simon By the time it was installed in 1989, the mechanical feat appeared seamless. At the Guggenheim, a retrospective of your writings was seen on a 163 metre-long sign, forming a continuous spiral up the museum's conical interior parapet wall. The grandness of the architectural intervention, as well as the combination of conical and spiral forms, and the spectacle itself, made me link your project with Tatlin's *Monument to the III International* (1919–20).

But back to *Under a Rock*. When it was first installed as a complete room in 1986, a single electronic sign was on the gallery's front wall; viewers, seated on the benches, faced the sign. The gathering place was likened to a chapel; you call it 'a Greyhound bus terminal'. And while the *Under a Rock* writings were extended meditations on what you once called 'unpleasant topics – things that crawled out from under a rock',[1] they were still reportorial in tone. What followed were the *Laments*, no less gruelling but now elegiac, even lyrical.

Holzer **Laments came during the AIDS epidemic. I had been writing about unnecessary death of any sort, for example, from bad government or accident. The *Laments* were shown at the Dia Art Foundation on thirteen stone sarcophagi and in thirteen vertical synchronized LED signs. I was pregnant when I was working on this series; Lili was crawling during the installation. The *Mother and Child* writing was done for Venice. It outlined fear. The work was programmed on twelve vertical LED signs and cut in the floor of the American pavilion. The text was reflected in the stone floor.**

Simon *War*, the next series, still brutal, begins to look outward again.

Holzer **The *War* series (1992) began during the Gulf conflict. I watched hours of coverage on CNN. Vertical signs with *War* made the stairs of the Kunsthalle Basel impassable (1992). The signs went to Saint Peter's Church in Cologne (1993). The Nordhorn *Black Garden* (1994) has *War* on five red sandstone benches.**

Simon *Lustmord* was published as a project in a newspaper's weekly magazine – a format similar to that of the Sunday magazine of the London *Sunday Times*, or the *New York Times*.

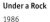

Under a Rock
1986
Misty Black granite benches, LED signs
Benches, 44 × 122 × 53.5 cm each
Signs, 25.5 × 286 × 115 cm each
Installation, Rhona Hoffman Gallery, Chicago, 1987
Collections, Art Gallery of Ontario; The Museum of Modern Art, New York; Museum of Contemporary Art, Chicago

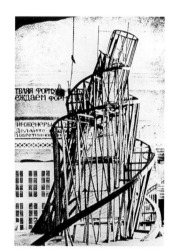

Vladimir Tatlin
Monument to the III International
1919–20 (model)
Wood, wire
Approx. h.670 cm

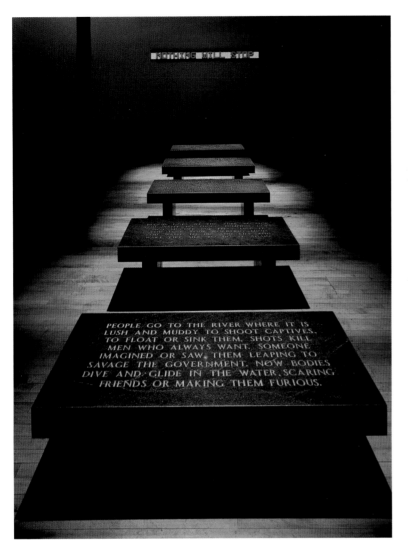

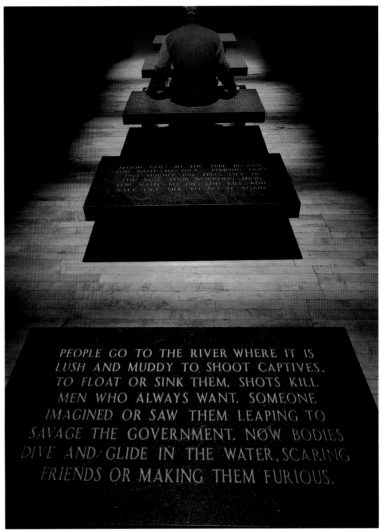

Holzer **The editors asked me to do a piece for the *Süddeutsche Zeitung Magazin*, and I didn't have anything. I waited a year for the writing. I had been working on the *War* series when *Lustmord* came. I thought it appropriate for the magazine.**

Simon There is no translation in English for the word *Lustmord* that is as specific, or as horrifically evocative.

Holzer **Nothing like the word in German, which means 'rape-slaying', 'sex-murder', 'lust-killing'.**

Simon You returned to writing in multiple voices.

Holzer ***Lustmord* was written from the vantage points of the perpetrator, the victim and the observer. Within each category there were a number of individuals. I didn't think the writing could be complete if written solely from perspective of the raped woman. I wanted to be able to explain the act to myself and then to other people.**

Simon The observer?

Holzer **That could be a family member who comes afterward and does**

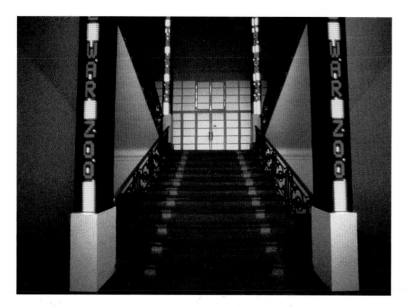 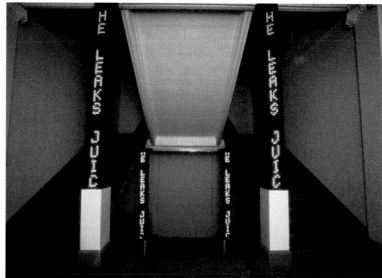

something or nothing, or someone with official standing, such as a United
Nations observer.

Simon While *Lustmord* is in good part about the Bosnian war, it is also about
family violence.

**Holzer It was prompted by the war in Bosnia, but it's about what happens in
other wars, and in peace time, in love and hate.**

Simon You've also said before that it had much to do with the loss of your
mother at this time.

**Holzer My mother died when I was writing and this influenced every part of
the work.**

Simon This particular project – almost thirty pages in the magazine – differed
from your other work in that you used a human body. The texts were handwritten
on the bodies of women and a man, then photographed in close-up so that hairs,
pores, skin are magnified as well as the words.

**Holzer I went to Tibor Kalman, a friend and designer (M & Co., Benetton's
Colors magazine), because I wasn't sure what to do on pages. I had used so
many electronic signs that by then I was afraid of paper. He and I decided to
write on skin, and to print in blood, so that words would be on and from bodies.**

Simon The card printed in blood was a small, very proper-looking folded white
card, the kind you might use to write a thank-you note. It was printed separately
and glued to the cover. The blood, donated by women volunteers, was treated
with intense heat to kill any contaminants, and then mixed with printing ink.

**Holzer German and Yugoslavian women donated blood so we could write in
it. We had a cover card that could be opened to show all three voices.**

Simon This cover caused a scandal far beyond what you anticipated.

From **War**
1992
LED signs
325 × 25.5 × 11.5 cm each
Installation, Kunsthalle Basel

Holzer **I wanted people to feel rather than simply to know. I thought they must touch the blood.**

We didn't imagine the way it turned out. We had everything from tears to outrage – the outrage almost exclusively from men.

Simon It also triggered other reactions and taboos, some spoken, some not. A fear of blood in general, of women's blood in particular, the notion of impure blood, whether racial or viral.

Holzer **There was a bloodbank scandal and so I think everyone was hyper-aware.**

Simon For me, more frightening than the almost dainty notecard on the cover were the photographs of bodies inscribed with texts, triggering thoughts of

From **War** (detail)
1992
LED signs
325 × 25.5 × 11.5 cm each
Installation, St. Peter's Church,
Cologne, 1993

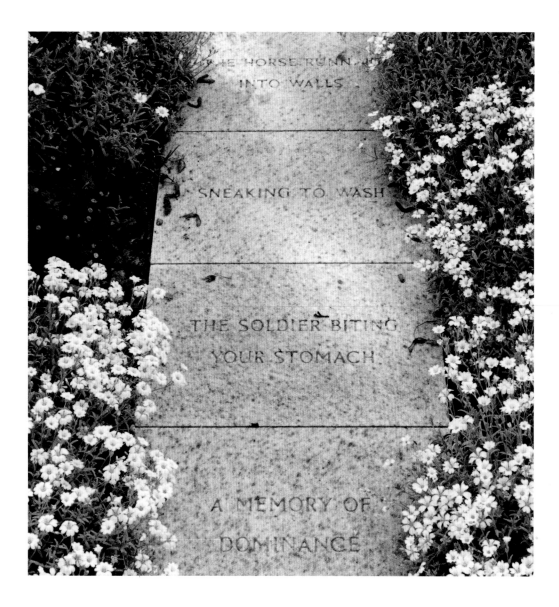

left and opposite, **Erlauf Peace Monument**
1995
Mile-high search light in Bethel White granite base with Bethel White granite paving stones inscribed with the *Erlauf* text
73 stones, 29 × 46 cm each
Permanent installation, Erlauf, Austria

branding, tattoos, concentration camp numbers. Was there a violent reaction to that part of the project as well?

> Holzer **People mostly spoke of the blood, but I suspect that everything, from the history of tattoos in Germany to the fact that it was women's blood, created the uproar. People were appalled by a small amount of donated blood used to highlight *Lustmord*.**

Simon Related to the next series of writings, the *Erlauf* texts, it should be noted that in recent years you have been commissioned to do several memorials, including a blacklist memorial for Los Angeles, to be built in 1998.

> Holzer **Before *Erlauf*, I did an anti-memorial memorial in Nordhorn, Germany, the *Black Garden*. It has a number of very dark, or black, flowers, foliage plants and trees in an uncanny, deathly space. There is a small, white, fragrant garden in front of a plaque commemorating the political opposition and the Jewish families who were murdered.**

Simon The de-emphasizing of words, not to mention the use of plants, is new to you.

Holzer Much of the content of the piece is carried by the black and white flowers. The black flowers are something like one of my rooms when the signs are off. The white flowers are light.

Simon Stone benches are used but take a modest place in the overall garden plan.

Holzer There are benches, but part of the piece is that the garden has to be kept alive; it requires attention and work and revision. A garden is an obligation.
There's a work in Erlauf, Austria, that commemorates the signing of the peace in that theatre of war. The Russian and American generals met in the town to accept the German surrender. The peace components are the white flowers and search light, visible for miles at night. The war part is the text that is on the paving stones.

Simon The most recent text series is *Arno*.

Holzer The *Arno* writing started as text for a video directed by Mark Pellington for 'Red Hot and Dance', an AIDS fund-raiser. I rewrote it for the 'Biennale di Firenze: il Tempo e la Moda' show in Florence. The text rose on signs in the pavilion I shared with Helmut Lang. In the middle of the night it was shown on the Arno River; this was my first Xenon projection. A variation of the text is at the Guggenheim, Bilbao.

Simon For Florence, you and Lang collaborated in another medium, odd even for you.

Holzer Helmut and I made a perfume that smelled of alcohol, tobacco, starch, sweat and sperm, a love of some sort.

Simon The equivalent of your *Arno* line I SMELL YOU ON MY CLOTHES. What's ahead?

Holzer Trying to write something again. I haven't locked myself up recently. As soon as I finish the next round of public pieces – in Europe and the US – I have to go to writing jail.

Simon The artists that have fed into your thinking are an extremely diverse lot. Among the earliest is writer, artist and printer William Blake.

Holzer When I read *Songs of Innocence* (1789–*c*.1800), for the first time I was entirely convinced that there was good in the world, including people.

Simon And his illustrations?

Holzer I liked the fact that Blake was able to have the text and images inhabit the same space.

Simon Was there any one poem in particular?

Holzer There is a lamb poem with just one little sinister turn that mentions a neck.

Interview

Simon 'Little Lamb
Here I am,
Come and lick
My white neck.'[2]

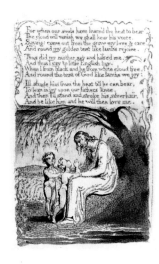

Holzer **That's the one. Then from *Songs of Experience*:**
'If thought is life
And strength and breath
And the want
Of thought is death.'

Simon You have spoken to me before of Malevich and Tatlin. The forms and functions of Tatlin's *Monument to the III International*, in particular. His tower was to be built of glass and steel geometries: a glass cylinder, cone and cube. It was to be a disorienting environment; each element was going to revolve on its axis. The cube at the top was to revolve once a day and was to be an information centre, with 'an open-air screen, lit up at night, which would constantly relay the latest news; a special projection was to be installed which in cloudy weather would throw words on the sky, announcing the motto for the day …'[3]

Holzer **I was fascinated by the tower, but didn't know much about it. In art history it was only covered in passing – flipped on the screen once. I loved how it looked and thought the way it was meant to function critically important. It makes the blimp in *Bladerunner* unidimensional.**

Simon The fact that it could not be built at the time …

Holzer **That seemed perfect in some way, too. The whole concept was grand and tragic, hopeful, cruel, necessary.**

Simon So much of its program makes me think of your hopes and also what technology has only recently allowed you to accomplish – that new kind of Xenon projection, for example, used to 'throw' writings onto water and buildings.

Holzer **It is a great luxury for me to have the laser and Xenon projections.**

Simon Your pieces share the palette of Russian constructivist work. I know you mentioned specifically Malevich's *Black Square and Red Square* (1914–16).

Holzer **All the colours required. Not coincidentally, they are the early LED sign colours.**

Simon What aspects of Duchamp have been key for you?

Holzer **I was encouraged by the fact that he used a sign-painter when necessary. I liked the fact that language came in and out of the work as required. It was much discussed that his work was responsive to the tension in the air before World War I. I think he was alive to whatever it was that culminated in war.**

Simon You were talking to me earlier about what you called his 'swirly optical'

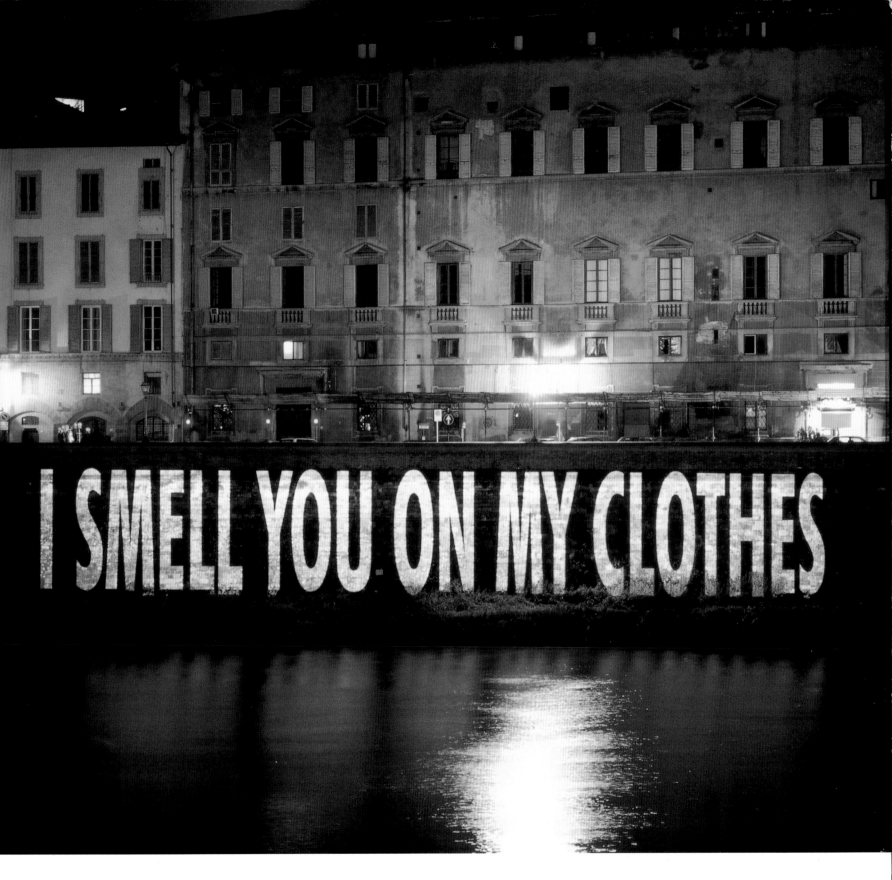

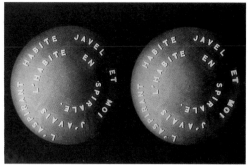

Marcel Duchamp
Anemic Cinema
1925–26
7 mins., black and white
animation
Film still

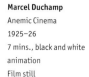

things: words and lines spiralling on the spinning disks filmed in *Anemic Cinema* (1925–26) and his emphatically colouristic swirls on the disks of his *Roto-Reliefs* (1935). From the artist of the 'non-retinal', these works are dazzlingly optical.

Holzer **For all his detachment, I've always thought his work looks perfectly right. The disks are eye candy, have content, and do move.**

Simon You mentioned also what you called Duchamp's 'female fig leaf' (*Feuille de Vigne Femelle*, 1950) and the 'crotch for Teeny' (*Coin de Chasteté*, 'Wedge of Chastity', 1954).

Holzer **You don't see too many crotches in art; I have to take my hat off to him. I recall thinking how important an object and subject this piece of anatomy was. I remember that the work was nicely puny, seemingly made with a minimum of effort and material. I saw *Fountain* and thought it represented artistic freedom. The fig leaf and the urinal are also good for contemplating form and function.**

Simon You threw many other artists' names at me the other day, among them Louise Nevelson and her black constructions.

Holzer **The relentless black spoke to me along with her compulsiveness in getting more and more material inside the frame. Then ordering was critical.**

Simon Mark Rothko and Ad Reinhardt were critical even when you abandoned painting.

Holzer **I thought I would have to leave everything like rapture or the sublime when I began the *Truisms* posters. When I was invited to do the indoor installations, I could practice something akin to what happens in a Reinhardt. This is too literal, but an example is the installation at Dia, when I made the room black for a moment before the signs could begin. There was nothing but the apprehension of a presence.**
 The language would rise on the signs and with it a glow. I am uneasy claiming that my work functions as Rothko's does, but I can say I wanted to offer light like that at the edges of his forms.

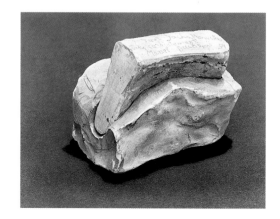

Simon When you finally began to put your words on something other than single, rectangular paper sheets, your structures and references are minimalist. You talk about being fascinated by the detail of LeWitt's pencilled wall drawings

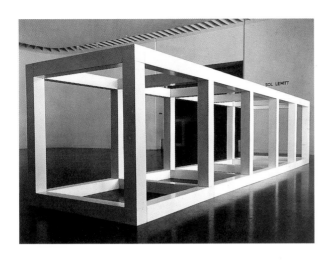 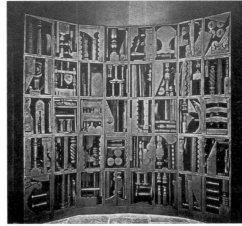

Sol LeWitt
Five Modular Units
1970
Baked enamel on steel
183 × 183 × 732 cm

Louise Nevelson
Tide I Tide
1963
Wood, paint
274 × 366 cm

Mark Rothko
Red on Maroon
1959
Oil on canvas
266 × 239 cm

and his large, white, open-cube, lattice-like constructions. You also cite Donald Judd as extremely important.

> Holzer **LeWitt, like Nevelson, displayed clarity, order and innumerable possibilities for structure. That was the great appeal, plus the fact that he did it so beautifully and economically. With Judd, much of the aforementioned applies, plus I liked his repetitions and the space made by his boxes. I also appreciated that everything of his lined up.**

Simon When you first began to show your work you were identified with the Colab collective.

> Holzer **Shortly after the Whitney program I met Colen Fitzgibbon when I staggered into the 'Doctor and Dentist' show at Robin Winters' loft. With Colen I conspired to make the 'Manifesto Show' (1979). This Colab show had everything from the Futurist Manifesto and the Communist Manifesto to proclamations by any number of artists and individuals. People said what they desperately wanted to happen or what they didn't ever want to transpire. These pronouncements were writings, images or performances.**

Simon How long did Colab hang together?

> Holzer **I don't know. I guess I intersected with the gang for four or five years.**

Marcel Duchamp
Coin de Chasteté (Wedge of chastity)
1954
Plaster, paint
7 × 10 × 6 cm

Simon Curators and critics have also linked you with Louise Lawler, Cindy Sherman and Barbara Kruger. You seem to share theoretical concerns, an ease with pop culture, an implicit politics, and you have come to know one another.

> Holzer **I am very interested by all the artists you mention. I only have a passing acquaintance with the theoretical, but I always felt Louise's work was great. I found what she did both fabulously opaque and absolutely transparent and solid. Sometimes when I'd see Michael Asher's work, I'd appreciate it because I couldn't get it. With Louise's, I could love that aspect, but I also knew what she was about. I knew her subjects, and I thought that the subjects were important.**

Simon You mentioned in particular the racehorse piece of Lawler's:

——————, Louise Lawler, Adrian Piper and Cindy Sherman Have Agreed to
Participate in an Exhibition Organized by Janelle Reiring at Artists Space,
September 23 through October 28, 1978 (1978).

**Holzer It had to do with wealth, privilege and illumination. It was blinding
light and the gorgeous body of a race horse. I got it, and she did not pander.**

Simon You also speak of particular pieces by Sherman and Kruger.

**Holzer The Kruger is *Your Manias Become Science* (1981). I thought it
important because getting blown off the face of the earth is relevant.
 That early work of Sherman's in which she looks like a young female
Mao Tse-tung was extremely good. It made me review what he did.**

Simon You have collaborated in many ways and in different media since the
beginning of your career: with the members of Colab on various projects; with
Peter Nadin on artists' books; with Mike Glier for drawings with texts; with
graffiti artist Lady Pink on paintings with texts; with Keith Haring on billboards;
with Helmut Lang on an installation and a perfume. Why do you think you're
such an avid and good collaborator?

Holzer I want to learn something.

Simon I recently learned about two collaborations of yours that re-form the
Truisms in radically different ways. One is on a Web page, begun in 1995, which
is about as disembodied a transmitter, vehicle, voice and receiver as can be. The
potential size of the audience using the Internet makes this one of your most
far-reaching public projects. The other is a dance work choreographed by Bill T.
Jones, *Holzer Duet … Truisms* (1985), where your *Truisms* are literally bodied
forth by Bill T. Jones and Larry Goldhuber. The *Truisms*, spoken aloud, structure
the dance.

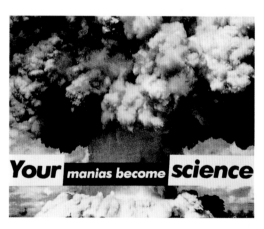

Holzer The äda'web project has something like 10,000 new *Truisms*.

Simon People are adding their own *Truisms* to yours?

**Holzer That's the idea. It's not so much to put my stuff there. My things are
prompts for people's rewrites. Once written, the new and improved *Truisms*
are automatically alphabetized and added to the list.**

Simon What's the address of the äda'web site?

Holzer http://adaweb.com/cgi-bin/jfsjr/truism⁴

Simon The Bill T. Jones work is a stunning visual correlative to your text. The
precise, strong movements that the pair of dancers hold as your words are heard
have the clarity of each of your phrases. The 'different voices' in your texts are
embodied by two very different-looking men. One is black, one is white; one is
taut, sculpted, athletic; he is bare-chested and barefoot, costumed in black
shorts. The other has what would have been called a 'non-dancer's' silhouette.
Big and pear-shaped, he wears a suit and tie, though he is sometimes seen

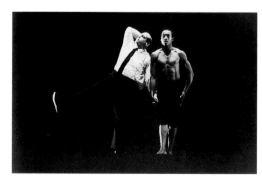

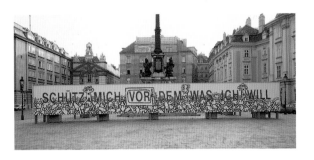

From **Survival,** with Keith Haring
1983-85
Billboards
Project, Am Hof, Vienna, 1986

Louise Lawler
--------, Louise Lawler, Adrian Piper
and Cindy Sherman Have Agreed to
Participate in an Exhibition
Organized by Janelle Reiring at
Artists Space, September 23
through October 28, 1978
1978
Oil painting by H. Stulman (1883),
2 VNSP par 64 1000 watt lights
Dimensions variable
Installation, Artists Space, New York

Barbara Kruger
Your Manias Become Science
1981
Black and white photograph, text
94 × 125 cm

Bill T. Jones
Holzer Duet ... Truisms
1985
Performance, Joyce Theatre, New
York

without his jacket, as if at work at the office, and dances in shirtsleeves, braces
revealed. His voice sounds New York City nasal. Another voice (from off-stage)
has 'no' accent, not unlike the broad sounds of upstate New York or the
Midwesterner's heartland speech.

Holzer **I was so thankful that Bill and Larry did it because I'm timid about
flesh. It was of great interest to me to have the *Truisms* said, touched, flopped
and rubbed by two people.**

Simon Each performer is correct to the spoken language and to the language
of form in movement. *Duet* is a great piece of dance formally, and it is powerful
emotionally.

Holzer **It was something I couldn't do and I'm relieved they could. I am
encouraged by it.**

Simon I saw excerpts of *Holzer Duet ... Truisms* in a film where Jones is
interviewed.[5] He said something that, to me, is on target about the intentions of
your work and also summarizes what a viewer feels in its presence; and he
characterizes the 'duet' between his work and yours, the politics and poetics,
the visual, formal and temporal essence of what you both offer your audience:
 'I'm laden with expressions. I'm laden with anger, and discontent and
social commentary. (For) the piece I made recently with Larry Goldhuber, I
purposely chose Jenny Holzer's writings because Holzer is dealing with
something I have felt. She would like to voice points of view that are left, centre
and right, and they all exist in some sort of disembodied presentation so that
we the observer(s) must decide where we fit. I don't take a particular stand. I'm
presenting political work without committing my own particular point of view.
Trying to balance abstraction, trying to give the audience the time, the breath,
to make their own decisions, and entertain their minds and eyes as they are
going through this process.'

Holzer **I am glad he said 'disembodied'; I am so happy he has the body.**

1 Quoted in Michael Auping, *Jenny Holzer*, Universe, New York, 1996, p. 38

2 William Blake, 'Spring', *Songs of Innocence and Songs of Experience*, Dover Publications, Inc., New
 York, 1992, p.23. For a discussion of some of the many and various writers that have been important to the artist,
 see Holzer's 'Book Report, A Response to Artist's Choice', page 102 of this volume, which began to find its
 voice as a long section of this interview.

3 Camilla Gray, *The Russian Experiment in Art: 1863–1922*, Harry N. Abrams, New York, 1971, p. 226

4 'Please Change Beliefs', on-line project, launched May 23, 1995

5 Sally Barnes, *Retracing Steps: American Dance Since Postmodernism*, Michael Blackwood Productions, New York,
 1988. My thanks to Kellie Jones for bringing to my attention this film and Bill T. Jones' *Holzer Duet ... Truisms*,
 1985.

With thanks to Tory Bender, Jerusha Clark, Mary Cross, Brenda Phelps and book project manager Amy Whitaker at
the Jenny Holzer studio, to Gilda Williams and Iwona Blazwick of Phaidon Press, and cheers to Lili Holzer-Glier
and Ani and Kira Simon-Kennedy.

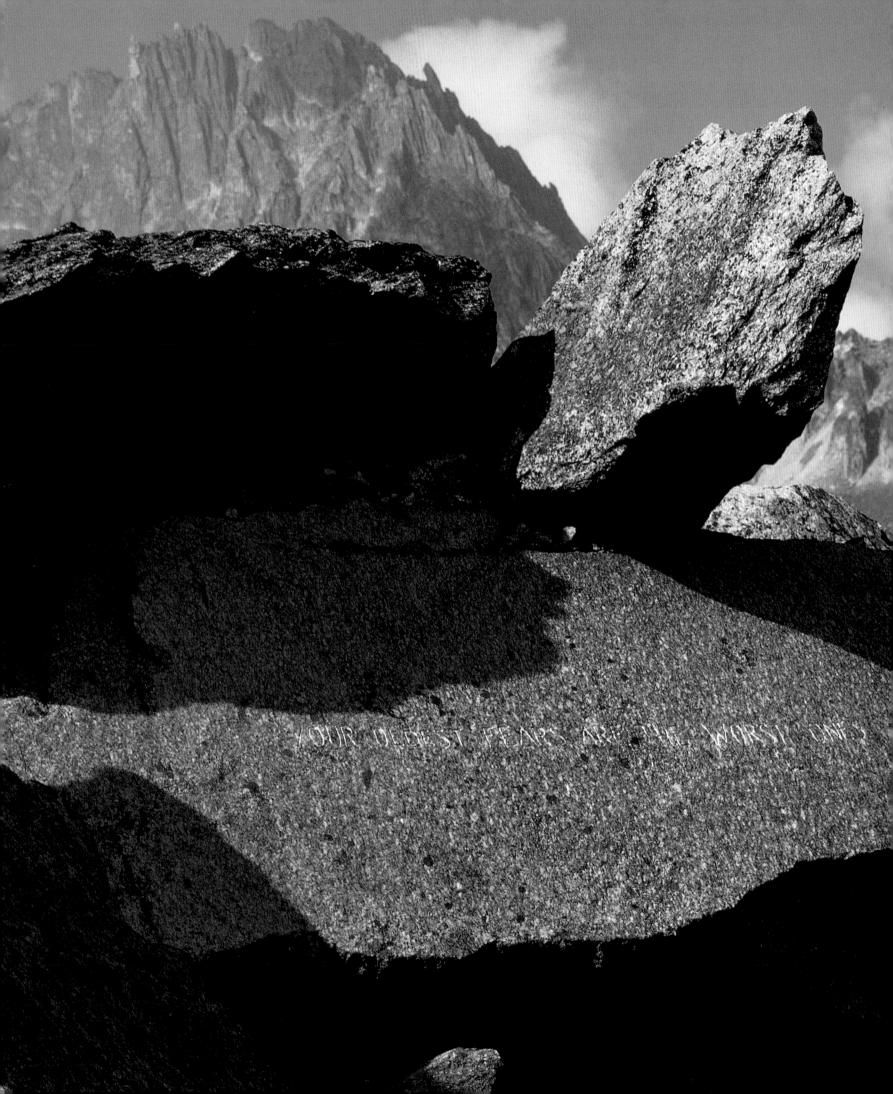

YOUR OLDEST FEARS ARE THE WORST ONES

Contents

I. Language

'A manifesto is a communication made to the whole world, whose only pretension is to the discovery of an instant cure for political, astronomical, artistic, parliamentary, agronomical and literary syphilis. It may be pleasant, and good-natured, it's always right, it's strong, vigorous and logical.

Apropos of logic, I consider myself very likeable.'
— Tristan Tzara[1]

This manifesto on manifestos is exemplary. It is global in scope, passionate in tone, and its flamboyant irony is matched by a breathtaking confidence. In Tzara's extravagant chain of adjectives, it is significant that 'artistic' is lodged between 'astronomical' and 'parliamentary': art is firmly situated among diverse forms of knowledge and political debate. A Xerox containing this passage, along with a dissonant array of texts ranging from Hitler's *Mein Kampf* to Valerie Solanas' *SCUM Manifesto*, remain in Jenny Holzer's files from the 'Manifesto Show', a collaborative project undertaken with Colen Fitzgibbon in 1979 at 5 Bleecker Street in New York.[2] According to Holzer's memory, the artists, friends and neighbours invited to present their own texts alongside historical manifestos on art and politics were asked 'to write, say, or somehow present as an image what you want to have happen – or don't – what is dearest to your heart, and what makes you furious'.[3] These instructions are consistent with the model of the avant-garde manifesto embodied by Tzara's text: they call for passionate commentary on a social question. And indeed Holzer's art has long been distinguished by its introduction of passionate and politicized speech into traditions of Conceptual and installation art of the late 1960s and 1970s characterized by detachment and neutrality. The paradox of Holzer's encounter with the manifesto lies in such political and art-historical collisions of hot and cool. In the 'Manifesto Show' for instance, this duality is evoked by a strategy of pluralization in which the content of any particular statement is subordinated to the system in which it circulates: democratic contradiction displaces revolutionary conflict.

By the late 1970s Holzer had developed several rhetorical models within her textual art. In addition to the manifesto, she has since explicitly identified the caption as a source of her later work. In a project undertaken while a student at the Rhode Island School of Design in the mid 1970s, she began copying diagrams from books only to become intrigued by their captions. It is worth quoting at length her own account of this project:

'I had also started a collection of diagrams. I went to the library at Brown and got books on subjects ranging from science to psychology to astrophysics to religion, and I looked at all the diagrams in them. At that time I thought that diagrams were the most reduced, the truest way of visual representation. So I collected them from all these disciplines and then redrew them, just to do something with them. And then I put the drawings in a box. I don't know exactly what made me shift, but finally I wound up being more interested in the captions than the drawings. The captions told you everything in a clean, pure way. This was the beginning – or one of the beginnings – of my writing.'[4]

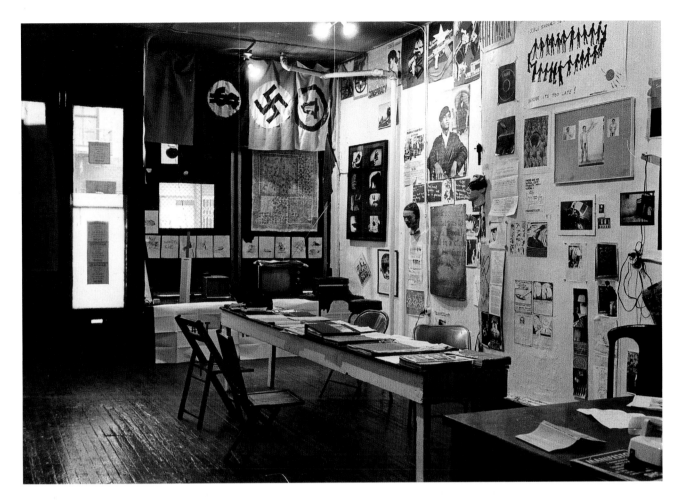

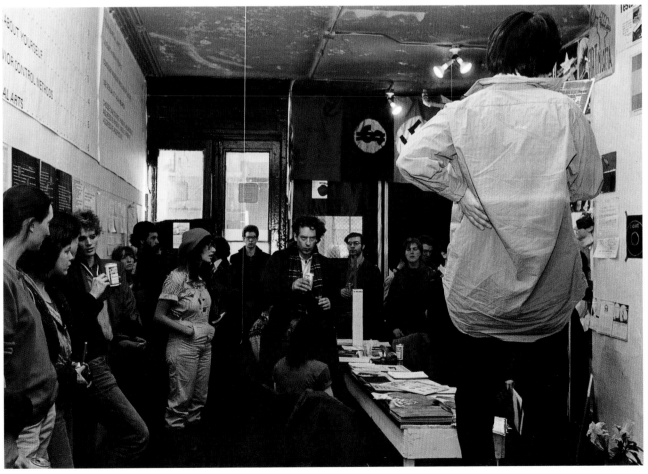

Manifesto Show, with Colen Fitzgibbon and Collaborative Projects
Installation, 5 Bleecker Street, New York, 1979

Survey

FEAR IS THE MOST ELEGANT WEAPON,
YOUR HANDS ARE NEVER MESSY.
THREATENING BODILY HARM IS CRUDE.
WORK INSTEAD ON MINDS AND BELIEFS,
PLAY INSECURITIES LIKE A PIANO. BE
CREATIVE IN APPROACH. FORCE
ANXIETY TO EXCRUCIATING LEVELS OR
GENTLY UNDERMINE THE PUBLIC
CONFIDENCE. PANIC DRIVES HUMAN HERDS
OVER CLIFFS; AN ALTERNATIVE IS
TERROR INDUCED IMMOBILIZATION. FEAR
FEEDS ON FEAR. PUT THIS EFFICIENT
PROCESS IN MOTION. MANIPULATION IS
NOT LIMITED TO PEOPLE. ECONOMIC,
SOCIAL AND DEMOCRATIC INSTITUTIONS
CAN BE SHAKEN. IT WILL BE
DEMONSTRATED THAT NOTHING IS SAFE,
SACRED OR SANE. THERE IS NO
RESPITE FROM HORROR. ABSOLUTES ARE
QUICKSILVER. RESULTS ARE SPECTACULAR.

FREEDOM IS IT! YOU'RE SO SCARED,
YOU WANT TO LOCK UP EVERYBODY.
ARE THEY MAD DOGS? ARE THEY
OUT TO KILL? MAYBE YES. IS LAW,
IS ORDER THE SOLUTION? DEFINITELY
NO. WHAT CAUSED THIS SITUATION?
LACK OF FREEDOM. WHAT HAPPENS
NOW? LET PEOPLE FULFILL THEIR
NEEDS. IS FREEDOM CONSTRUCTION
OR IS IT DESTRUCTION? THE
ANSWER IS OBVIOUS. FREE PEOPLE
ARE GOOD, PRODUCTIVE PEOPLE.
IS LIBERATION DANGEROUS? ONLY
WHEN OVERDUE. PEOPLE AREN'T
BORN RABID OR BERSERK. WHEN
YOU PUNISH AND SHAME YOU CAUSE
WHAT YOU DREAD. WHAT TO
DO? LET IT EXPLODE. RUN
WITH IT. DON'T CONTROL OR
MANIPULATE. MAKE AMENDS.

Black Book
1980
Artist's book
Book, 18 × 17.5 cm

A caption is meant to explain and interpret; it is neutral, factual and anonymous. On the other hand, the manifesto is partisan, often blatantly implausible, and deeply rooted in the voice of its author. Much of the force of works like the *Truisms* (1977–79) and the *Inflammatory Essays* (1979–82) lies in Holzer's explosive combinations of such contradictory rhetorics.

This literary fusion is particularly apparent in the *Inflammatory Essays*, a series influenced by Holzer's own reading of manifestos. In addition to her organizational labour of researching and presenting historical texts, Holzer's individual contribution to the 'Manifesto Show' was the *Inflammatory Essays*. They are characterized by a seamless but nonetheless jarring mobility in tone – from calm explanation to, for instance, unspeakable cruelty:
FEAR IS THE MOST ELEGANT WEAPON,
YOUR HANDS ARE NEVER MESSY.
THREATENING BODILY HARM IS CRUDE.
WORK INSTEAD ON MINDS AND BELIEFS,
PLAY INSECURITIES LIKE A PIANO. BE
CREATIVE IN APPROACH. FORCE ANXIETY
TO EXCRUCIATING LEVELS OR GENTLY
UNDERMINE THE PUBLIC CONFIDENCE.
PANIC DRIVES HUMAN HERDS OVER CLIFFS;

AN ALTERNATIVE IS TERROR INDUCED
IMMOBILIZATION. FEAR FEEDS ON FEAR.
PUT THIS EFFICIENT PROCESS IN MOTION.
MANIPULATION IS NOT LIMITED TO PEOPLE.
ECONOMIC, SOCIAL AND DEMOCRATIC
INSTITUTIONS CAN BE SHAKEN. IT WILL BE
DEMONSTRATED THAT NOTHING IS SAFE,
SACRED OR SANE. THERE IS NO RESPITE
FROM HORROR. ABSOLUTES ARE
QUICKSILVER. RESULTS ARE SPECTACULAR.

The message of this work – its 'manifesto-effect' – is a chilling and impressively amoral endorsement of intimidation, but its rhetoric also belongs to the discourse of the caption. Often a fundamental aspect of a manifesto is the reader's firm knowledge of the writer's identity; it is an act of *identification* whose force derives from the association of a strong program or point of view with a particular person. Lenin's *What is to be Done?* or Hitler's *Mein Kampf* would have had very different literary and practical effects if issued from different authors (not to mention the fact that our understanding of 'Lenin' and 'Hitler' as historical figures would be transformed if they were not linked to these and other writings[5]). But in Holzer's *Inflammatory Essays*, authorship while emphatic is undecidable – here the voice is that of the anonymous caption, saturated by the idiom of social science. The first person pronoun is nowhere present: Holzer does not write I WILL DEMONSTRATE … but, IT WILL BE DEMONSTRATED THAT NOTHING IS SAFE SACRED OR SANE. Phrases like BE CREATIVE IN APPROACH, PUT THIS EFFICIENT PROCESS IN MOTION, and RESULTS ARE SPECTACULAR seem to be drawn from *Adweek* rather than *The Communist*

Manifesto. The rhetoric of the caption evacuates any personal dimension from the overheated emotional messages of the manifesto. Indeed, such an intersection of sentiment and science was already present in Holzer's early booklet *Diagrams* (1977), where complex and abstract concepts like 'Symbolism' are combined with diagrams made opaque by their extraction from any specific disciplinary context.

The marriage of contradictory rhetorics wraps passionate and even irrational impulses in commonsense reasoning. But it does so only through a specific subjective effect: the undecidability or pluralization of the authorial voice. Certainly the point of Holzer's earlier, and perhaps best known work, the *Truisms*, whose alphabetized list includes astounding contradictions, like AN ELITE IS INEVITABLE followed by ANY SURPLUS IS IMMORAL, is meant to loosen any unilateral tie between author and text. Indeed, Holzer has long been conscious of this quality of her work: 'I always try to make my voice unidentifiable ... I wouldn't want it to be isolated as a woman's voice, because I've found that when things are categorized they tend to be dismissed. I find it better to have no particular associations attached to the "voice" in order for it to be perceived as true' (1986).[6] As this statement suggests, Holzer uses text not merely – or even primarily – to dematerialize art *objects*, but rather to evaporate the *subject* of art – the artist – to the point where qualities as ostensibly fundamental to identity as gender are indeterminate and perhaps irrelevant. The 'author' projected by Holzer's texts is nowhere and everywhere – both uncannily

personal and rigidly ideological. There's that shock: what is this, who's saying this, where's it coming from, what does it mean to me?

This ambition – to dematerialize the author – has a history in recent art to which we should attend in order to assess the significance of Holzer's accomplishment. There are two traditions in particular within art of the 1960s and 1970s where textual forms of image-making intersect with questions of authorship: Conceptual Art and semiotically sophisticated feminist artworks. In his foundational essay of 1969, 'Art After Philosophy', Joseph Kosuth established several of what would become the central tenets of Conceptual Art. Kosuth suggests that, since the practice of art is itself a succession of distinct formal vocabularies organized into specialized and often arcane codes, linguistic structure is not merely a metaphor for art, but rather its essence:

'*In other words, the propositions of art are not factual, but linguistic in* character *– that is, they do not describe the behaviour of physical, or even mental objects; they express definitions of art, or the formal consequences of definitions of art.*'[8]

Implicit in this passage are the two most influential conclusions Kosuth draws in 'Art After Philosophy': that art should consist of the artist's invention of critical *propositions* about art,[9] and that the proposition's form (usually language) serves to de-materialize art objects, or in fact, to make them entirely irrelevant.[10]

One of the most significant legacies of Kosuth's thought has been the widespread critical perception that an inverse relationship exists between words and objects – that text has the

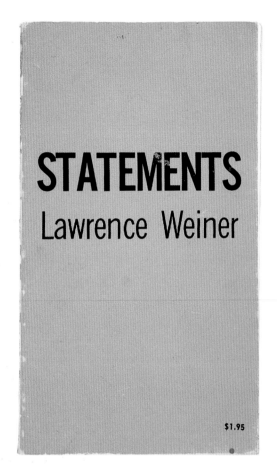

$1.95

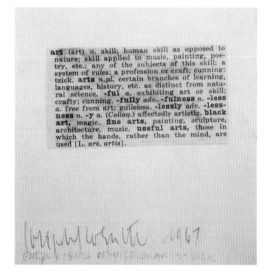

Lawrence Weiner
Statements
1968
Artist's book
Book, 18 × 10 cm

Joseph Kosuth
Art as Idea as Idea
1967
Collage on card
7.5 × 7.5 cm

capacity to displace or dissolve material things. Indeed Lawrence Weiner's art would seem to exemplify the transformation of material processes into language.[11] In a 1968 exhibition organized by the curator/gallerist Seth Siegelaub, Weiner's work consisted exclusively of phrases published in a small book titled *Statements*. Many functioned as an anonymous and curiously anti-imperative form of instruction for producing post-abstract expressionist painting: ONE QUART EXTERIOR GREEN INDUSTRIAL ENAMEL THROWN ON A BRICK WALL or AN AMOUNT OF PAINT POURED DIRECTLY UPON THE FLOOR AND ALLOWED TO DRY. In these works, making is displaced by saying; an act is eclipsed by a thought.[12]

It would seem that Kosuth and Weiner's textual strategies for dematerializing the art object occlude the position of the author altogether. In a well-known series of works from the mid 1960s, for instance, Kosuth appropriated, enlarged and exhibited a number of dictionary definitions of symbolically charged words like 'meaning'. In these works a single authoritative (and collective) voice – the dictionary – seems to take the place of the individual author. And in Weiner's statements the work's (possible) execution is purposely alienated from his person. But paradoxically, a more impersonal but no less authorial term emerges in works such as these. In place of the artist's *expression* is his/her *intention*. The validity of the work is attached not to the artist's gesture – as it might have been in a painting by Pollock, Rothko, Louis or Frankenthaler – but rather in the correct understanding of his or her concept. As Kosuth states in 'Art After Philosophy', 'A work of art is a

tautology in that it is a presentation of the artist's intention, that is, he is saying that a particular work of art is art, which means, is a definition of art'.[13] The ramifications of this statement seem contradictory, given the widespread presumption that Conceptual Art dismantles traditional models of authorship. Kosuth's point is simple: when the work of art becomes tautological, dematerialized and textual, the only way it can be recognized as art is through recourse to the artist. The role of the artist as ultimate guarantor not only of the authenticity of a particular work, but also of the very definition of art under which s/he is labouring, suggests a return of artistic authority in the midst of its apparent disappearance.

This 'para-legal'[14] understanding of authorship as a guarantee of artistic intention is an important historical precedent for Holzer's linguistic work. But in her own art, unlike that of conceptual artists like Kosuth, intention is not cited as an authorization for the aesthetic status of a text. On the contrary, as we have seen, Holzer's rhetorical heterogeneity submits intentionality to extreme forms of dislocation and pluralization: it is impossible to know 'who's saying this, where's it coming from, what does it mean ... ' This differing attitude towards the intersection of language and authorship is due in great part to gender. It must have seemed natural to male conceptual artists working in the late 1960s and 1970s that the discourse they produced *belonged* to them – culturally and legally. But a number of feminist artists working in the 1970s began to understand the 'possession' of language as a profoundly gendered privilege. Influenced by psychoanalytic

thought, and particularly the theories of Jacques Lacan, artists like Mary Kelly insisted on the close association between discourse and patriarchal relations of power – a link that rendered feminine authorship logically impossible. In 1977 Kelly wrote:

'Because of this coincidence of language and patriarchy, the feminine is, metaphorically, set on the side of the heterogeneous, the unnameable, the unsaid. But the radical potential of women's art practice lies precisely in this coincidence, since, in so far as the feminine is said, it is profoundly subversive.'[15]

Kelly's foundational work, the *Post-Partum Document* (1973–77), exists in the paradoxical space between femininity's unsayability and the subversive force of its utterance. The *Document* is a complex and multi-layered meditation on the mother-child relationship from the period of infancy through the child's acquisition of language. It demonstrates that femininity emerges not from the 'natural' biological character of women, but is defined in great part by institutional discourses such as medicine, psychoanalysis and natural history. The drama of the *Document* – the inevitable separation between mother and son – pivots on the child's acquisition of language,[16] and consequent initiation into what Lacan calls the symbolic order.

Kelly has used the phrase, 'the heterogeneity of discourse'[17] to describe a feminist response to the 'para-legal' model of authorship in Conceptual Art. In place of a single textual statement guaranteed by the artist's intention, the feminist author is *situated* within language, not so much its source as its effect. In Martha Rosler's *Service: A*

Trilogy on Colonization (1976–78), for example, the 'author' is multiplied into three fictional narrators of three 'novellas' originally published in instalments and sent through the mail on postcards. Each novella explores the impact of class and gender through 'first-person' accounts of food preparation: a middle-class homemaker who makes exotic foreign dishes for her family; a fast-food cook who collectivizes her workplace in an effort to improve the quality of the meals it serves; and a Mexican maid who is asked to prepare authentic Mexican food for her Anglo employers in the United States. In Kelly's work 'heterogeneity of discourse' serves to demonstrate the female author's dispossession from, or at best provisional possession of, her own voice, whilst in Rosler's work the multiple personae gathered under the aegis of a single author allow her to give a complex account of the relations between class- and gender-based servitude. In Holzer's art each of these feminist strategies – dispossession from patriarchal authority and pluralization of political perspective – is deployed. And yet there is a difference. Kelly and Rosler situate their textual art in a way that Holzer does not: despite its large theoretical scope, the

Mary Kelly
Post-Partum Document:
Documentation V, Classified
Specimens, Proportional
Diagrams, Statistical Tables,
Research and Index
1977
Perspex units, white card, wood,
paper, ink, mixed media
3 of the 33 units, 18 × 38 cm each

```
plastered      stuccoed
rosined      shellacked
   vulcanized
inebriated
polluted
```

Martha Rosler
The Bowery in Two Inadequate
Descriptive Systems
1974-75
Black and white photographs with
text
2 parts, 20 × 25 cm each

From **Living**
1980-82
Cast bronze plaque
12.5 × 25.5 cm
Installation, List Visual Arts
Center, Boston, 1987
Collection, National Gallery of
Canada, Ottawa

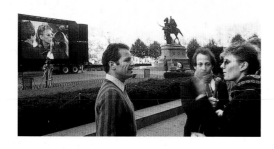

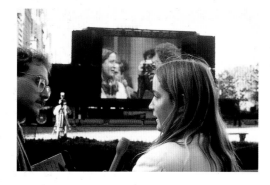

Sign on a Truck
1984
Mobile 2000 video control system
Screen, 400 × 550 cm
Project, Grand Army Plaza, New
York
Holzer invited other artists – Vito
Acconci, Barbara Kruger, Lady
Pink and Keith Haring among
others – to show pre-recorded
videos on a special screen on the
side of a truck. Passers-by were
invited to broadcast live messages
about the 1984 presidential
election and related issues. *Sign
on a Truck* took place at two New
York City sites: Grand Army Plaza
by Central Park and Bowling Green
Plaza in the Wall Street area.

Post-Partum Document remains rooted in Kelly's personal experience as a mother; and Rosler's *Service* pivots on the specificity and coherence of each of its diverse fictional narrators. Holzer, on the other hand, often prevents her texts from being attached to a particular point of view, or individualized character. Even when, as in recent works such as *Lustmord* (1993–94), there are three distinct 'voices' – Perpetrator, Victim, Observer – these positions are generalized to such an extent that it is impossible to associate them with any particular historical event, place or person. Nor is this pluralization an abdication of responsibility. By holding authorship in suspension, Holzer forces the viewer/reader into the position of evaluating and adjudicating often contradictory points of view. By making identification with a range of positions compulsory, some of which an individual spectator might agree with and others s/he might not, Holzer implicitly exhorts the spectator to take a stance. Indeed, in works like *Sign on a Truck* (1984), in which p[...] make their own sta[...] broadcast on a mob[...] activization of the p[...] public') was explicitl[...]

I think the *Truis[...]* Holzer's particular m[...] *Truisms* impersonate c[...] *linguistic* readymades – Holzer wrote [...] herself with great effort – but their effect is that of conceptual readymades. Phrases like MORALS ARE FOR LITTLE PEOPLE sound like the nasty received ideas or prejudices that roll around all of our minds while sitting alone on the subway, or cooking a solitary

(handwritten note: not sale by reading but was a influence)

meal. No one knows where such convictions come from, or when, because the nature of a truism is that it comes from nowhere and everywhere at once. Even the most intense of Holzer's texts – like TRUST VISIONS THAT DON'T FEATURE BUCKETS OF BLOOD drawn from the *Survival* series (1983–85) – sound like something you may have read in an evangelist's brochure handed out on the street, or what some guy was mumbling on the bus. They are fragments of internalized ideology, dislocated fact, and half-appealing, half-revolting rushes of hatred, assertion and prejudice. They are a version of what the world looks like when your internal censor stops functioning and the barrage of information from outside of you feels like your own thoughts. They are instances of authorship turned outside in and inside out.

II. Inside Out

THE [...] ESTING BECAUSE IT'S ONE OF [...] E THE DRY OUTSIDE MOVES [...] Y INSIDE. (*Living*)

[...] 1980–82) and the *Survival* [...] Holzer's self-avowed [...] occupation with the exigencies of survival and the threat of death trained her language more precisely on the body as a privileged object of manipulation and signification. If, as I have argued, Holzer's model of authorship is premised on how facts and concepts from outside (ideology) are internalized as thought (conceptual readymades), and then turned inside out to make art (internal monologues as public speech), a similar dynamic of involution rules her

From **Survival**
1983-85
Offset silver sticker on rubbish bin
lid
7.5 × 7.5 cm
Project, New York, 1983

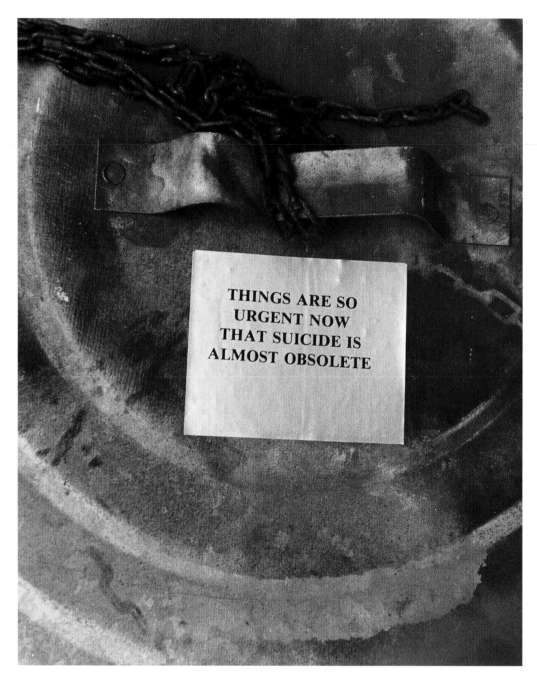

representations of the body. Since 1980 Holzer's texts have returned over and over to violations of the charged boundary between self and world: WHAT A SHOCK WHEN THEY TELL YOU IT WON'T HURT AND YOU ALMOST TURN INSIDE OUT WHEN THEY BEGIN. (*Living*)

WITH ALL THE HOLES IN YOU ALREADY THERE'S NO REASON TO DEFINE THE OUTSIDE ENVIRONMENT AS ALIEN. (*Survival*)

BLOOD KEEPS GOING IN OUTER SPACE UNTIL YOU FORGET. IT STREAMS IN A LINE FROM THE KILLED CONTAINER THAT HAD A MIND. THERE IS NO MATERIAL TO SOAK AND NO MEMORY NEARBY. (*Under a Rock*)

In Holzer's art, linguistic evocations of physical violation are paralleled by their sculptural *performance* of the body's inscription. When the *Truisms* are 'worn' on T-shirts they suggest both that the body 'speaks' sartorially, and that ideology may be turned inside out, literally worn on one's sleeve. Such attention to the performative meanings of language in relation to the body was dramatically intensified after Holzer's adoption of electronic signs in 1982. The mobility of the texts she presents is heightened by intricate programs that vary colour and word flow, while punctuating phrases with flashing lights, schematic images, and changes in direction. These modulations make the viewer vividly aware of the *physiological* nature of seeing: as words rush across Holzer's signs one must be conscious of his or her capacity, or incapacity, to keep up the pace. This self-consciousness in

reading is heightened by kinaesthetic experiences ranging from hypnotic fascination – akin to watching TV – in some of the slower works, to vertigo and even nausea, especially in the multiple vertically installed machines. Regardless of what specific effect she achieves, Holzer's choice of light as a medium insistently reminds the viewer of the physiological experience of vision and the spectacular quality of words. Language is imagined as provoking particular responses from the body, sometimes through out-and-out assault. In later series, like *Under a Rock*, the physicality of the viewer is emphas̲i̲̲̲ ̲d̲i̲f̲f̲e̲r̲ently. In this project, vivid and emot̲ ̲ ̲ ̲ ̲ ̲ ̲xts are inscribed on benches̲ ̲ ̲ ̲ ̲ ̲ ̲ ̲ ̲ ̲xperiences the capacity ̲ ̲ ̲ ̲ ̲ ̲ ̲ ̲f flesh on top of the ̲ ̲ ̲ ̲ ̲ ̲ ̲ ̲ ̲ ̲ecomes a perf̲ ̲ ̲ ̲ ̲ ̲ ̲ ̲ ̲ ̲ ̲usting on̲ ̲ ̲ ̲ ̲ ̲ ̲ ̲ ̲ ̲ ̲ ̲

to̲ ̲ ̲ ̲ ̲ ̲ ̲ ̲ ̲ ̲ ̲ ̲ ̲ ̲ ̲ ̲ ̲ la̲ ̲ ̲ ̲ ̲ ̲ ̲ ̲ ̲ ̲ ̲ ̲ ̲ ̲ ̲ ̲ ̲ is ̲ ̲ ̲ ̲ ̲ ̲ ̲ ̲ ̲ ̲ ̲ ̲ ̲ ̲ ̲ ̲ is ̲ ̲ ̲ ̲ ̲ ̲ ̲ ̲ ̲ ̲ ̲ Perpetrator, Victim̲ an̲ ̲ ̲ ̲ ̲ ̲ ̲ ̲ ̲ ̲ ̲ ̲ ̲ ̲ ̲ ̲ of̲ ̲ ̲ ̲ ̲ ̲ ̲ ̲ ̲ ̲ ̲ ̲ ̲ ̲ op̲ ̲ ̲ ̲ ̲ ̲ ̲ ̲ ̲ ̲ ̲ describe the woman he violates as a hard medium which he must conquer:
I SWIM IN HER AS SHE QUIETS.
I SINK ON HER.
I SING HER A SONG ABOUT US.
I STEP ON HER HANDS.
I SPLAY HER FINGERS.
SHE ROOTS WITH HER BLUNT FACE.

SHE HUNTS ME WITH HER MOUTH.
SHE HAS THREE COLORS IN HER EYES.
I BITE HER CLOSED AGAIN.
The aqueous metaphors of the opening lines – he *swims in* and *sinks on* her – give way to images of restraint: stepping on hands, splaying fingers. The Perpetrator's text is structured by oppositions between his victim's leaking body (HER SALIVA RUNS WHEN SHE SLEEPS) and his own efforts to contain her (I BITE HER CLOSED AGAIN). Finally, it is the obscenity of her body transgressing its boundaries that incites murderous desire in the Perpetrator. His monologue ends with this chilling admission: THE COLOR OF HER WHERE SHE IS INSIDE OUT IS ENOUGH TO MAKE ME KILL HER.

The Victim's monologue reorganizes the terms of this encounter. Her body is invaded by the Perpetrator, and she needs to withstand this assault in order to maintain her selfhood as well as her life. Near the middle of her monologue she laments:
̲ITH YOU INSIDE ME COMES THE KNOWLEDGE
̲ ̲Y DEATH.
̲ ̲AVE SKIN IN YOUR MOUTH. YOU LICK ME
̲ ̲DLY.
̲ ̲ONFUSE ME WITH SOMETHING THAT IS IN
̲ ̲ ̲I WILL NOT PREDICT HOW YOU WANT TO
̲ ̲ ̲E.
These lines move powerfully from a crude sexual image of rape – WITH YOU INSIDE ME COMES THE KNOWLEDGE OF MY DEATH – to a subtle analysis of the Perpetrator's psychological motivation – YOU CONFUSE ME WITH SOMETHING THAT IS IN YOU. His invasion of her body is balanced – and even to some degree provoked – by 'her' invasion of his mind. He

MY NOSE BROKE
IN THE GRASS.
MY EYES ARE
SORE FROM
MOVING AGAINST
YOUR PALM

HER BREASTS
ARE ALL
NIPPLE

I FIND HER
TOWELS SHOVED
IN TIGHT SPOTS.
I TAKE THEM TO
BURN ALTHOUGH
I FEAR TOUCHING
HER THINGS

I HAVE
THE BLOOD
JELLY

From **Lustmord**, collaboration
with Tibor Kalman
1993-94
Photographs of handwriting in ink
on skin
32 × 22 cm each page
Project for *Süddeutsche Zeitung
Magazin*, No. 46, 1993
Collection, Center for Curatorial
Studies, Bard College, Annandale-
on-Hudson, New York

brutally brings his 'outside' – his penis – into her in order to exorcise what she represents 'inside' his mind. For the third persona in the *Lustmord* text, the Observer, the drama of the body turned inside out is a less immediate but nonetheless powerful instance of shame: SHE STARTED RUNNING WHEN EVERYTHING BEGAN POURING FROM HER BECAUSE SHE DID NOT WANT TO BE SEEN.

In *Lustmord* the body's violation – its involution or externalization – is framed by a parallel slippage between the private and the public. Whereas this text is divided into countervailing voices – a practice Holzer developed in *Truisms* – it would be wrong to think of the Perpetrator, the Victim and the Observer as 'characters'. Rather, they are 'positions' – the legitimate though more developed heirs of the discordant voices of the *Truisms*. The generalized relationship Holzer establishes between these three subjective locations accommodates both private and public identifications with their emotionally charged scenario of assault. In an interview Holzer has described how, in making the *Lustmord* project, attempting to address the bodily violations and loss of life of women during the war in former Yugoslavia, she was forced into a deeper realization of the loss of her own mother, who died during this time, as well as traumas which had occurred in both of their lives.[18]

It is not the autobiographical dimension that I wish to stress here,[19] but rather the structural association she points to between 'personal experiences' and 'world events'. When she describes the connection she felt between the fate of the women in the war and her mother's death,

she is operating from a particular model of the public sphere which is ubiquitous in contemporary America: current events are understood through empathy with intimately described strangers and this empathy is based on the traumatic events of one's own life.

The literary theorist Mark Seltzer has called this sort of identification 'wound culture' or the 'pathological public sphere'. His analysis resonates profoundly with Holzer's art:

'*The convening of the public around scenes of violence – the rushing to the scene of the accident, the milling around the point of impact – has come to make up a wound culture: the public fascination with torn and opened bodies and torn and opened persons, a collective gathering around shock, trauma, and the wound.*'[20]

In other words, the constitution of a contemporary public sphere is premised on collective identification with the victims of, for instance, an airplane crash or the bombing of a federal office building. These 'atrocity exhibitions'[21] become the occasion for articulating and consolidating national and racial identities, while 'torn and opened bodies' come to represent 'a shock of contact that encodes … a breakdown in the distinction between the individual and the mass, and between private and public registers'.[22] The body turned inside out is not merely the image of individual suffering; it is a privileged figure for the slippage of private and public experience. Indeed, Seltzer expands the psychoanalytic definition of trauma – a physical shock originating outside the body which is subsequently experienced as internal psychic pain – in order to produce a theory of

subjectivity that uncannily matches Holzer's art:

'The problem that trauma poses is a radical breakdown as to the determination of the subject, from within or without: the self-determined or the event-determined subject; the subject as cause or as caused; the subject as the producer of representations or their product. These breakdowns devolve on a basic uncertainty as to the subject's and the body's distance, or failure of distance, with respect to representation.'[23]

Holzer's preoccupation with bodily assault and manipulation is more than an individual artist's fixation with death. By submitting bodies to physical trauma, her texts question the social and psychic constitution of subjects. Bodies turned inside out raise a question that the *Truisms* and the *Inflammatory Essays* pose on the less visceral level of authorship: is the subject 'cause or caused; … the producer of representations or their product?'

The first publication of *Lustmord,* in *Süddeutsche Zeitung Magazin* on 19 November 1993, not only represented but produced the kind of 'pathological public sphere' that Seltzer theorizes. The work consisted of a 28-page spread inside the magazine, an interview with Holzer and a special cover. The interior section reproduced photographs of the *Lustmord* texts written with red, black or blue ink onto skin. As chilling as these pictures were in their evocation of text carved into flesh, it was the cover that provoked controversy. In the centre of a black field, a white card was attached which read, *DA WO FRAUEN STERBEN BIN ICH HELLWACH* (I AM AWAKE IN THE PLACE WHERE WOMEN DIE). The red ink used for this text was mixed with a small amount of blood drawn from women volunteers (including some from the former Yugoslavia). This mingling of fluids caused an uproar in which the media accused Holzer of offenses ranging from political agitation to wasting blood. But at the heart of the public anxiety played out in various newspaper articles (in contrast to a predominantly positive actual reception of the work) was a fear of contaminated bodies: the trauma of blood, even when duly tested by doctors as it had been in Holzer's work, was intense:

'That's the irony in the whole affair. Hardly anyone is disgusted by how much blood is spilled in this world. But just as soon as the blood gets into our living rooms, we panic. Is the blood germ-free, is it lab-tested, medically inspected, ethical, legal?'[24] As this account suggests, it is the slippage of private and public, that Seltzer attributes to torn and opened bodies, which underlies this controversy. Blood 'spilled in this world' is brought 'into our living rooms'. This transgression of boundary – the body turned inside out and the world turned outside in – is simulated in Holzer's texts, but *enacted* through their distribution in the *Süddeutsche Zeitung Magazin*. In *Lustmord*, as in all of her works, linguistic utterances are put into circulation. They occupy space, and in doing so they initiate – if only provisionally – a public sphere.

III. Space
'But the real non-places of supermodernity – the ones we inhabit when we are driving down the motorway, wandering through the supermarket or sitting in an airport lounge waiting for the next flight to London or Marseille – have the peculiarity that they are defined partly by the words and texts they

offer us: their "instructions for use" … This
establishes the traffic conditions of spaces in which
individuals are supposed to interact only with texts,
whose proponents are not individuals but "moral
entities" or institutions (airports, airlines, Ministry
of Transport, commercial companies, traffic police,
municipal councils) …'
— Marc Augé, *Non-Places: Introduction to an*
Anthropology of Supermodernity[25]

'This architecture of styles and signs is anti-spatial; it
is an architecture of communication over space;
communication dominates space as an element in
the architecture and in the landscape.'
— Robert Venturi, Denise Scott Brown and
Steven Izenour, *Learning from Las Vegas*[26]

Thus far I have considered Holzer's texts in
terms of their model of authorship and the
rhetorical or metaphorical topographies they
chart. It remains to address a third dimension of
her art that is integral to its effect: her practice of
using words to define spaces. Language is often
assumed to be without weight or dimension and for
that reason it appears as an ideal means of
abstracting or dematerializing things. And yet the
environments we inhabit every day are largely
constructed with words: as Robert Venturi, Denise
Scott Brown and Steven Izenour have declared with
regard to the topography of Las Vegas,
'communication dominates space'. The Las Vegas
strip, which is exceptional in its intensity but
typical of recent American urbanization in its
structure, subordinates architectural form to
legible signs. And as the anthropologist Marc Augé

has argued, this condition exists well beyond the
Nevada desert. What Augé calls 'non-places' –
those sites of anonymous transportation,
consumption and entertainment ranging from local
supermarkets to international airports – are as
much defined, or *structured*, by words as they are by
bricks and mortar, or more appropriately, glass and
steel. Indeed, Venturi, Scott Brown and Izenour
invented a term – 'the decorated shed' – for a type
of building whose spatial form is no more than a
generic reflection of the economic parameters of its
construction, but whose architectural character
and functional legibility are established in a
decorative appliqué, a type of sign. Holzer's texts
sometimes mimic, but always recode the discursive
'skins' of contemporary places. Even a partial list of
her several methods of presenting text
demonstrates the variety of her efforts to seize the
institutional power of language as it exists in the
built environment. The *Truisms* were printed on
posters and anonymously wheat-pasted all over
New York; the *Living* series was originally produced
on bronze and hand-lettered wall plaques
impersonating the authoritative voice of historical
monuments or otherwise distinguished buildings;
and in 1982, after working on the Spectacolor
Board in Times Square for the first time, she began
to use various types of electronic signboards,
whose endless rush of text matches perfectly the
transitional spaces – and spaces of transit – which
her public works typically occupy.
In her public projects Holzer tends to exhibit
not a single work but an interrelated network of
pieces directed towards different, often
overlapping, audiences. In this way she suggests

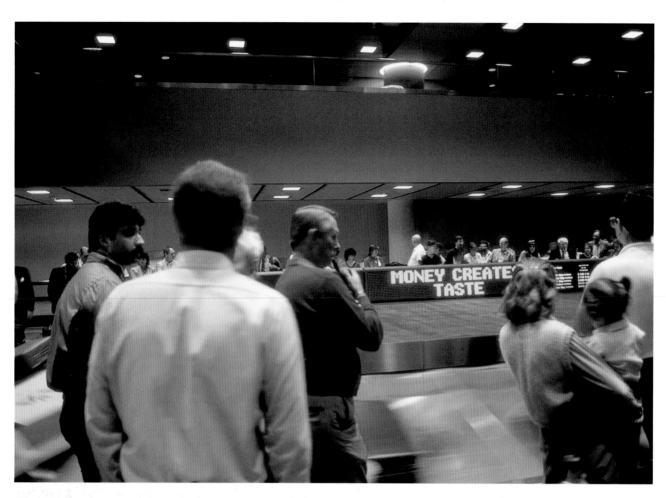

From **Truisms**
1977–79
Electronic signs
240 × 400 cm
Project, baggage carousel,
McCarran International Airport,
Las Vegas, 1986

From **Survival**, with Dennis Adams
1983–85
Duratrans on bus shelter
Approx. 90 × 250 cm
Project, 66th and Broadway, New
York, 1984

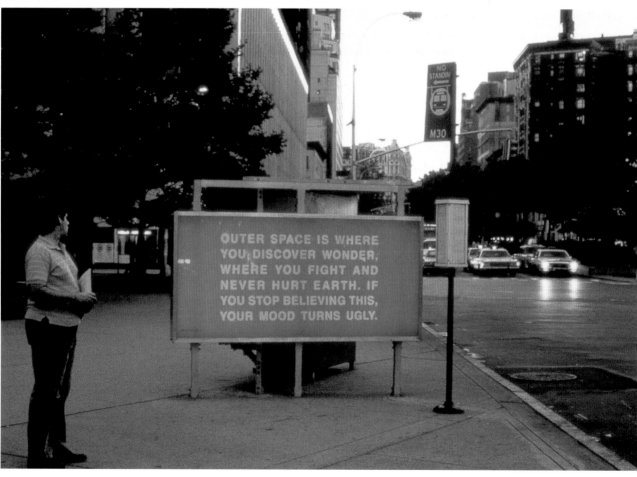

that communities – and the media that serve them – are complex and multiple. A project of 1986, *Protect Me from What I Want*, is exemplary in that it establishes a map or genealogy of non-places for a single city. Commissioned by the Nevada Institute of Contemporary Art in Las Vegas – the epicentre of late twentieth-century transience of people and capital – Holzer installed signs in a number of sites including McCarran International Airport, Caesars Palace and the Fashion Show Mall. Sited in this way, Holzer's signs appropriated the authority which is granted to official communications in public places. As Augé argues in the passage quoted above, the texts that define contemporary non-places are issued by specific 'moral entities' or institutions: they can be simple and direct, like a prohibition against smoking in airports, or complex and ambiguous like the intermingling of commerce and news on the Spectacolor Board in Times Square. When, for instance, the bland announcements of flight numbers and points of embarkation that one would expect to see on an LED sign above a Las Vegas baggage carousel are replaced by *Truisms* and *Survival*, the artist's message is (perhaps only temporarily) mistaken for an announcement from the airport management. More recently, in her contribution to the Biennale di Firenze, 'Il Tempo e la Moda'(1996), Holzer once again approached a tourist capital as a network of physical and informational circulation. Her texts were presented in two sites – a pavilion by the architect Arata Isozaki, which was enhanced by a perfume intended to suggest sex (a collaboration between Holzer and Helmut Lang); and a Xenon projection across the Arno river, which

superimposed the phrases I SMELL YOU ON MY SKIN/I SAY THE WORD/I SAY YOUR NAME onto the river, its banks and a building at the river's edge. Circulating like linguistic nomads between these points and beyond were a number of city taxis whose hoods were inscribed with *Truisms* or *Survival* texts. Each of the locations Holzer seized upon in Las Vegas and Florence was public, but each proposed a different model of community. In combination, they suggested a map of the slippages between alternate worlds occupying the same topography. They invoked a public sphere in which monumentality is balanced by mobility and engaged spectatorship is driven by distracted, fleeting encounters.

This systemic approach to space places Holzer's art within two distinct artistic traditions of the late 1970s and early 1980s: the manipulation of gallery and museum spaces as ideologically-charged sites of social contradiction and the spread of activist art collectives in New York. In the course of the 1970s the 'white cube' of the gallery or museum became a laboratory for investigations into the institutional nature of the art market and the conditions of perception among gallery visitors. The spectator's role in determining what the object was, or could be, became a central issue among artists like Michael Asher, Peter Campus, Dan Graham and Hans Haacke. Questions of *how* perception is structured began to eclipse *what* was being perceived. For instance, Brian O'Doherty has written:

'*[The] intimacies [of 1970s art] have a somewhat anonymous cast since they turn privacy inside out to make it a matter of public discourse – a*

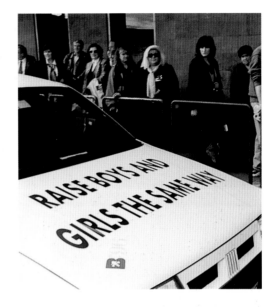

From **Truisms** and **Survival**
White taxis, black text
Project, 'Biennale di Firenze: il Tempo e la Moda', Florence, 1996

Road scene from the book
Learning from Las Vegas, Robert Venturi, Denise Scott Brown and Steven Izenour, 1977

opposite, **Painted Room**
1978
Acrylic wash over latex paint
Dimensions unknown
Installation, Institute for Art and
Urban Resources, P.S. 1, New York

Twelve Views of a 4-D Solid
1976
Acrylic on muslin
Approx. 107 × 122 cm

1970s form of distancing. Despite this personal focus, there is no curiosity about matters of identity. There is great curiosity about how consciousness is constructed. Location is a key word. It telescopes concerns about where *(space) and* how *(perception).'*[27]

O'Doherty's concept of anonymous intimacies and his emphasis on location as an elision of space and perception provide apt critical tools for Holzer's art of the 1980s. But they describe even more precisely two of her little-known installations of the mid and late 1970s. In a number of interviews, Holzer mentions a 1975 project at the Rhode Island School of Design in which she painted her entire studio and its contents 'white, and then … stained it with a light Thalo blue acrylic wash'. This work belonged precisely to the tradition that O'Doherty charts: 'it was interesting when you'd walk in the room, because you couldn't tell where your feet were. Spatially things were interrupted'.[28] The RISD piece might be dismissed as an anomalous student experiment given Holzer's later career, but she revisited the idea in 1978 in New York – only a year before the 'Manifesto Show'. This second project consisted of a single room at P.S. 1 in which each architectural surface – including pipes and windows – had been painted: walls of yellow, green and red; the floor purple; the ceiling blue. Like an expanded version of her wrap-around paintings of the mid 1970s, or a series of canvases from 1976 based on diagrams of the fourth dimension, these works pursued painterly ideas of the sublime. If Holzer had abandoned this direction by 1979 in favour of textual environments like the tightly packed walls of the 'Manifesto Show', spatial

dislocation remained a central strategy in her art. The disorienting Gallery E at the 1990 Venice Biennale, for instance, consisted of twenty-one horizontal LEDs (with yellow, green and red text) whose linguistic cacophony was redoubled in a reflective marble floor. This environment, which was so physically overwhelming it was nicknamed the 'microwave' or 'the toaster oven', accomplished with words and light the vertigo Holzer had evoked with paint over ten years earlier.

If perceptual experiments conducted in the art-world's 'white cubes' during the 1970s sought to specify the *location* of the spectator, a different understanding of site emerged late in the decade with the establishment of community-based art initiatives in neighbourhoods of New York not traditionally associated with the art market: Collaborative Projects (Colab), Fashion/Moda, ABC No Rio and Group Material among them. In 1980, exhibitions like 'The Real Estate Show', which eventually resulted in the community art space ABC No Rio in the Lower East Side, and Colab's 'The Times Square Show' in a former bus depot and massage parlour, raucously claimed under-developed, ignored and dilapidated corners of the city and filled them with an art that was often figurative, and always impassioned and polemical. In 'The Real Estate Show', *location* was a socially-specific and thoroughly material concept: the exhibition was organized in an abandoned city-owned storefront that an organizing committee had seized; the art addressed the disastrous effects that landlord profiteering and gentrification had had on residents of the surrounding neighbourhood. The exhibition was almost

immediately closed by the city in an effort to reclaim control of its building. This repressive gesture, though effective in the short term, inadvertently confirmed the insidious collaborations between city government and private development that the exhibition intended to unveil.[29]

Holzer's spatial tactics of the late 1970s through the mid 1980s, including the deployment of posters, stickers and plaques in anonymous locations throughout the city, synthesized the multiple notions of *location* that circulated in art of the late 1970s. On the one hand, as a member of Colab from 1978 to 1985 she was well aware of guerrilla attempts to enter illicitly and, even if only temporarily or imaginatively, overturn the economy of gentrification that gripped New York in the 1980s. Her anonymous posting of texts in the street was an effort to claim an unauthorized space of signification in the city. On the other hand, unlike the expressionist rhetoric of much of the work

included in exhibitions like 'The Real Estate Show' and 'The Times Square Show', Holzer's tone – including the ostensible neutrality, plurality and anonymity of her observations – and her acumen in producing kinaesthetically affecting installations, belonged as much to the ethos of the 'white cube' as to the downtown storefront. This duality, or tension, situates Holzer's art within a community of artists including Barbara Kruger, Justen Ladda, Louise Lawler, Sherrie Levine, Richard Prince and Cindy Sherman, as well as many others, who during the late 1970s and 1980s sought to demonstrate the ways in which print media, television and film function as sites of cultural meaning. Through techniques of appropriation and montage these artists redefined *location* in terms of information, and suggested that subjectivity is experienced through complex encounters with media stereotypes characterized by both identification and resistance.

Holzer's most effective early synthesis of the

Sign on a Truck (Image of Ronald
Reagan contributed by Barbara
Kruger)
1984
Mobile 2000 video control system
Screen, 410 × 550 cm
Installation, Grand Army Plaza,
New York

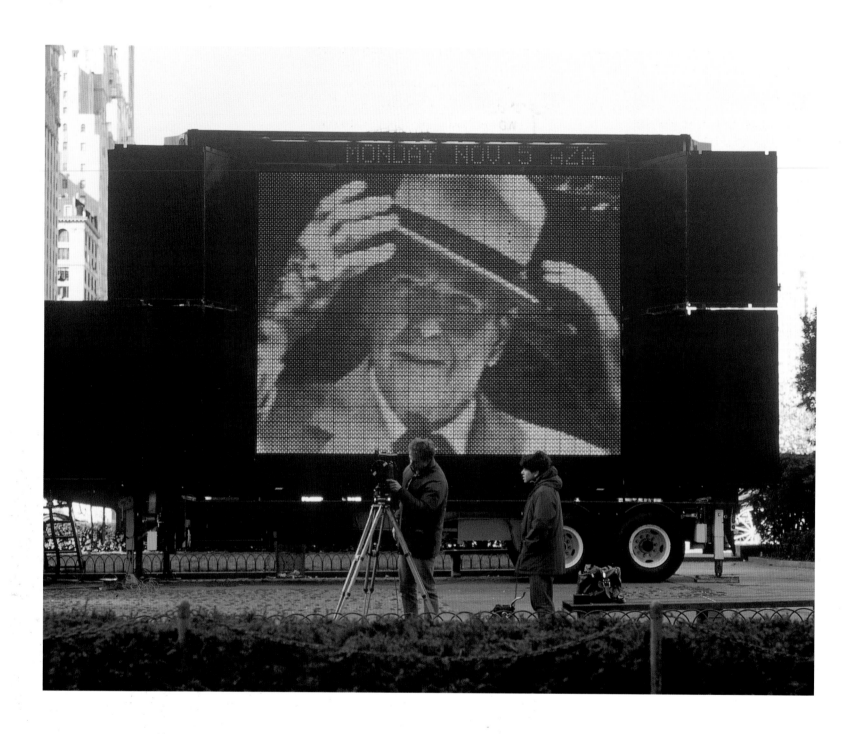

multiple dimensions of location occurred in her projects for the Times Square Spectacolor sign in 1982 (*Truisms*) and in 1985–86 (*Survival*) as well as her collaborative work, *Sign on a Truck,* whose New York installation responded to the 1984 presidential election. The Spectacolor Sign itself exemplifies Venturi, Scott Brown and Izenour's notions of the decorated shed (the shed is vestigial) and Augé's understanding of the non-place as an effect of discourse. The sign is a monument composed of information whose purpose is to define a place – Times Square, but also New York City. This, in itself, is nothing new: monuments have always marked places with signs. What distinguishes the Spectacolor sign is the mobility of its information – always changing, constantly updated – and the banality of its content. There is no effigy of George Washington here, no list of fallen soldiers, nothing but the buzz and flash of commerce and news. The contemporary nature of the Spectacolor sign lies in its uneasy synthesis of place and non-place. The square is a ceremonial site where people gather (on New Year's Eve, for instance), and a street corner through which they rush on foot and by car. The information the sign projects is intended to establish a supra-geographic community (Augé might call it a non-community) founded in the shared rhetorics of news and advertising. But when programmed with Holzer's texts the original Spectacolor sign (which has since been replaced) called forth a different public sphere. Holzer seized this great monument to our information-capital-entertainment nexus only to fill its ostensibly accessible and pluralistic spaces with an image of the 'non-communities'

whose access to such media is either suppressed or tightly controlled.

In two permanent 'anti-memorials' she has produced in the 1990s Holzer has applied the lessons of Times Square to more contemplative and ostensibly natural environments. In the *Black Garden* in Nordhorn, Germany, plants that were chosen for their black, deep red or dark brown blossoms or foliage create a living zone of darkness. At the *Erlauf Peace Monument* in Erlauf, Austria, the site of German surrender in World War II is marked by a vertical searchlight that projects over a mile into the sky and is surrounded by white plantings. In these gardens, as in the heart of New York, the singularity of the monument is undermined: it becomes a territory for both the cultivation of plants and the cultivation of memory – a memory that lives and changes like the shrubs, flowers and trees devoted to it.

In each of Holzer's three powerful museum

From **Truisms**
1977–79
Spectacolor sign
Project, 'Messages to the Public',
Times Square, New York, 1982

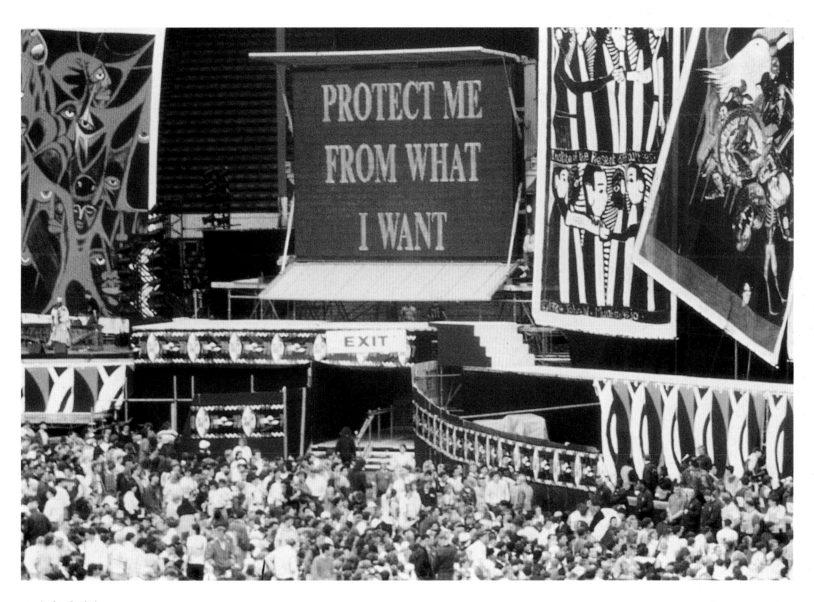

opposite, from **Survival**
1983–85
Spectacolor sign
460 × 910 cm
Piccadilly Circus, London,
1988–89

above, from **Survival**
1983–85
Electronic sign
Project, Nelson Mandela 70th
Birthday Tribute, Wembley
Stadium, London, 1988

From **Laments**
1988–89
13 LED signs
325 × 25 × 11 cm each
9 Nubian Black marble sarcophagi
62 × 208 × 76 cm each
2 Verde Antique marble
sarcophagi
46 × 137 × 61 cm each
1 Ankara Red marble sarcophagus
62 × 208 × 76 cm
1 Honey Onyx marble sarcophagus
30 × 91 × 46 cm
Installation, Dia Art Foundation,
New York, 1989
Collection, Williams College
Museum of Art, Williamstown,
Massachusetts

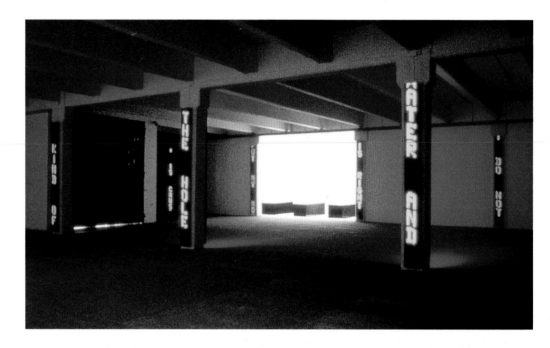

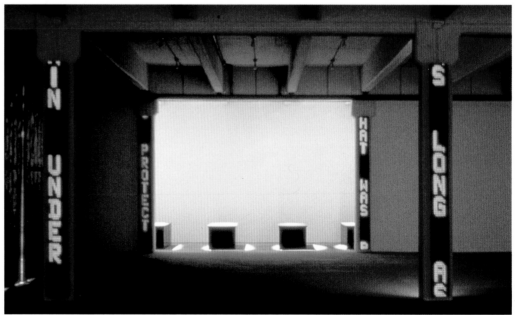

projects of 1989–90 – 'Laments' at the Dia Foundation, a retrospective installation at the Solomon R. Guggenheim Museum (both in New York), and the American Pavilion of the 1990 Venice Biennale – traditional forms of the monument were provocatively juxtaposed with their contemporary electronic progeny. She began to inscribe the texts from her series *Under a Rock* (1986) on stone benches; later the *Laments* (1988–89) were exhibited on stone sarcophagi. On the one hand, Holzer's progression to stone was an effort to address the monument's traditional promise of permanency:

'The rock crept in for a couple of reasons. One was my move to the country. I saw stone for the first time in years. I thought, "Rocks are pretty nice", and nature eased into the work. Another consideration was, as I said, my apocalyptic preoccupations. I thought I should put something on rock so that after Armageddon, someone could overturn the stone and read. Another reason was simply practical. I needed benches so people could sit and read my signs. Stone makes good inscribed benches.'[30]

But if, when placed outdoors, the benches might suggest melancholic, sylvan ruins, they achieved a different effect when exhibited in combination with LED signs indoors as they were in their first exhibition at Barbara Gladstone Gallery in 1986. When asked by Michael Auping about the religious nature of the benches, Holzer responded:

'I say "stadium", or "auditorium", so that religious references don't dominate. I like the spiritual to be an element of the work, but I don't want it to take over. This said, the array for the Mother and Child writing was something like a futuristic altarpiece. This seemed right for Venice.

'The Under a Rock *installation looked like a combination of a church, a space station, a Greyhound bus stop, and a high school auditorium. It was a place where you could sit by yourself or where people could gather to review information. There were a number of benches so a crowd could form.'*[31]

The spectacular 1989 Guggenheim installation produced such a hybrid environment. The work consisted of a continuous series of LED signs fitted on the inner surface of the spiralling parapets of three floors of the museum, thus aligning the ambulatory circulation of the ramp with the informational flow of words. Below, a series of inscribed benches stood in a circle. The activities of sitting and walking matched the rhetorics of informatics and commemoration. The 'eternity' of stone was twinned with the mobility of information.[32] In her most recent project for Frank Gehry's Guggenheim Museum in Bilbao, Spain, Holzer has designed a 'colonnade' of double-sided LED signs, which seem suspended within one of the building's organically contoured galleries. Whereas in her project for the New York Guggenheim text floated along the internal spiral of the building's interior like confetti, the Bilbao installation suggests a virtually classical architectural skeleton of language within a distinctively biomorphic space.

It is precisely such contradictory juxtapositions – the 'futuristic altarpiece', a 'colonnade of words', or 'a combination of a church, a space station, a Greyhound bus stop, and a high school auditorium' – that characterize Holzer's approach to space. Her 1994 presentation of the

WHEN SOMETHING TERRIBLE HAPPENS PE

TH PERSEVERANCE YOU CAN DISCOVER A

ARE

YOU ARE A VICTIM O

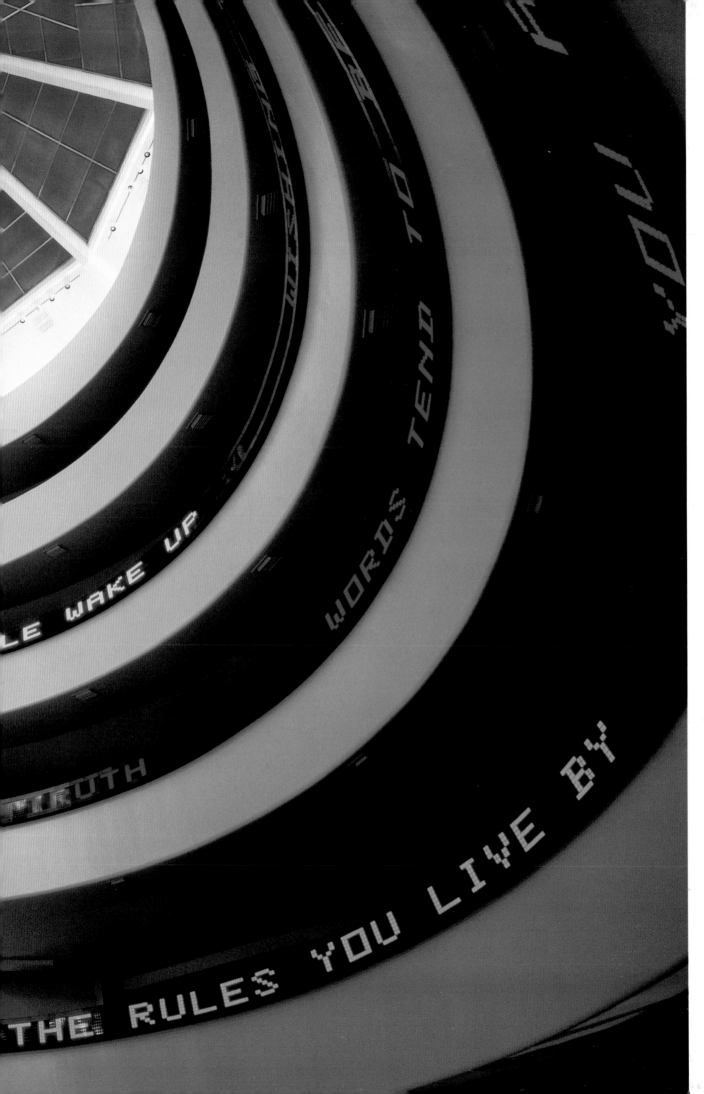

left and following pages,
From **Truisms**, **Inflammatory Essays**, **Living**, **Survival**, **Under a Rock**, **Laments**, **Mother and Child**
LED sign
36 × 16180 × 10 cm
Bethel White granite benches
46 × 91 × 43 cm each
Indian Red granite benches
107 × 43 × 45.5 cm each
Installation, Solomon R. Guggenheim Museum, New York, 1990
Collection, Solomon R. Guggenheim Museum, New York

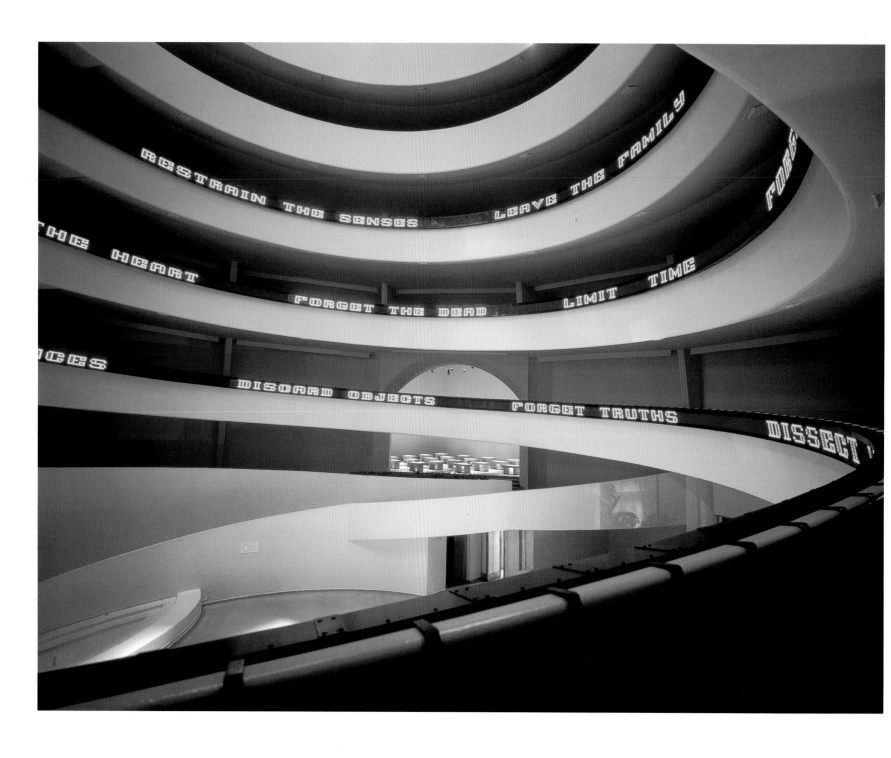

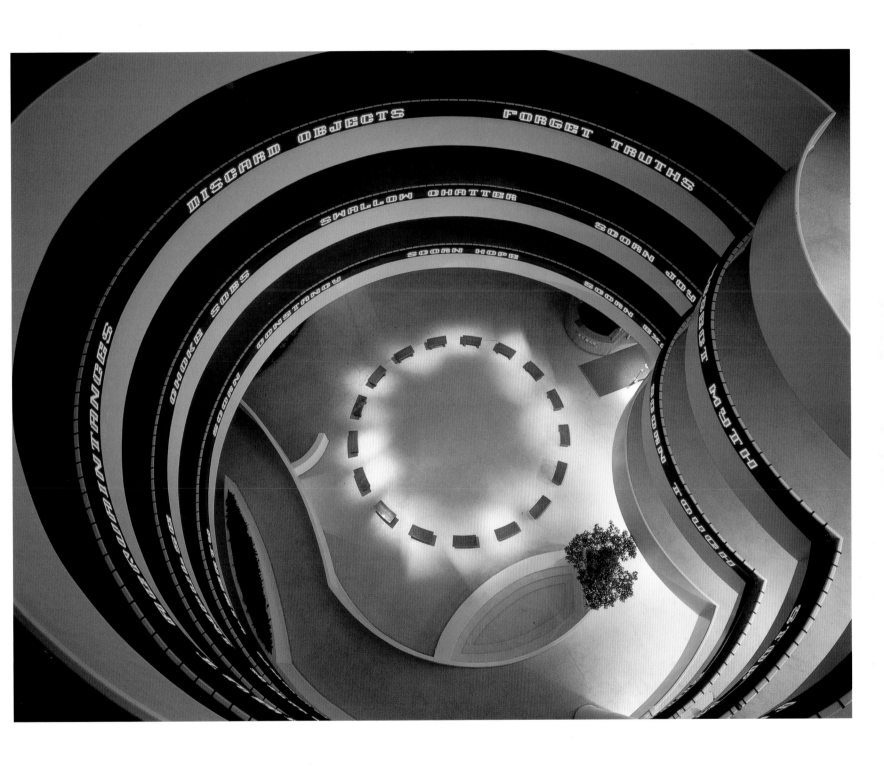

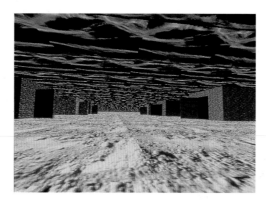

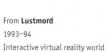
From **Lustmord**
1993–94
Interactive virtual reality world

Lustmord texts at Barbara Gladstone Gallery in New York exemplified such productive collisions of the remote past and the future. The exhibition consisted of a simplified barrel-vaulted 'hut' suspended within a structural grid whose interior was lined in red leather imprinted with a diamond grid pattern and embossed text. This rudimentary structure functioned both as a transhistorical signifier of shelter and, on account of its red walls composed of tanned skin, as a visceral evocation of body cavities. The hut was combined with two anthropomorphic and futuristic three-dimensional LED signs: one standing just outside its entrance like a sentry and the other located in its interior, each generating an illusion of text rotating in space. Hut and text-generator invoked an opposition between space and information that also performed a jarring involution of past and future in which the eternal – hut, skin – was folded over the ephemeral – electronic text. Such temporal slippages, which characterize much of Holzer's production in the last decade, suggest a kind of epistemological doubt at the heart of her work – and that of many of her peers.

In our time, experience seems to drain away into successive layers of mediation: the present is elusive. This might explain why, for cultural practitioners ranging from Hollywood producers to Ivy League English professors, bodies need to be torn open and turned inside out in order to arrest our attention. During the 1990s Holzer has developed such themes through new technologies including virtual reality. This oxymoronic term is in itself an emblem of the multiple involutions she has accomplished in her art – an involution of voices, bodies and spaces. Virtual reality simulates an external environment within the confines of the mind; in Holzer's video of a virtual reality presentation of the *Lustmord* text (Guggenheim Museum, SoHo, 1993–94), the spectator's point of view moves vertiginously across a blighted landscape and in and out of undifferentiated huts, never pausing in its erratic movement. Although Holzer worked only briefly with virtual reality, the perpetual restlessness of virtual space – between inside and outside, private and public, victim and perpetrator – seems to provide a perfect emblem for her art. A characteristic of virtual space, also suggested in Holzer's more recent public projects in architectural locations – the laser projection on the Battle of Nations Monument, Leipzig, *KriegsZustand* (1996) or the installation at the Museo Guggenheim Bilbao (1997) – is that mobility and monumentality are deployed, not as opposing forces, but as complementary terms, whose fusion produces a distinctively contemporary experience of the public sphere.

From **Lustmord**
1993–94
Two 3-D imagers, leather, wood
380 × 400 × 560 cm overall
89 × 69 × 69 cm each imager
Installation, Barbara Gladstone
Gallery, New York, 1994
Collection, Bergen Billedgalleri,
Norway

From **Lustmord**
1993–94
Two 3-D imagers, leather, wood
380 × 400 × 560 cm overall
89 × 69 × 69 cm each imager
below, Installation, Barbara
Gladstone Gallery, New York, 1994
opposite, Installation, Art Tower
Mito, Mito, Japan, 1994

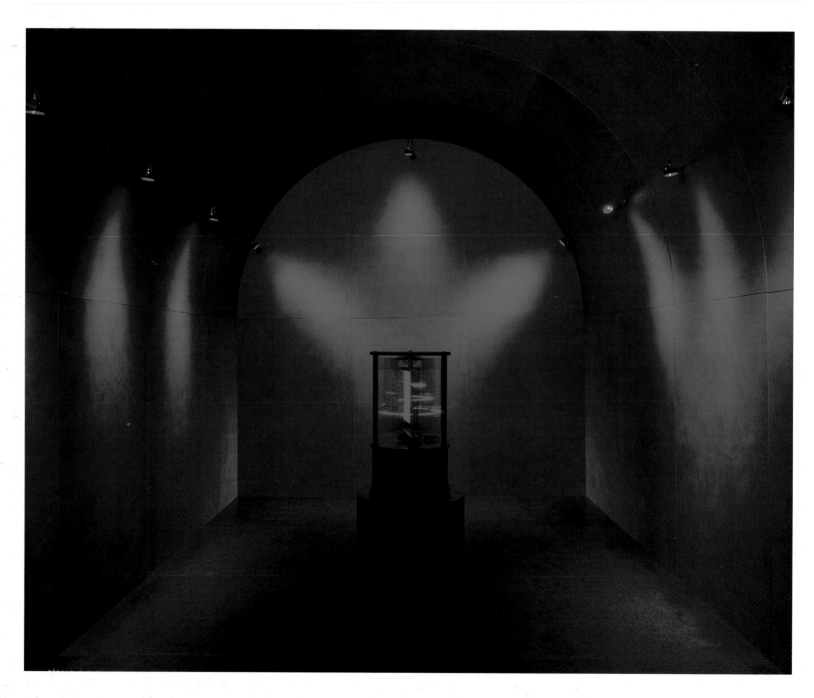

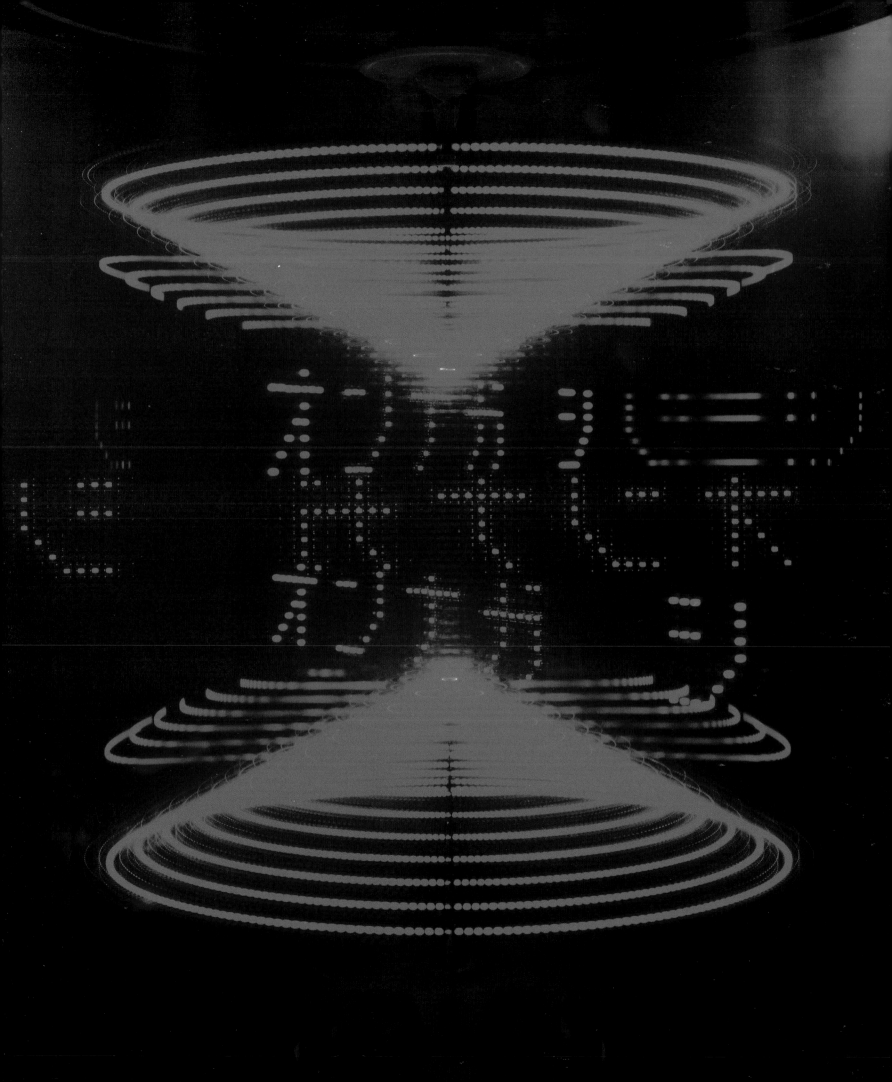

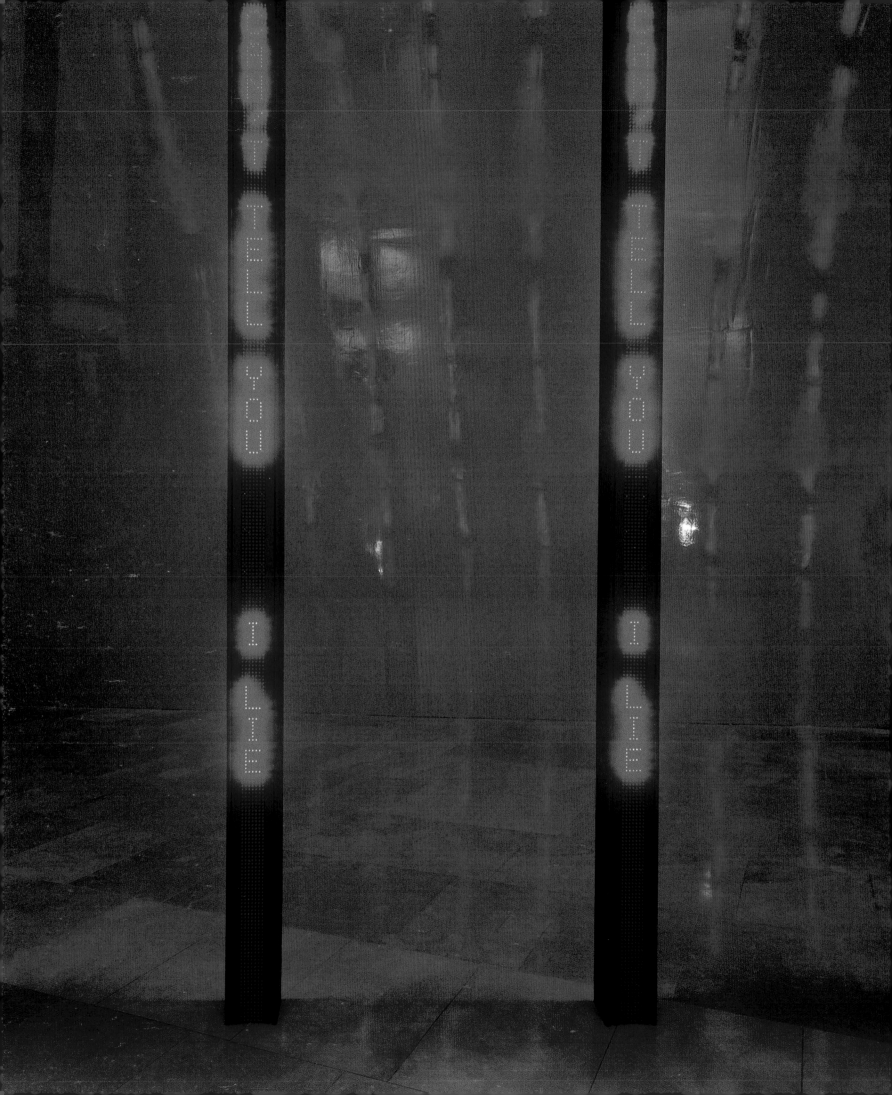

From **Arno**
1996–97
Nine 2-sided electronic LED signs
1300 × 16 × 16 cm each
Permanent installation, Museo
Guggenheim Bilbao, Spain, 1997

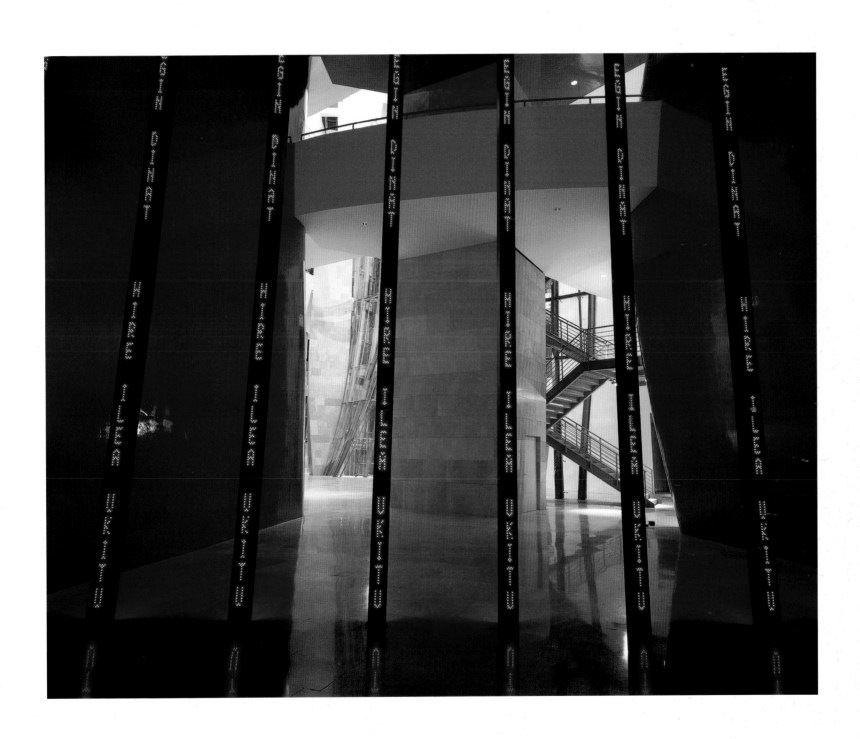

1 Tristan Tzara, *Seven Dada Manifestos and Lampisteries*, Calder
 Publications, London, 1977. trans. Barbara Wright, p. 33

2 The project was conducted under the aegis of Collaborative Projects,
 or Colab.

3 Jenny Holzer in a letter to the author from the artist's assistant Amy
 Whitaker, July 31, 1997.

4 Bruce Ferguson, 'Wordsmith: An Interview with Jenny Holzer', *Art in
 America*, New York, vol. 74, no. 12, December 1986, p. 111

5 Foucault, for instance, argues that the 'author' is an effect of the texts
 attributed to him or her. See Michel Foucault, 'What Is an Author?' in
 Language, Counter-Memory, Practice: Selected Essays and Interviews,
 ed. Donald F. Bouchard, trans. Donald F. Bouchard and Sherry Simon,
 Cornell University Press, Ithaca, 1977, pp. 113–138

6 Ferguson, 'Wordsmith', p. 114

7 Diana Nemiroff, 'Personae and Politics: Jenny Holzer', *Vanguard* vol.
 12, no. 9, November 1983, p. 26

8 Joseph Kosuth, *Art After Philosophy and After: Collected Writings, 1966–
 1990*, ed. Gabriele Guercio, MIT Press, Cambridge, 1991. pp. 20–21

9 'What is the function of art, or the nature of art? If we continue our
 analogy of the forms art takes as being art's *language* one can realize
 then that a work of art is a kind of *proposition* presented within the
 context of art as a comment on art'. Ibid., pp. 19–20

10 'objects are conceptually irrelevant to the condition of art'. Ibid., p. 26

11 Kosuth's and Weiner's positions should not be collapsed. Kosuth believed
 that Weiner's continued emphasis on materiality (in the 'content' of
 his texts, and in the poetic materiality of his words) placed him outside
 the realm of Conceptual art. He stated this explicitly in 'Art After
 Philosophy': 'Three artists often associated with me (through Seth
 Siegelaub's projects) – Douglas Huebler, Robert Barry, and Lawrence
 Weiner – are not concerned with, I do not think, 'Conceptual Art' as it
 was previously stated'. Kosuth, op. cit., p.26

12 This effect derives in large part from the passive construction of the
 statements.

13 Kosuth, op. cit., p.20

14 I believe it is more than coincidental that in 1971 Seth Siegelaub,
 whose exhibition and publishing activities were central to establishing
 an international profile for Conceptual art, produced 'The Artist's
 Reserved Rights Transfer and Sale Agreement' with the attorney Bob
 Projansky. A parallel between this document and the redefinitions of
 authorship undertaken by Kosuth, Weiner and others is suggested by
 its publication in the Documenta 5 catalogue in 1972 as a pseudo-
 artwork, or what Siegelaub called a 'Contract-poster'. The 1971
 contract form is reprinted in Monroe E. Price and Hamish Sandison,
 eds., *A Guide to The California Resale Royalties Act*, Los Angeles,
 Advocates for the Arts and UCLA Law School, Bay Area Lawyers for the
 Arts, Inc., Berkeley, 1976.
 In his introduction to the contract in the *Documenta 5* catalogue all of
 the artists Siegelaub cites as using the contract were engaged with
 dematerializing art objects: 'Among the artists who are known to have
 used the Contract are: Carl Andre, Robert Barry, Mel Bochner, Hans
 Haacke, Sol LeWitt and Mario Merz'. Reprinted in Kristine Stiles and
 Peter Selz, eds., *Theories and Documents of Contemporary Art: A
 Sourcebook of Artists' Writings*, University of California Press, Berkeley,
 1996, p. 838

15 Mary Kelly, 'Notes on Reading the Post-Partum Document' , (1977) in
 Imaging Desire, MIT Press, Cambridge, 1996, p. 23

16 'Preface and Footnotes to the Post-Partum Document', (1983) in Mary
 Kelly, op. cit., p. 55

17 'I was referring to the heterogeneity of discourse, that is, to the
 different ways that you're drawn into the work. There's the experiential
 narrative, which is the mother's voice; there's the kind of empirical or
 pseudoacademic discourse that frames the work in some kind of social
 sense; and there's the psychoanalytic reading, which you could consider
 almost as another level of the way those events were experienced'. In
 'Mary Kelly and Laura Mulvey in Conversation', (1986) in Mary Kelly,
 op. cit., p. 30

18 When asked in a 1994 interview if she saw any recurring themes in her
 work, Holzer responded, 'Unnecessary and premature death ... I almost
 laughed when I said that, because it sounds gothic, but that's what is
 always there'. Barbaralee Diamonstein, *Inside the Art World: Convers-*

ations with Barbaralee Diamonstein, Rizzoli, New York, 1994. p. 112

19 Having been at pains to argue that Holzer's texts are meant to 'dematerialize' authorship, I want to avoid taking her own statements as any form of ultimate explication of her art. Rather they are important testimony that enables some, but not all, possible readings.

20 Mark Seltzer, 'Wound Culture: Trauma in the Pathological Public Sphere', October 80, Spring 1997, p.3. See also Mark Seltzer, 'Serial Killers (II): The Pathological Public Sphere', Critical Inquiry 22, Autumn 1995, pp.122–149

21 This is Seltzer's term, which he draws from the title of J.G. Ballard's novel, The Atrocity Exhibition. See Seltzer, 'Serial Killers (II)', p. 129ff

22 'Wound Culture: Trauma in the Pathological Public Sphere', in Seltzer, op. cit., p. 3

23 Ibid., p. 11

24 Christian Kämmerling, in Kämmerling and Holzer, 'Interview', Jenny Holzer, Lustmord; Süddeutsche Zeitung Magazin, No. 46, 1993, p. 122

25 Marc Augé, Non-Places: Introduction to an Anthropology of Supermodernity, Verso, London, 1995, trans. John Howe, p. 96

26 Robert Venturi, Denise Scott Brown, Steven Izenour, Learning From Las Vegas, revised edition, MIT Press, Cambridge, 1977, p. 8

27 Brian O'Doherty, Inside the White Cube: The Ideology of the Gallery Space, Lapis Press, Santa Monica, 1986, p. 78. The essays included in this book were published in slightly different form in Artforum in 1976.

28 Ferguson, 'Wordsmith', pp. 110–11

29 For an account of 'The Real Estate Show' as well as the history of ABC No Rio see Alan Moore and Marc Miller, eds., ABC No Rio Dinero: The Story of a Lower East Side Gallery, ABC No Rio, New York, 1985, see especially pp. 52–69

30 'Interview' in Michael Auping, Jenny Holzer. Universe Publishing, New York, 1992, p. 90

31 Ibid., pp. 92–93

32 What better site for such an encounter than in the institution that in recent years has done more than any other to 'globalize' the museum.

I would like to thank Jenny Holzer and her assistant Amy Whitaker for their invaluable assistance in preparing this essay.

From **Living**
1980–82
Cast bronze plaque
12.5 × 25.5 cm
Installation, 41 West 57th Street, New York, 1982
Collections, Australian National Gallery, Canberra; National Gallery of Canada, Ottawa

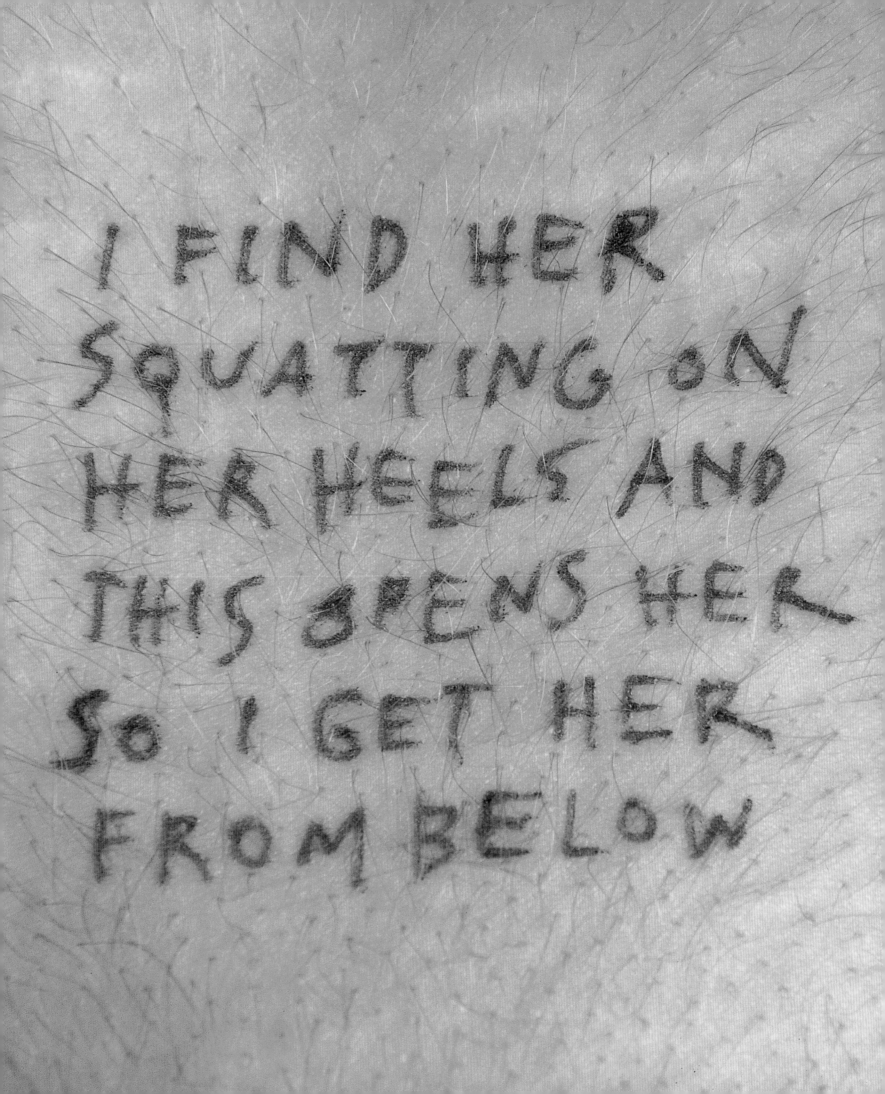

Contents

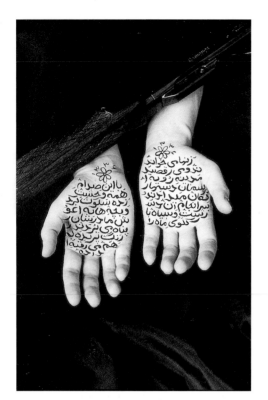

Shirin Neshat
Stories of Martyrdom
1994
Black and white photograph
24 × 16 cm

Many contemporary women artists deal with the dilemma of the relationship between language and violence. Sue Williams,[1] for example, has exhibited a mannequin doll that looks like a beaten woman and on whose body we read the violent sentences uttered by her tormentor. Shirin Neshat[2] photographs Iranian women covered in headscarves, who hold in their arms a pistol or a gun and whose faces, palms or feet are overwritten by women's writings. In the case of these two artists we have, on the one hand, a woman who is a passive object of male violence and whose body is marked by male words, and on the other, women who are also oppressed by patriarchal culture, but who resist this culture with guns as well as with their own literature. When Jenny Holzer takes up the issue of violence and writing, however, she further complicates the matter. In Holzer's art we do not have women who are simply objects of male violence or women who try to act against this violence. Holzer presents in *Lustmord* three completely different viewpoints of a rape: that of the perpetrator, the victim and the observer. It is crucial here that one cannot discern from which position the artist herself speaks. One can guess that she speaks simultaneously from all three positions – and from none of them.

By presenting three different accounts of the same rape, Holzer shows that the other is incomprehensible, not simply because of one's ignorance, but because of the radical impossibility of comprehending the other's perspective, as well as 'feeling' his or her pain. What does this radical impossibility mean?

The most horrible violence that can happen to a subject is usually not physical pain, but violence that destroys the subject's identity, his or her self-perception. Psychoanalysis teaches us that this self-perception is structured like a fantasy. The notion of fantasy here is not meant as an illusion, but as a scenario that helps the subject to mask the lack, the so-called Lacanian real (which can also be understood as a trauma) that shatters the subject's very being. The most horrible violence occurs when the subject is touched in his or her inner being, in such a way that the story s/he was telling him or herself no longer makes sense. When the subject's fantasy has thus been destroyed, he or she may feel like a mere pile of

opposite, from **Lustmord**,
collaboration with Tibor Kalman
1993–94
Offset print on card
30 × 23 cm each
Project for *Süddeutsche Zeitung
Magazin*, No. 46, 1993

following pages, **Lustmord**,
collaboration with Tibor Kalman
1993–94
Photographs of handwriting in ink
on skin
32 × 22 cm each page
Project for *Süddeutsche Zeitung
Magazin*, No. 46, 1993

bones, covered by flesh and skin. The subject has lost a sense of identity and desperately tries to fashion a new story about him or herself that would also give meaning to the traumatic event.

Jenny Holzer's *Lustmord* project uses cropped photographs of naked skin upon which texts have been written. We are not told whether these skin surfaces belong to a victim, perpetrator or observer, or even to someone else. Although the texts give three accounts of the event, attempting to make rape comprehensible, the trauma remains unspoken. Of course, one can easily draw the conclusion here that words cannot recount the traumatic dimensions of the violence of the act of rape, but in Holzer's work the writing on the skin actually opens up the incongruity between the rape as a traumatic act and its symbolic inscription.

The *Lustmord* project was first presented in the *Süddeutsche Zeitung Magazin* (19 November, 1993). The cover of the magazine reproduced one of the texts in red ink mixed with a few drops of blood provided by women volunteers who had been involved in the project. The blood-writing added a further dimension, making it seem as if an inner element of the body had come to the surface in order to symbolize the trauma that had disrupted it. Holzer, however, does not make the banal statement that the body actually speaks through the text that is inscribed with blood. In Holzer's blood-writings, it is not as if the reality of the trauma suddenly came to the surface and thus became inscribed in language. On the contrary, the inscriptions remain somehow detached from the body; they appear as painful, incomprehensible messages that can never convey the trauma of the act itself. Holzer's body-writings thus show that violence is symbolically mediated, but that it also touches the real, which cannot be symbolized.

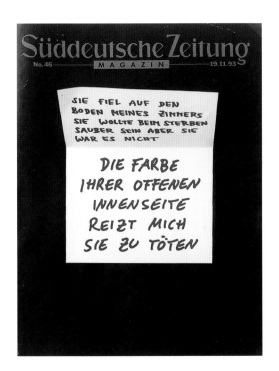
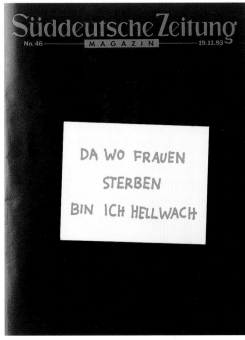

The *Lustmord* project signals a shift in Holzer's art practice: if in

I TRY TO
EXCITE MYSELF
SO I
STAY CRAZY

I WANT TO
FUCK HER
WHERE SHE
HAS TOO
MUCH HAIR

I WANT TO BRUSH
HER HAIR BUT
THE SMELL OF HER
MAKES ME CROSS
THE ROOM. I HELD
MY BREATH AS
LONG AS I COULD.
I KNOW I DISAPPOINT HER

MY BREASTS
ARE SO
SWOLLEN
THAT I
BITE THEM

I KNOW WHO
YOU ARE AND
IT DOES ME
NO GOOD
AT ALL

SHE ACTS
LIKE AN ANIMAL
LEFT FOR COOKING

SHE FELL ON THE FLOOR
IN MY ROOM.
SHE TRIED TO BE
CLEAN WHEN SHE DIED
BUT SHE WAS NOT.
I SEE HER TRAIL

SHE HAS NO
TASTE LEFT
TO HER AND
THIS MAKES IT
EASIER FOR ME

SHE STARTED RUNNING
WHEN EVERYTHING
BEGAN POURING FROM
HER BECAUSE
SHE DID NOT WANT
TO BE SEEN.

THE BIRD TURNS
ITS HEAD AND
LOOKS WITH
ONE EYE WHEN
YOU ENTER

THE COLOR OF
HER WHERE SHE
IS INSIDE OUT
IS ENOUGH TO
MAKE ME
KILL HER

WITH YOU
INSIDE ME
COMES THE
KNOWLEDGE OF
MY DEATH

YOU CONFUSE ME
WITH SOMETHING
THAT IS IN YOU
I WILL NOT
PREDICT HOW
YOU WANT TO
USE ME

YOU HAVE SKIN
IN YOUR MOUTH
YOU LICK ME
STUPIDLY

HER GORE IS IN
A BALL OF CLEANING
RAGS. I CARRY OUT THE
DAMPNESS LEFT FROM
MY MOTHER. I RETURN
TO HIDE HER JEWELRY

THE BLACK SPECKS
INSIDE MY EYES
FLOAT ON HER BODY
I WATCH THEM WHILE
I THINK ABOUT HER

YOUR AWFUL
LANGUAGE
IS IN
THE AIR
BY MY HEAD

I TAKE HER
FACE WITH ITS
FINE HAIRS.
I POSITION
HER MOUTH

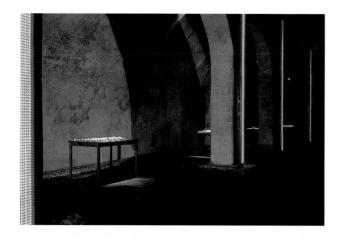

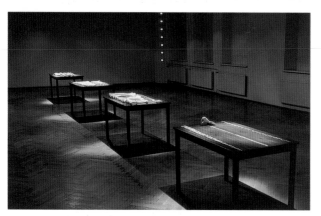

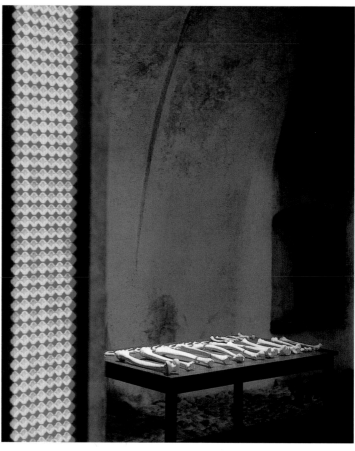

the past she used electronic messages to undermine our spontaneous perception of a public space, she now challenges the use of the body as a means for expression. The return to the body has significantly marked the contemporary art of the last decade, but Holzer is taking a different approach from the current generation of performance artists who make art projects involving self-mutilation. It seems as if she shares the contempt for this form of practice expressed in one of the texts from the *Living* series: IT'S NO FUN WATCHING PEOPLE WOUND THEMSELVES SO THAT THEY CAN HOLE UP, NURSE THEMSELVES BACK TO HEALTH AND THEN REPEAT THE CYCLE. THEY DON'T KNOW WHAT ELSE TO DO.'[3]

But some may wish to interpret Holzer's skin-writings as just this form of violence to the body. Therefore, the question is: does Holzer's use of the body differ from that of artists who masochistically scar their own bodies, tattoo them or even mutilate their genitals? Before trying to answer this question, let us first deal with the problem of how we understand the artistic use of body-mutilation. What a specific culture perceives as art always depends on some social consensus.[4] Mutilation, torture and sado-masochistic practices have historically been engaged in as private and social rituals; but self-mutilation became understood as an artistic practice, not simply a private masochistic indulgence, at

the moment when a shift occurred in social symbolic organization that allowed this to happen. The generally accepted thesis is that this radical change occurred when our identification with the law, and by extension with the entire existing symbolic order, began to shift. The dissolution of traditional family structures altered our relationship with authority, allowing us to chose our own identity and sexual orientation.

In pre-modern and 'other' societies, initiation rituals situated the subject in the social structure and assigned to him or her a special place and sexual role. In modern, post-Enlightenment society, although we no longer have these forms of ritual, we still retain the authority of the law, which in patriarchal society is linked to the role of the father. In taking up a position in relation to this law, i.e. by distancing ourselves from the law, we acquire our 'freedom'. Postmodern society is characterized by its disbelief in authority or the power of the symbolic order, the so-called big Other; this disbelief has not simply resulted in our liberation from the law or other forms of social coercion. Postmodern subjects, no longer accepting the power of institutions or society to fashion their identity, often experiment with the power of self-creation, perhaps in the form of exploring different sexual identities or transforming their appearance, becoming 'works of art'. However, in the process of the subject breaking free from the big Other, one can also observe the subject's anger and disappointment in regard to the big Other's authority. A reversal occurs: it is not the *subject* who recognizes that the big Other does not exist and that its authority is fraudulent; it is the *big Other* that has somehow 'betrayed' the subject. The father's authority, for example, reveals itself only as a mask for his impotence. Similarly, social rituals in institutions appear increasingly farcical. Yet this apparent liberation of the subject from authority can also be understood as a 'forced' choice that the subject has to make when he or she acknowledges the impotence of authority.

One of the ways in which the subject comes to terms with the absence of the big Other is in turning to narcissistic self-admiration. The lack of identification with an ego ideal (a symbolic role, or authority-model) results in identification with some imaginary role (an idealized ego) in which the subject can discover a liking for him or herself. Another way in which the contemporary subject tries to resolve anxiety over the non-existence of the big Other is discernible in the phenomenon of the so-called 'culture of complaint'. Western societies are nowadays overflowing with people's complaints about all kinds of injustices in

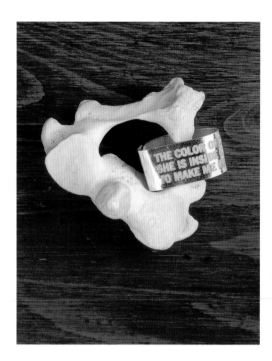
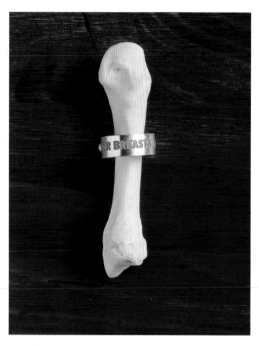
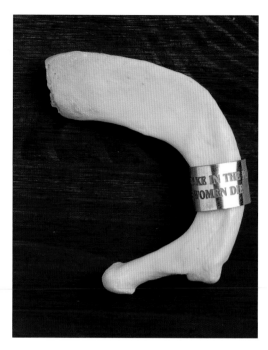

their private and public lives, as they search for the culprits who deprived them of their enjoyment, wealth, respect, etc. A disbelief in the power of the big Other has resulted in the conviction that there are various small others (institutions and authorities in the subject's immediate environment) who are guilty of the troubles in the subject's life. The legal and financial compensation that the subject often seeks is supposed, at least for a moment, to reinstate the lost equilibrium.

Narcissism and the culture of complaint are the most common ways in which the contemporary subject deals with the lack of the big Other. The practice of body art, particularly when it takes the form of inscription on the body, can be seen as a further method of marking this absence. There is, however, a radical difference between the often sado-masochistically based practices of body art and the type of body texts presented in the *Lustmord* project. Artists who make work that incorporates such actions as cutting themselves or mutilating their sexual organs are undertaking a perverse search for the law. Of course, the term 'perversion' here should not be understood as a pejorative description. For psychoanalysis, the pervert is the subject for whom castration has not been completed and who therefore searches endlessly for the missing dimension of the symbolic prohibition. Perversion is thus described not as beyond the law, but as an attempt to find it, and this search for the law can be observed in the masochistic practices of body art. The artists often imitate initiation rituals by marking their bodies; some even perform rituals of actual castration in the form of gender-mutilation. Holzer's use of writing on the body does not

From **Lustmord** (detail)
1993–94
Human bones, engraved silver,
LED signs, 4 tables
Installation, Galerie Rähnitzgasse,
Dresden, Germany, 1996

align itself with this kind of perverse search for the law, although the *Lustmord* project does reflect the contemporary disbelief in the big Other. In this work there is no authority that can help us to understand the logic of rape, there is no point in the symbolic network with which the subject might identify in order to get answers for his or her trauma. We are left with an utterly fragmented corpus of texts written on the body, and neither the text nor the reality of the skin gives ground to the subject. With the non-existence of the big Other that would dress the subject with some identity, we come to the point where the subject necessarily becomes the designer of his or her own story, and the only material available is his or her own skin. A crucial difference between masochistic body art practice and the *Lustmord* project is that the body artists seem to be constantly attempting to re-establish the big Other through the laws that their practice itself invents, while Holzer's work assumes that the big Other does not exist, without attempting to cover up this realization of emptiness. This acknowledgement, in contrast to the actions of body art, endows Holzer's work with a far more heroic dimension.

1　See Sue Williams' project *Irresistible* (1992). The mannequin doll is covered in sentences such as: 'Look what you made me do' and 'I think you like it'.
2　See Shirin Neshat's projects *Unveiling Series* (1993), *Women of Allah* (1994), *Under Duty* (1994). For an account of contemporary art that uses writing on the body, see *Auf den lieb gescriben*, Kunsthalle Wien im Museumquartier, Vienna, 1995.
3　See Holzer's *Living* series (1980–82).
4　See Jacques Lacan, *Ethics of Psychoanalysis*, Routledge, London, 1993

Contents

From where she lies she sees Venus rise. On. From where she lies when the skies are clear she sees Venus rise followed by the sun. Then she rails at the source of all life. On. At evening when the skies are clear she savours its star's revenge. At the other window. Rigid upright on her old chair she watches for the radiant one. Her old deal spindlebacked kitchen chair. It emerges from out the last rays and sinking every brighter is engulfed in its turn. On. She sits on erect and rigid in the deepening gloom. Such helplessness to move she cannot help. Heading on foot for a particular point often she freezes on the way. Unable till long after to move on not knowing whither or for what purpose. Down on her knees especially she finds it hard not to remain so forever. Hand resting on hand on some convenient support. Such as the foot of her bed. And on them her head. There then she sits as though turned to stone face to the night. Save for the white of her hair and faintly bluish white of face and hands all is black. For an eye having no need of light to see. All this in the present as had she the misfortune to be still of this world.

The cabin. Its situation. Careful. On. At the inexistent centre of a formless place. Rather more circular than otherwise finally. Flat to be sure. To cross it in a straight line takes her from five to ten minutes. Depending on her speed and radius taken. Here she who loves to – here she who now can only stray never strays. Stones increasingly abound. Ever scanter even the rankest weed. Meagre pastures hem it round on which it slowly gains. With none to gainsay. To have gainsaid. As if doomed to spread. How come a cabin in such a place? How came? Careful. Before replying that in the far past at the time of its building there was clover growing to its very walls. Implying furthermore that it the culprit. And from it as from an evil core that the what is the wrong word the evil spread. And none to urge – none to have urged its demolition. As if doomed to endure. Question answered. Chalkstones of striking effect in the light of the moon. Let it be in opposition when the skies are clear. Quick then still under the spell of Venus quick to the other window to see the other marvel rise. How whiter and whiter as it climbs it whitens more and more the stones. Rigid with face and hands against the pane she stands and marvels long [...]

What is it defends her? Even from her own. Averts the intent gaze. Incriminates the dearly won. Forbids divining her. What but life ending. Hers. The other's. But so otherwise. She needs nothing. Nothing utterable. Whereas the other. How need in the end? But how? How need in the end? [...]

Not possible any longer except as figment. Not endurable. Nothing for it but to close the eye for good and see her. Her and the rest. Close it for good and all and see her to death. Unremittent. In the shack. Over the stones. In the pastures. The haze. At the tomb. And back. And the rest. For good and all. To death. Be shut of it all. On to the next. Next figment. Close it for good this filthy eye of flesh. What forbids? Careful.

Such – such fiasco that folly takes a hand. Such bits and scraps. Seen no matter how and said as seen. Dread of black. Of white. Of void. Let her vanish. And the rest. For good. And the sun. Last rays. And the moon. And Venus. Nothing left but black sky. White earth. Or inversely. No more sky or earth. Finished high and low. Nothing but black and white. Everywhere no matter where. But black. Void. Nothing else. Contemplate that. Not another word. Home at last. Gently gently.

Panic past pass on. The hands. Seen from above. They rest on the pubis intertwined. Strident white. Their faintly leaden tinge killed by the black ground. Suspicion of lace at the wrists. To go with the frill. They tighten then loosen their clasp. Slow systole diastole. And the body that scandal. While its sole hands in view. On its sole pubis. Dead still to be sure. On the chair. After the spectacle. Slowly its spell unbinding. On and on they keep. Tightening and loosening their clasp. Rhythm of a labouring heart. Till when almost despaired of gently part. Suddenly gently.

Spreading rise and in midair palms uppermost come to rest. Behold our hollows. Then after a moment as if to hide the lines fall back pronating as they go and light flat on head of thighs. Within an acre of the crotch. It is now the left hand lacks its third finger. A swelling no doubt – a swelling no doubt of the knuckle between first and second phalanges preventing one panic day withdrawal of the ring. The kind called keeper. Still as stones they defy as stones do the eye. Do they as much as feel the clad flesh? Does the clad flesh feel them? Will they then never quiver? This night assuredly not. For before they have – before the eye has time they mist. Who is to blame? Or what? They? The eye? The missing finger? The keeper? The cry? What cry? All five. All six. And the rest. All. All to blame. All […]

One evening she was followed by a lamb. Reared for slaughter like the others it left them to follow her. In the present to conclude. All so bygone. Slaughter apart it is not like the others. Hanging to the ground in matted coils its fleece hides the little shanks. Rather than walk it seems to glide like a toy in tow. It halts at the same instant as she. At the same instant as she strays on. Stockstill as she it waits with head like hers extravagantly bowed. Clash of black and white that far from muting the last rays amplify. It is now her puniness leaps to the eye. Thanks it would seem to the lowly creature next her. Brief paradox. For suddenly together they move on. Hither and thither toward the stones. There she turns and sits. Does she see the white body at her feet? Head haught now she gazes into emptiness. That profusion. Or with closed eyes sees the tomb. The lamb goes no further. Alone night fallen she makes for home. Home! As straight as were it to be seen.

Was it ever over and done with questions? Dead the whole brood no sooner hatched. Long before. In the egg. Long before. Over and done with answering. With not being able. With not being able not to want to know. With not being able. No. Never. A dream. Question answered […]

Absence supreme good and yet. Illumination then go again and on return no more trace. On earth's face. Of what was never. And if by mishap some left then go again. For good again. So on. Till no more trace. On earth's face. Instead of always the same place. Slaving away forever in the same place. At this and that trace. And what if the eye could not? No more tear itself away from the remains of trace. Of what was never. Quick say it suddenly can and farewell say say farewell. If only to the face. Of her tenacious trace.

Decision no sooner reached or rather long after than what is the wrong word? For the last time at last for to end yet again what the wrong word? Than revoked. No but slowly dispelled a little very little like the last wisps of day when the curtain closes. Of itself by slow millimetres or drawn by a phantom hand. Farewell to farewell. Then in that perfect dark foreknell darling sound pip for end begun. First last moment. Grant only enough remain to devour all. Moment by glutton moment. Sky earth the whole kit and boodle. Not another crumb of carrion left. Lick chops and basta. No. One moment more. One last. Grace to breathe that void. Know happiness.

From **Laments**
1988–89
Graphite on tracing paper
213.5 × 81.5 cm
Collections, The Museum of
Modern Art, New York; Walker Art
Center, Minneapolis

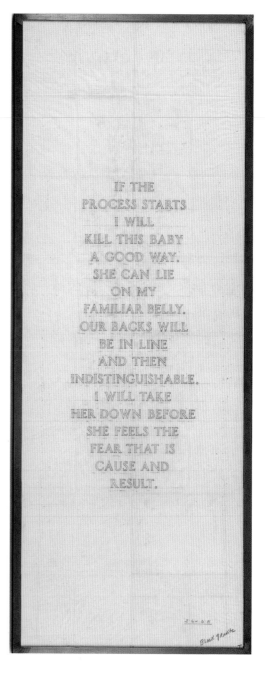

THE NEW DISEASE CAME.
I LEARN THAT TIME
DOES NOT HEAL.
EVERYTHING GETS
WORSE WITH DAYS.
I HAVE SPOTS
LIKE A DOG.
I COUGH AND CANNOT
TURN MY HEAD.
I CONSIDER SLEEPING
WITH PEOPLE
I DO NOT LIKE.
I NEED TO LIE
BACK TO FRONT
WITH SOMEONE
WHO ADORES ME.
I WILL THINK MORE
BEFORE I CANNOT.
I LOVE MY MIND WHEN
IT IS FUCKING THE
CRACKS OF EVENTS.
I WANT TO TELL YOU
WHAT I KNOW
IN CASE IT IS OF USE.
I WANT TO GO TO
THE FUTURE PLEASE.

NO RECORD OF JOY
CAN BE LIKE THE
JUICE THAT JUMPS
THROUGH YOUR SKULL
WHEN YOU ARE
PERFECT IN SEX.
YOU POSITION
YOUR SPINE UNTIL
IT WAVES.
YOUR HANDS RUN
TO SPOTS
THAT FEEL
DIFFERENT.
BREATHING TELLS
THE PERSON
WHAT TO DO.
YOU TRY TO STOP
BECAUSE THAT
IS THE FUN.
THEN YOU SQUEEZE
AND BECOME
UNCONSCIOUS NEAR
WHOMEVER WHICH IS
THE DANGEROUS
THING IN
THE WORLD.
AT THE END
YOU DO NOT WANT.
YOU CARRY THIS
SENSATION TO THE
CRUEL PLACES
YOU GO.

IF THE
PROCESS STARTS
I WILL
KILL THIS BABY
A GOOD WAY.
SHE CAN LIE
ON MY
FAMILIAR BELLY.
OUR BACKS WILL
BE IN LINE
AND THEN
INDISTINGUISHABLE.
I WILL TAKE
HER DOWN BEFORE
SHE FEELS THE
FEAR THAT IS
CAUSE AND
RESULT.

THERE IS NO ONE'S
SKIN UNDER
MY FINGERNAILS.
THERE IS NO ONE
TO WATCH
MY HAIR GROW.
NO ONE LOOKS AT
ME WHEN I WALK.
PEOPLE WANT ME
TO PAY MONEY FOR
EACH THING I GET.
I HAVE EVERY KIND
OF THOUGHT AND THAT
IS NO EMBARRASSMENT.
I LOOK AT MYSELF
WHEN I BATHE.
WHAT I GIVE
TO ALL THE PEOPLE
WHO DO NOT WANT
TO LIVE WITH ME
IS ARITHMETIC.
I COUNT INFANTS AND
PREDICT THEIR DAYS.
I SUBTRACT PEOPLE
KILLED FOR ONE
REASON OR ANOTHER.
I GUESS THE NEW
REASONS AND PROJECT
THEIR EFFICACY.
I DECORATE MY
NUMBERS AND
CIRCULATE THEM.

BLACK
Granite

I WAS
SICK FROM
ACTING NORMAL.
I WATCHED
REPLAYS OF
THE WAR.
WHEN NOTHING
HAPPENED I
CLOSED A ZONE
WHERE I
EXERT CONTROL.
I FORMED A
GOVERNMENT THAT
IS AS WELCOME
AS SEX.
I AM GOOD
TO PEOPLE
UNTIL THEY DO
SOMETHING STUPID.
I STOP THE
HABITUAL MISTAKES
THAT MAKE FATE.
I GIVE PEOPLE
TIME SO THEY
FEEL THEIR LIVES
MOVING OVER
THEIR SKINS.
I WANT A
LARGER ARENA.
I TEASE WITH
THE POSSIBILITY
OF MY
ABSENCE.

THE KNIFE CUT
RUNS AS LONG
AS IT WANTS.
IT IS THROUGH
MY STOMACH.
I KEEP LOOKING
AT IT.
I HAVE MORE
COLORS THAN
I WOULD
HAVE THOUGHT.
THE HOLE IS
LARGE ENOUGH
FOR MY HEAD.
THE HOLE WAS
BIG ENOUGH
FOR THEIR HANDS
TO MOVE FREELY.
THEY PUT THEIR
FINGERS IN
BECAUSE THEY
SHOULD NOT AND
BECAUSE THEY
DO NOT GET
THE CHANCE
EVERY DAY.

Crowds and Power (extracts), 1960 **Elias Canetti**

The Killers Are Always the Powerful

It is not only the whole hand which has served as a model and stimulus. The individual fingers, and particularly the extended index finger, have also acquired a significance of their own. The tip of the finger is pointed and armoured with a nail. It first provided man with the sensation of stabbing. From it developed the dagger, which is a harder and more pointed finger. The arrow is a cross between finger and bird; it was lengthened in order to penetrate further, and made more slender to fly better. Beak and thorn also influenced its composition; beaks in any case are proper to feathered objects. A pointed stick became a spear, an arm extended into a single finger.

All weapons of this kind are concentrated on a point. Man was himself stabbed by long, hard thorns and pulled them out with his fingers. The finger which detached itself from the rest of the hand and, acting like a thorn, passed on the stab is the psychological origin of this kind of weapon. The man who has been stabbed stabs back with his finger and with the artificial finger he gradually learns to make.

Not all the operations of the hand are invested with the same degree of power; their prestige varies greatly. Things which are particularly important for the practical existence of a group of men may be highly valued, but the greatest respect is always accorded to anything which has to do with killing. That which can kill is feared; that which does not directly serve killing is merely useful. All that the patient skills of the hand bring to those who confine themselves to them is subjection. It is those who devote themselves to killing who have power.

The Patience of the Hand

It is the violent activities of the hands which are thought of as the oldest. We not only think of the act of seizing with hostile intent, which is expected to be cruel and sudden, but automatically, and in spite of their technical complexity and the remoteness of their derivation, we add to the group many movements which in fact only developed later: hitting, stabbing, thrusting, throwing, shooting. The speed and precision of these movements may be greater, but in substance and in intent they have remained the same. They are important for hunters and soldiers, but they have added nothing to the special glory of the human hand.

The hand has found other ways to perfect itself and these, in all cases, are ways which renounce predatory violence. Its true greatness lies in its *patience*. It is the quiet, prolonged activities of the hand which have created the only world in which we care to live. The potter whose hands are skilled in shaping clay stands as creator at the beginning of the Bible.

But how did the hands learn patience? How did the fingers of the hand become sensitive? One of the earliest occupations we know of is the picking over of the fur of a friend which monkeys delight in. We imagine that they are searching for something and, as they often do undoubtedly find something, we have ascribed a purely practical and far too narrow purpose to this activity. In reality they do it principally for the agreeable sensation that the individual fingers receive from the hairs of the skin. It constitutes the most primitive 'finger exercises' that we know. It was through them that the hand became the delicate instrument we marvel at today.

From **Survival**
1983–85
UNEX sign
77.5 × 288 × 30.5 cm
Collections, Whitney Museum of
American Art, New York;
National Gallery of Canada,
Ottawa

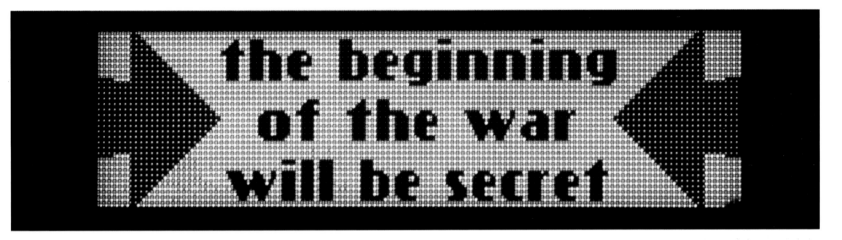

The Mongols. The Horse and the Arrow

One of the most striking things about the history of the Mongols is the closeness with which command is linked to the horse and the arrow. One of the main reasons for the sudden and rapid rise of their power is to be found in this combination. It is essential for us to consider it briefly.

Commands, as we have seen, have their biological origin in the flight-command. Like all similar hoofed animals the horse is built for flight. Flight, one might almost say, was its original mode of being. It lived in herds and these herds were accustomed to *fleeing together*. The command to flee was given them by the dangerous animals which preyed on their life. Mass flight was one of the commonest experiences of the horse and came to be part of its nature. As soon as the danger was past, or seemed past, it reverted to the care-free state of herd-life, each animal doing again as it pleased.

By taking possession of the horse and taming it, man formed a new unit with it. He trained it by a series of operations which can very well be regarded as commands. A few of these are sounds, but most are movements – of pressure or of pulling – which transmit to the horse the will of its rider. The horse understands the rider's wishes and obeys them. Among equestrian peoples the horse is so necessary and so close to its master that a very personal relationship grows up between them; it is subjection, but of intimacy only possible in these circumstances.

In it the physical distance normal between the giver and the recipient of an order, including for example, that between master and dog, is obliterated. It is the rider's body which gives directions to the horse's body. The *space* of command is thus reduced to a minimum. The distant, alien quality which is part of the original character of command disappears. Command is domesticated in a quite special way and a new actor introduced into the history of relationships between creatures – the riding-animal, a servant on which one sits, which is exposed to the physical weight of its master and responds to the pressure of his body.

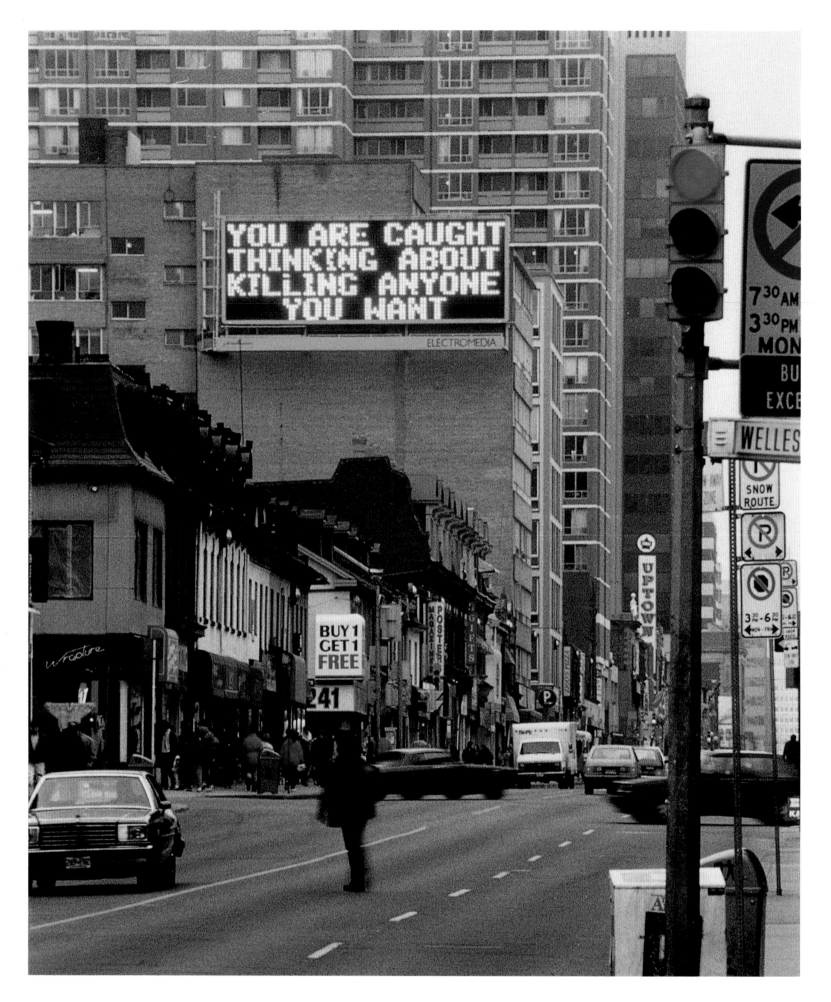

From **Survival**
1983–85
Electronic sign
Approx. 9 × 4 m
Project, Toronto, 1985

How does this relationship to his horse affect the command-economy of the horseman? The first thing to be said is that a rider can pass on to his horse commands he himself has received from a superior. If a goal is set him he does not reach it by running himself, but by making his horse run. Since he does this immediately, the order does not leave any sting in him; he avoids this by passing the order on to his horse. He gets rid of the particular constraint which the order would have imposed on him before he has properly felt it. The sooner he carries out his task, the quicker he mounts and the faster he rides, the less the sting remains in him. The real art of horsemen, as soon as they take on a military character, consists in being able to train another larger crowd of recipients of commands, to whom they can directly pass on everything they receive from their own superiors.

The armies of the Mongols were characterized by their very strict discipline. To the peoples they fell upon and conquered, and who were forced to observe them from close quarters, this discipline seemed the most formidable and astonishing thing they had ever encountered. Whether they were Persians, Arabs, Chinese, Russians or the Franciscan monks sent by the Pope, they all found it equally inconceivable that men should be able to obey so absolutely. But the Mongols, or Tartars, as they were generally called, bore this discipline easily, for the reason that the section of their people which carried the main burden of it was the *horses*.

Children of only two or three years old were set on horseback by the Mongols and taught to ride. We spoke earlier of how, from the very start of his upbringing, a child is crammed full of the stings of command: first, and foremost, by his mother, but later and from a rather greater distance by his father, by those to whom his education is entrusted and, in fact, by every adult or older person in his environment. None of these can rest content unless imposing ceaseless directions, commands and prohibitions on the child. From his earliest days stings of all kinds accumulate in him and it is round these that there form the compulsions and pressures of his later life. He is driven to search for other creatures on whom to unload his stings. His life becomes one long endeavour to get rid of them; he *has* to get rid of them. They are what drive him towards this or that otherwise inexplicable deed or meaningless relationship.

overleaf, from **Survival**
1983–85
UNEX sign
77.5 × 288 × 30.5 cm
Collections, Whitney Museum of
American Art, New York; National
Gallery of Canada, Ottawa

Compared with the child of higher, sedentary civilizations the Mongol or Kirghiz child, who learns to ride so early, enjoys a freedom of a special kind. As soon as he can manage a horse he can pass on to it everything he himself is ordered to do. He can very early discharge the stings which, although to a much smaller degree, are part of his unbringing too. A horse does the child's will long before any human being. He grows used to receiving this obedience and his life is easier for it, but he later expects of men he has conquered the same absolute physical submission.

This relationship to the horse plays a decisive part in the command-economy of man, but among the Mongols there is another important factor. This is the *arrow*, the exact image of the original, non-domesticated command.

An arrow is hostile; it is meant to kill. It travels straight through space. It can be evaded, but if a mean does not succeed in this it will lodge in him. It can be pulled out, but, even if it does not break, leaving the head behind, the wound remains. (The *Secret History of the Mongols* contains many stories of arrow-wounds.) The number of arrows which can be shot is unlimited. It was the Mongols' main weapon. They killed from a distance, and they also killed while moving, from the backs of their horses. We have seen that every command retains from its biological origin something of the character of a death sentence. Anything which does not flee is caught and anything which is caught is torn to pieces.

With the Mongols commands retained the character of a death sentence in the highest possible degree. They slaughtered men as they slaughtered animals. Killing was third nature to them, as riding was second. Their massacres of men were battues; down to the last detail they resembled their massacres of animals. When not going to war they went hunting; hunts to them were manoeuvres. They must have been astonished when, in the course of their wide-ranging expeditions, they came on Buddhists or Christians whose priests spoke to them of the sanctity of all life. Scarcely ever has there been a greater contrast: the masters of the naked command, instinctive embodiments of it, confronted with those who seek, through their faith, so to weaken or transform it that it loses its deadliness and becomes humane.

THE CONVERSATION ALWAYS TURNS TO LIVING LONG ENOUGH TO HAVE FUN

SPIT ALL OVER SOMEONE WITH A MOUTHFUL OF MILK IF YOU WANT TO FIND OUT SOMETHING ABOUT THEIR PERSONALITY FAST

IT IS IN YOUR SELF-INTEREST TO FIND A WAY TO BE VERY TENDER

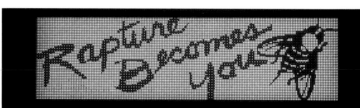

DIE FAST AND QUIET WHEN THEY INTERROGATE YOU OR LIVE SO LONG THAT THEY ARE ASHAMED TO HURT YOU ANYMORE

Rapture Becomes You

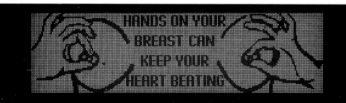

HANDS ON YOUR BREAST CAN KEEP YOUR HEART BEATING

IF YOU HAD BEHAVED NICELY THE COMMUNISTS WOULDN'T EXIST

THE BREAKDOWN COMES WHEN YOU STOP CONTROLLING YOURSELF AND WANT THE RELEASE OF A BLOODBATH

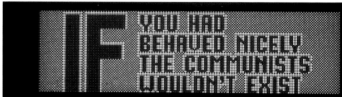

WHAT URGE WILL SAVE US NOW THAT SEX WON'T?

DON'T WATCH THE UNDERCLASS IT'S MORE LIKELY THAT THE WARLORDS WILL KILL YOU

FINDING EXTREME PLEASURE WILL MAKE YOU A BETTER PERSON IF YOU'RE CAREFUL ABOUT WHAT THRILLS YOU

SAVOR KINDNESS BECAUSE CRUELTY IS ALWAYS POSSIBLE LATER

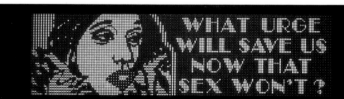

IN A DREAM YOU SAW A WAY TO SURVIVE AND YOU WERE FULL OF JOY

TRUST VISIONS THAT DON'T FEATURE BUCKETS OF BLOOD

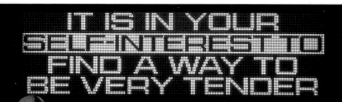

DANCE ON DOWN TO THE GOVERNMENT AND TELL THEM YOU'RE EAGER TO RULE BECAUSE YOU KNOW WHAT'S GOOD FOR YOU

MOTHERS WITH REASONS TO SOB SHOULD DO IT IN GROUPS IN PUBLIC AND WAIT FOR OFFERS

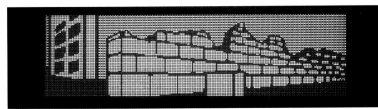

FAT ON YOUR HIPS COMES WHEN YOU SIT AND LIE

PUT FOOD OUT IN THE SAME PLACE EVERY DAY AND TALK TO THE PEOPLE WHO COME TO EAT AND ORGANIZE THEM

YOU ARE TRAPPED ON THE EARTH SO YOU WILL EXPLODE

WHAT COUNTRY SHOULD YOU ADOPT IF YOU HATE POOR PEOPLE?

WHEN THERE'S NO SAFE PLACE TO SLEEP YOU'RE TIRED FROM WALKING ALL DAY AND EXHAUSTED FROM THE NIGHT BECAUSE IT'S TWICE AS DANGEROUS THEN

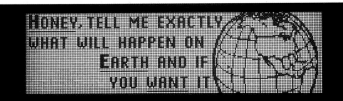

HONEY, TELL ME EXACTLY WHAT WILL HAPPEN ON EARTH AND IF YOU WANT IT

PEOPLE SMELL 2 DEATHS: REGULAR & NUCLEAR

TURN SOFT & LOVELY ANY TIME YOU HAVE A CHANCE

REMEMBER TO REACT

KIDS GO BANANAS WHEN THEY HEAR THAT SOMEONE FACELESS CONTROLS THEM

IT'S EASY TO GET MILLIONS OF PEOPLE ON EVERY CONTINENT TO PLEDGE ALLEGIANCE TO EATING AND EQUAL OPPORTUNITY

Tear ducts seem to be a grief provision

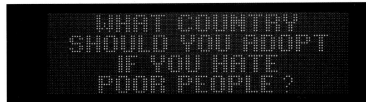

USE A STUN GUN WHEN THE PERSON COMING AT YOU HAS A GOOD EXCUSE

WED

THU

FRI

SAT

Rudi + Jan in Town

2 10 AM Vanity Fair @ Spectru - p-u. tapes from Jack

1 PM @ gallery

hair !!

stretcher delivery AM

there !!

3 10 AM Trans- mix instr @ Spilling

call phone machine repair

4 Gladstone preview Arnold Prince ask Bueflow - trans. +

5 Gladstone opens

9 10 AM Reba @ WilliWear

10 Whitney party 6:30 @ Whitney
Stefan 11 Sky to
call Pakula about bill - $2,000

11 Veterans' Day Book @ Trans - lease - how pay - ask Bob program
call Kiki Friday AM

12 9:30 - N.Y. AIR mike Reinsurg @ aqueduct

PHONE MACHINE aid-o-Fone - 586-8055

16 10 AM - Publica F 25 C.P. West Suite 25 R. 6 PM @ PHON @ B'2A ask about Future program 11:00 call Pakula + no bill

17 ✓ CLUB slides @ Caldwell + Burgess @ Bldg dept 12 pm DeWaart @ B'B Catalogue pkg @ Gladstone 4:30 St. Jacques call Cosimo Thanksgiving Day

18 slides - write Christophe June Burgess @ bldg dept. after 10:30 AM call Pakula about future programming call Finkelstein @ bldg dept call aid o phone 586-8055

19 P-4 dupes Janine $5 thru slides @
pillow ca @ Schafer Friday bef. RETURN N.Y. $

23 to Cinta. Budget Rent Car $38 per day - ← COMENZO →

24 COMENZO! FIND WILLI → WEAR CONTRACT for Maureen

25 call Cosimo about photo appt. → confirm Joe + Henry John H

26 RETURN N.Y. $ 86 QS Att F# 474 Delta 10:55 1:38 F#148 $20 1:34 3:05 Delta

30 call Pakula Spectrumedia future program 12 PM Pink here

ISLAND ad for Coosje cinco de mayo - o real war. shot - call X11

DO ISLAND ad for Coosje

deposit ZIVIC #20. to corp. acc

SID SINGER call him

231-35 325.00 105,000.00

3.32 $77.50 6

7 23 0 0

28

Contents

I thought of books that accompany me and made a list for the Artist's Choice section of this book. My idea was to include quotations from these titles without comment, but there were too many words and the text mix was bewildering to anyone but me. A deal was struck that I could print more choices here if I wrote about them.

I read these books at various stages of my life. Reviewing them was a tour of the past and rereading passages let me visit the thinking I did while writing my own work. I'll give you the texts in the order I encountered them.

'I must stop it, nevertheless!' I muttered, knocking my knuckles through the glass … stretching an arm out … my fingers closed on the fingers of a little, ice cold hand! The intense horror of nightmare came over me: I tried to draw back my arm, but the hand clung to it, and a most melancholy voice sobbed, 'let me in – let me in!' 'Who are you?' I asked … I discerned, obscurely a child's face looking through the window. Terror made me cruel; and, finding it useless to attempt shaking the creature off, I pulled its wrist on to the broken pane, and rubbed it to and fro till the blood ran down and soaked the bedclothes.
— Emily Bronte, *Wuthering Heights*[1]

Bronte goes on to mention a barricade of books to protect against 'it', the nightmare presence. Terror at night was part of my childhood. The resulting fear and knowledge has much to do with my world view. I read *Wuthering Heights* when I was an adolescent. I was reassured to find an author who knew and could represent this quality of horror.

On a cloud I saw a child,
And he laughing said to me: …

' … Sing thy songs of happy cheer!'
So I sung the same again,
While he wept with joy to hear.

'Piper, sit thee down and write
In a book that all may read.' …
And I pluck'd a hollow reed,

And I made a rural pen,

From **Arno**
1996–97
185mm Kodaclit-film Xenon projection
Dimensions variable
Project, Arno river, 'Biennale di Firenze: il Tempo e la Moda', Florence, 1996

And I stain'd the water clear,
And I wrote my happy songs
Every child may joy to hear.
— William Blake, *Songs of Innocence*[2]

Blake's *Songs of Innocence* is nothing like the night in *Wuthering Heights*. Blake wrote about watchful guardians and laughing, expansive children. I had not entertained safety and blamelessness. What is given to many was a revelation for me.

Little girl
Sweet and small
Cock does crow
So do you
Merry voice
Infant noise...
— William Blake, *Songs of Innocence*[3]

I was certain idiots and liars talk about innocence, but I found Blake neither. I was an adolescent when I read Blake, and the *Songs* provided balance.

Blake signed as the author and printer W. Blake. I am a printer of sorts who spends time on technology to integrate text in a surround.

It is night: now do all gushing fountains speak louder.
And my soul also is a gushing fountain.
It is night: now only do all songs of the loving ones
wake. And my soul also is the song of a loving one.
Something unappeased, unappeasable, is within me:
It longs to find expression. A craving for love is within
me, which speaks itself the language of love.
Light am I: Ah, that I were night! But it is my lone-
someness to be encircled with light!
Ah, that I were dark and nightly! How would I suck
at the breasts of light!
And you yourselves would I bless, you twinkling

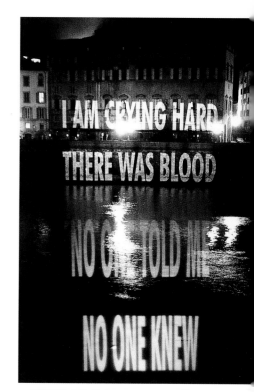

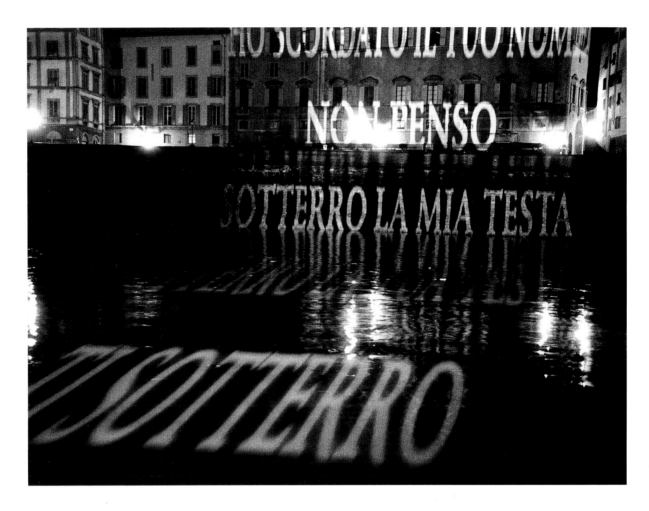

From **Arno**
1996–97
185mm Kodaclit-film Xenon
projection
Dimensions variable
Project, Arno river, 'Biennale di
Firenze: il Tempo e la Moda',
Florence, 1996

starlets and glowworms aloft! – And would rejoice in the
gifts of your light.
But I live in my own light, I drink again into myself
The flames that break forth from me.
I know not the happiness of the receiver ...
It is my poverty that my hand never ceases bestowing ...
I should like to rob those I have gifted:
Then do I hunger for wickedness.
Withdrawing my hand when another hand is already
Stretched out to it ... :
Then do I hunger for wickedness! ...
Where have gone the tears of my eye, and the down of my heart? ...
Many suns circle in desert space: to all that is dark
Do they speak with their light – but to me they are silent ...
— Friedrich Nietzsche, *Thus Spake Zarathustra*⁴

I was fumbling Nietzsche by my late teens and fixed upon *Thus Spake Zarathustra*. I was
curious about an apartness from conventional morality. I wondered if a principled
ruthlessness could be preferable to and less dangerous than the hypocrisy that sustains
inequity and murder. At 19, I was uncertain that law protects the vulnerable.

In 'The Night Song', Zarathustra is unappeased, unappeasable, craving for love, hoping
to injure and to illumine, lonesome, hungry, shameless, icy, longing for speech, as I was. I
have some sense of why the Nazis misappropriated Nietzsche's work; they wanted it as
permission to operate beyond evil. A corrective follows:

Ruthless revolutionary energy and tender humanity – this alone is the true essence of socialism. One world must now be destroyed, but each tear that might have been avoided is an indictment; and a man who hurrying on to important deeds inadvertently tramples underfoot even a poor worm, is guilty of a crime.
— Rosa Luxemburg, *Rosa Luxemburg: Selected Political Writings*[5]

I began to look for writing that answers urgent social questions. I was taken by Luxemburg who demands revolutionary justice while insisting that it not be blood fun. (It is instructive that she was murdered for her trouble). I found Luxemburg in a New York city library when I was researching the *Inflammatory Essays*.

I read absolutists, pacifists, utopian theorists, generals. I read nihilists, anarchists, reformers, communards, the mad and the religious. The writing's certainty was extremely attractive, even when certainty included sacrifice. Remembering the books that seem like speeches, I want to fall into the cadence that is as important as sense.

I collected political and art manifestos. These appeared on the walls of the 'Manifesto Show'. I wanted the writing to be in a room full of people. We read holy, certain, essential speech. We read Orwellian nonsense and Orwell. We saw authors ride the desire for justice all the way to purges and mass imprisonment. We read the prelude to passionate action, the announcement of great need, the proof of common interest, the call to others and the fair warning. I wanted to examine every possibility and not have them cancel each other.

Freedom only for the supporters of the government, only for the members of one party … is no freedom at all. Freedom is always and exclusively freedom for the one who thinks differently. Not because of any financial concept of 'justice' but because all that is instructive, wholesome and purifying in political freedom depends on this essential characteristic, and its effectiveness vanishes when 'freedom' becomes a special privilege.
— Rosa Luxemburg, *Rosa Luxemburg: Selected Political Writings*[6]

I would return with respect to Luxemburg who insists upon tolerance. She is certain that society must be transformed immediately to become just, but she does not coerce. The desire not to force anyone had me write the *Truisms* and *Essays* in such a way that many speak and no one dominates. This seemed clean, and it always has been easier for me to

write while imagining I am someone else. The ideal at the time of writing was to be hundreds of people.

From the same research period in New York City, is Emma Goldman on coexistence of the sexes. I had assumed that the solution for writing and living was to be an indeterminate or unidentifiable sex, or when in doubt male. I was interested to hear Goldman propose an alternative, and her last line makes me laugh.

Peace or harmony between the sexes and individuals does not necessarily depend on a superficial equalization of human beings; nor does it call for the elimination of individual traits and peculiarities. The problem that confronts us today, and which the nearest future is to solve, is how to be one's self and yet in oneness with others, to feel deeply with all human beings and still retain one's own characteristic qualities. This seems to me to be the basis upon which the mass and the individual … man and woman, can meet without antagonism and opposition. The motto should not be: forgive one another; rather, understand one another. The oft-quoted sentence of Madame De Stael: 'To understand everything means to forgive everything', has never particularly appealed to me …
— Emma Goldman, *Red Emma Speaks*[7]

The following is Goldman about mothers and babies. I was surprised that Goldman sited this material in politics. It is different from baby-kissing before elections.

She will become a mother only if she desires the child, and if she can give the child, even before its birth, all that her nature and intellect can yield: harmony, health, comfort, beauty, and above all, understanding, reverence, and love, which is the only fertile soil for new life, a new being.[8]

For contrast, here is Valerie Solanas on men:

The male, because of his obsession to compensate for not being female combined with his inability to relate and to feel compassion, has made of the world a shitpile. He is responsible for: war… proving his manhood is worth an endless amount of mutilation and suffering, and an endless number of lives, including his own – his own life being worthless, he would rather go out in a blaze of glory than plod grimly on for fifty more years.
— Valerie Solanas, *SCUM Manifesto*[9]

Solanas again, on revolution, as featured in the 'Manifesto Show':

No genuine social revolution can be accomplished by the male, as the male on top wants the status quo, and all the male on the bottom wants is to be the male on top. The male 'rebel' is a farce; this is the male's 'society', made by him to satisfy his needs. He's never satisfied, because he's not capable of being satisfied. Ultimately, what the male 'rebel' is rebelling against is being male. The male changes only when forced to do so by technology, when he has no choice, when 'society' reaches the stage where he must change or die. We're at that stage now; if women don't get their asses in gear fast, we may very well all die. [10]

Here is Solanas on screwing; that she is funny is generous.

Eaten up with guilt, shame, fears, and insecurities and obtaining, if he's lucky, a barely perceptible physical feeling, the male is, nonetheless, obsessed with screwing; he'll swim a river of snot, wade nostril-deep through a mile of vomit, if he thinks there'll be a friendly pussy awaiting him. He'll screw a woman he despises … why? Relieving physical tension isn't the answer, as masturbation suffices for that. It's not ego satisfaction: that doesn't explain screwing corpses and babies. [11]

Solanas sustains her invective for a whole book. She is talking the unspeakable, the inequality of women, the matter often greeted with boredom or disgust, the subject impossible to broach in much of the world.

Solanas declares:

A woman not only takes her identity and individuality for granted, but knows instinctively that the only wrong is to hurt others, and that the meaning of life is love. [12]

I suspect Solanas attributes every fine thing to women to mimic the way that men claim noble qualities, great achievements and all rights worth having. It is sickening to be quiet, polite and functional when legally subordinate. Solanas died a junkie prostitute in a cheap hotel, but was able to write for a while. I found her book in New York and was hoping the city would make me talk.

Here is a text by another one-time New York City resident who died in obscurity. I read

From **Arno**
1996–97
185mm Kodaclit-film Xenon projection
Dimensions variable
Project, Arno river, 'Biennale di Firenze: il Tempo e la Moda', Florence, 1996

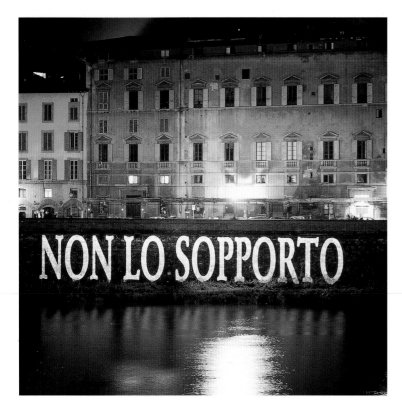
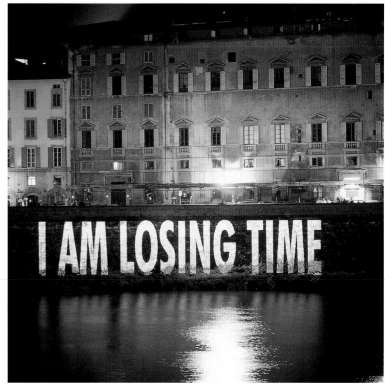

Paine for the 'Manifesto Show' and again recently.

After I got home, being alone and wanting amusement I sat down to explain to myself (for there is such a thing) my ideas of natural and civil rights and the distinction between them ...
— Thomas Paine, *Rights of Man, Common Sense, and Other Political Writings*[13]

This is the start of a letter from Paine to Thomas Jefferson. I like to be near anyone who thinks about the rights of man as soon as home alone, and I appreciate anyone who posits a self. I puzzle about how personal freedom can be preserved along with government. I am awkward and backward when discussing politics, but books let me debate in privacy.

... What strange folk they are, these artists. Politically babies, all of them.
— Josef Goebbels, from Gitta Sereny, *Albert Speer: His Battle With Truth*[14]

I read the Speer biography last year. Speer worked self-importantly and tirelessly for Hitler. Goebbels' diary entry is an all-purpose caution when architects and artists receive commissions. These projects can be challenging in the best way; the artist must engage politics or business, the politician or tycoon has to contend with the artist and all must be responsive to the community in which the work is located. That said, Goebbels reminds me that artists should be useless at times.

Abode where lost bodies roam each searching for its lost one. Vast enough for search to be in vain. Narrow enough for flight to be in vain ...

... After a pause impossible to time finds at last his place and pose whereupon dark descends and at the same instant the temperature comes to rest not far from freezing point

From **Arno**
1996–97
185mm Kodaclit-film Xenon
projection
Dimensions variable
Project, Arno River, 'Biennale di
Firenze: il Tempo e la Moda',
Florence, 1996

… suddenly such silence as to drown all the faint breathings put together. So much roughly speaking for the last state of the cylinder and of this little people of searchers one first of whom if a man in some unthinkable past for the first time bowed his head if this notion is maintained.
— Samuel Beckett, *The Lost Ones*[15]

Here is the beginning and the conclusion of *The Lost Ones*, a prospect and an end to a world. When I do not exert some effort to be cheerful, I watch for the death of everything. I like the idea of a future, so I have it in my work. The Dia installation, the Guggenheim spiral, the 3-D imagers, the virtual reality worlds and the lasers are futuristic. I try to show the future to itself so it will want to come.

The next quotation completed *Lustmord* for me.

This time my despair escaped from my control: someone other than myself was weeping in me. I talked to Sartre about my mother's mouth as I had seen it that morning and about everything I had interpreted in it – greediness refused, an almost servile humility, hope, distress, loneliness – the loneliness of her death and of her life – that did not want to admit its existence. And he told me that my own mouth was not obeying me any more: I had put maman's mouth on my own face and in spite of myself, I copied its movements. Her whole person, her whole being, was concentrated there, and compassion wrung my heart.
— Simone De Beauvoir, *A Very Easy Death*[16]

My mother, Virginia Holzer, died in 1993. Thoughts about her appeared in *Lustmord*, but I could not describe the size and import of her death. De Beauvoir explained a mother's dying to herself, to me and to any reader. My mother's death was especially difficult because she may have suffered sexual assault of which she did not speak. I was attacked by the man who may have harmed her. When De Beauvoir places her mother's mouth on her own I am overcome.

I wonder to myself about the origins of power and its abuse. In *Crowds and Power* Canetti locates it in the hand and its sharpened fingers.[17] Some irrational extension of this thinking has me make artwork I do not touch.

Canetti discusses horses. I have had horses for many reasons, including that a child 'who

From **Arno**
1996–97
Two 4-sided LED signs
390 × 30. 5 × 30.5 cm each
Installation, collaboration with
Helmut Lang, pavilion by Arata
Isozaki, 'Biennale di Firenze: il
Tempo e la Moda', Forte de
Belvedere, Florence, 1996

learns to ride so early, enjoys a freedom of a special kind. As soon as he can manage a horse he can pass on to it everything he himself is ordered to do' and 'anything which does not flee is caught and anything which is caught is torn to pieces'.[18]

Beckett's *Ill Seen Ill Said* has me think about my grandmother, Jennie Donaldson. The book is spare and lovely as she was. When I try to present what I feel about her or any subject held as closely, I am unable to write adequately. I show what I can with words in light and motion in a chosen place, and when I envelop the time needed, the space around, the noise, smells, the people looking at one another and everything before them, I have given what I know. The Florentine Xenon projections were an effort of this sort.

1 Emily Brontë, *Wuthering Heights*, Random House, New York, 1931, pp.24–25

2 William Blake, 'Introduction', *Songs of Innocence*, Oxford University Press, Oxford, 1967, n.p.

3 William Blake, 'Little Girl', *Songs of Innocence*, Oxford University Press, Oxford, 1967, n.p.

4 Friedrich Nietzsche, 'The Night Song', *Thus Spake Zarathustra*, Prometheus Books, Buffalo, New York, 1993, pp.127–29

5 Robert Looker, ed., *Rosa Luxemburg: Selected Political Writings*, Grove Press, New York, 1974, trans. William D. Graf, p.261

6 Robert Looker, ed., *Rosa Luxemburg: Selected Political Writings*, Grove Press, New York, 1974, trans. Bertram D. Wolfe, pp.244–45

7 Alix Kate Shulman, ed., *Red Emma Speaks: Selected Writings and Speeches by Emma Goldman*, Random House, New York, 1972, pp.133–34

8 Ibid., p.132

9 Valerie Solanas, 'SCUM Manifesto', AK Press, San Francisco, 1966, pp.4–5

10 Ibid., p.22

11 Ibid., pp.2–3

12 Ibid., p.20

13 Thomas Paine, *Rights of Man, Common Sense and Other Political Writings*, Oxford University Press, Oxford, 1995, p.81

14 Gitta Sereny, *Albert Speer: His Battle With Truth*, Vintage Books, New York, 1995, p.171

15 Samuel Beckett, *The Lost Ones*, Grove Press, New York, 1972, pp.7, 62–63

16 Simone de Beauvoir, *A Very Easy Death*, Pantheon, New York, 1965, pp.30-31

17 Elias Canetti, *Crowds and Power*, Continuum, New York, 1973, pp. 219

18 Ibid., p. 318

Book Report, A Response to Artist's Choice, arose in large part from the artist's conversations with Joan Simon.

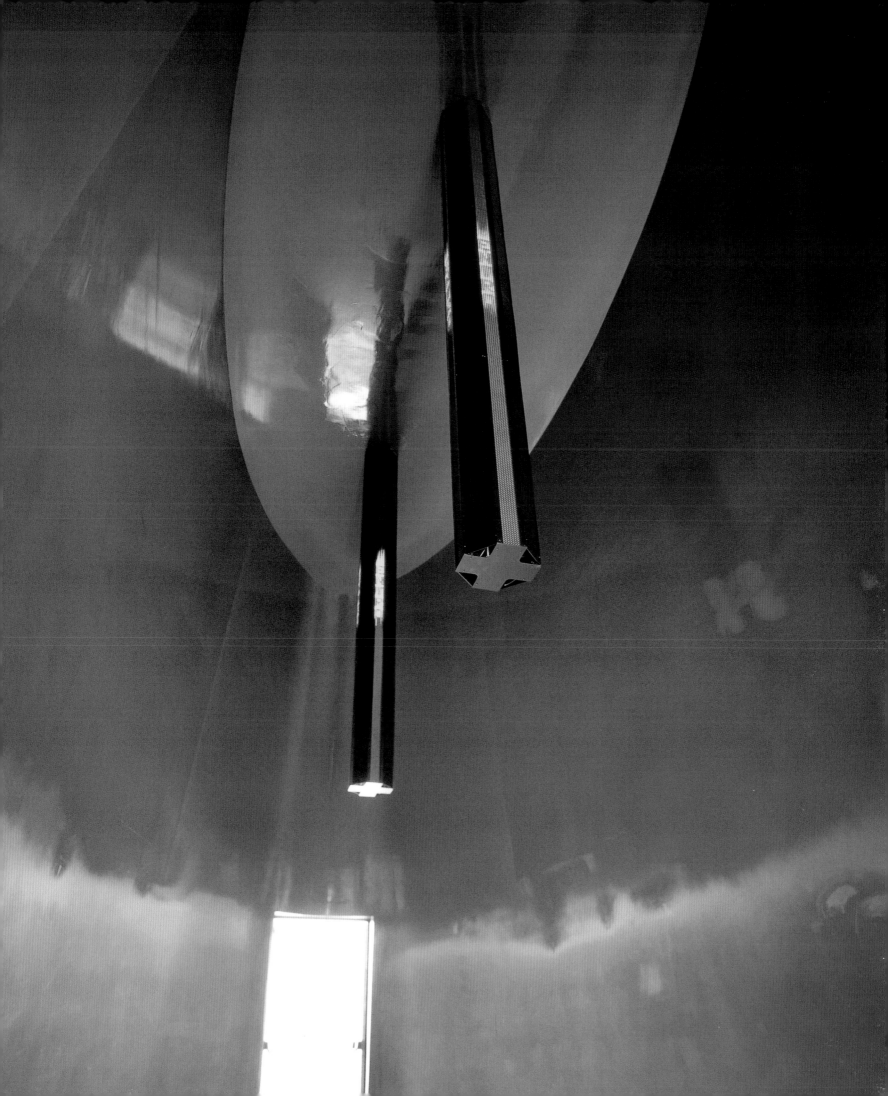

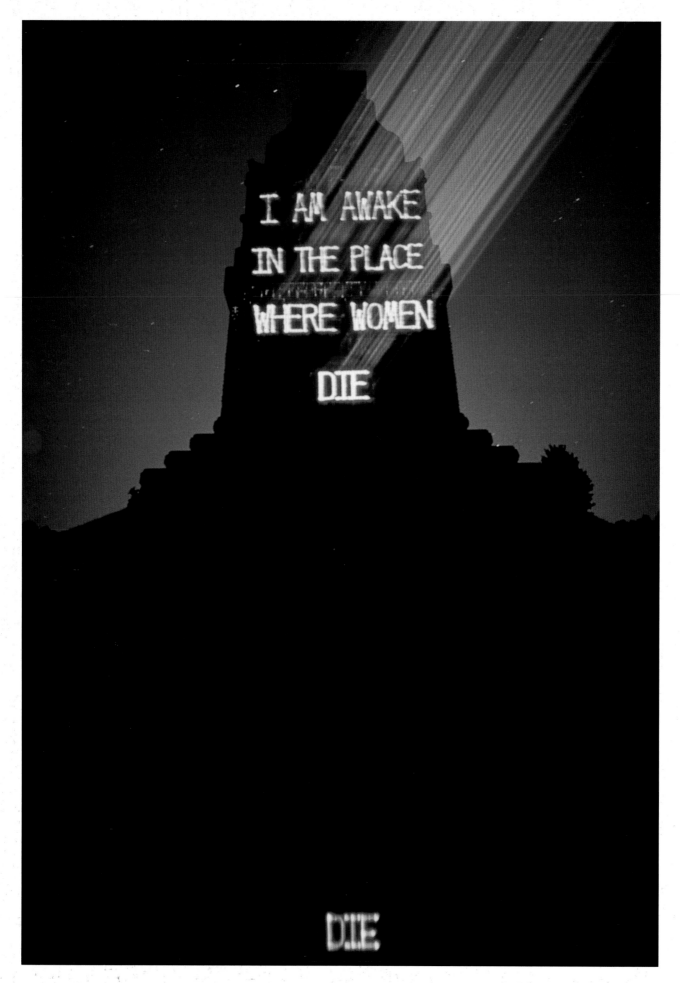

the color
of her
where she is
inside out is
enough to make
me kill her

Truisms 1977–79

From **Truisms**
1977–79
Theatre Marquees
Dimensions variable
Project, '42nd Street Art Project,'
New York, 1993–94

A LITTLE KNOWLEDGE CAN GO A LONG WAY

A LOT OF PROFESSIONALS ARE CRACKPOTS

A MAN CAN'T KNOW WHAT IT'S LIKE TO BE A MOTHER

A NAME MEANS A LOT JUST BY ITSELF

A POSITIVE ATTITUDE MAKES ALL THE DIFFERENCE IN THE WORLD

A RELAXED MAN IS NOT NECESSARILY A BETTER MAN

A SENSE OF TIMING IS THE MARK OF GENIUS

A SINCERE EFFORT IS ALL YOU CAN ASK

A SINGLE EVENT CAN HAVE INFINITELY MANY INTERPRETATIONS

A SOLID HOME BASE BUILDS A SENSE OF SELF

A STRONG SENSE OF DUTY IMPRISONS YOU

ABSOLUTE SUBMISSION CAN BE A FORM OF FREEDOM

ABSTRACTION IS A TYPE OF DECADENCE

ABUSE OF POWER COMES AS NO SURPRISE

ACTION CAUSES MORE TROUBLE THAN THOUGHT

ALIENATION PRODUCES ECCENTRICS OR REVOLUTIONARIES

ALL THINGS ARE DELICATELY INTERCONNECTED

AMBITION IS JUST AS DANGEROUS AS COMPLACENCY

AMBIVALENCE CAN RUIN YOUR LIFE

AN ELITE IS INEVITABLE

ANGER OR HATE CAN BE A USEFUL MOTIVATING FORCE

ANIMALISM IS PERFECTLY HEALTHY

ANY SURPLUS IS IMMORAL

ANYTHING IS A LEGITIMATE AREA OF INVESTIGATION

ARTIFICIAL DESIRES ARE DESPOILING THE EARTH

AT TIMES INACTIVITY IS PREFERABLE TO MINDLESS FUNCTIONING

AT TIMES YOUR UNCONSCIOUS IS TRUER THAN YOUR CONSCIOUS MIND

AUTOMATION IS DEADLY

AWFUL PUNISHMENT AWAITS REALLY BAD PEOPLE

BAD INTENTIONS CAN YIELD GOOD RESULTS

BEING ALONE WITH YOURSELF IS INCREASINGLY UNPOPULAR

BEING HAPPY IS MORE IMPORTANT THAN ANYTHING ELSE

BEING JUDGMENTAL IS A SIGN OF LIFE

BEING SURE OF YOURSELF MEANS YOU'RE A FOOL

BELIEVING IN REBIRTH IS THE SAME AS ADMITTING DEFEAT

BOREDOM MAKES YOU DO CRAZY THINGS

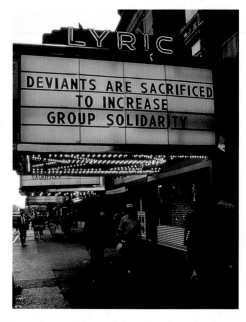

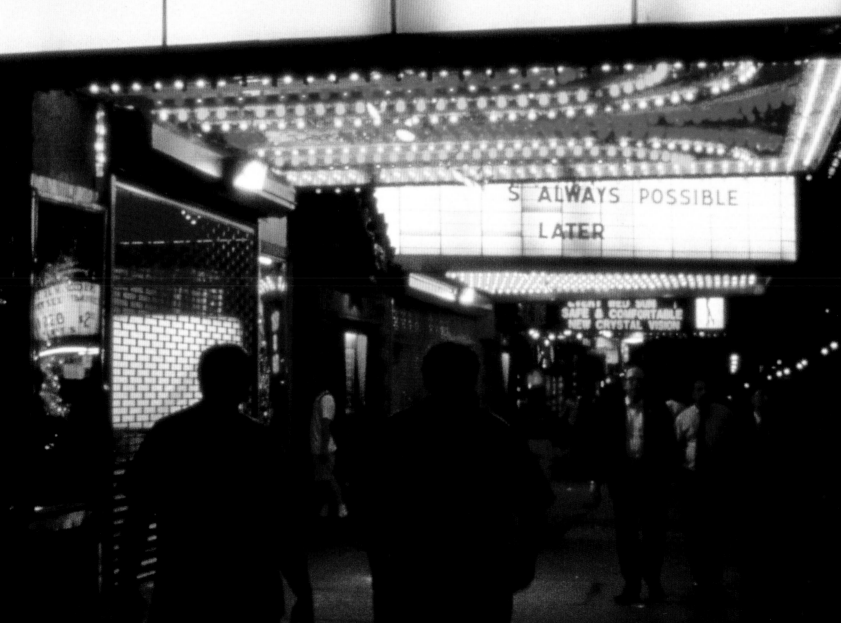

top, left, from **Truisms**
1977–79
Electronic sign
Project, Waterloo Station,
London, 1989

top, right, from **Truisms**
1977–79
TV monitors
Project, Leicester Square
Underground Station, London,
1988

below, left and right, **Truisms**
1977–79
Electronic sign
Project, Dupont Circle,
Washington, DC, 1986

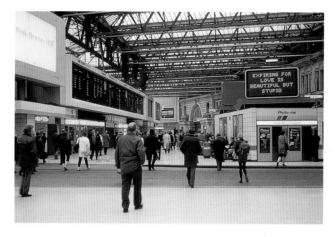

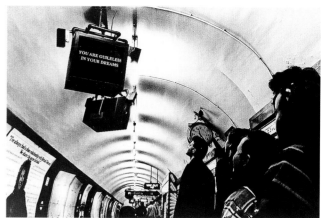

CALM IS MORE CONDUCIVE TO CREATIVITY THAN IS ANXIETY

CATEGORIZING FEAR IS CALMING

CHANGE IS VALUABLE WHEN THE OPPRESSED BECOME TYRANTS

CHASING THE NEW IS DANGEROUS TO SOCIETY

CHILDREN ARE THE HOPE OF THE FUTURE

CHILDREN ARE THE MOST CRUEL OF ALL

CLASS ACTION IS A NICE IDEA WITH NO SUBSTANCE

CLASS STRUCTURE IS AS ARTIFICIAL AS PLASTIC

CONFUSING YOURSELF IS A WAY TO STAY HONEST

CRIME AGAINST PROPERTY IS RELATIVELY UNIMPORTANT

DECADENCE CAN BE AN END IN ITSELF

DECENCY IS A RELATIVE THING

DEPENDENCE CAN BE A MEAL TICKET

DESCRIPTION IS MORE VALUABLE THAN METAPHOR

DEVIANTS ARE SACRIFICED TO INCREASE GROUP SOLIDARITY

DISGUST IS THE APPROPRIATE RESPONSE TO MOST SITUATIONS

DISORGANIZATION IS A KIND OF ANESTHESIA

DON'T PLACE TOO MUCH TRUST IN EXPERTS

DRAMA OFTEN OBSCURES THE REAL ISSUES

DREAMING WHILE AWAKE IS A FRIGHTENING CONTRADICTION

DYING AND COMING BACK GIVES YOU CONSIDERABLE PERSPECTIVE

DYING SHOULD BE AS EASY AS FALLING OFF A LOG

EATING TOO MUCH IS CRIMINAL

ELABORATION IS A FORM OF POLLUTION

EMOTIONAL RESPONSES ARE AS VALUABLE AS INTELLECTUAL RESPONSES

ENJOY YOURSELF BECAUSE YOU CAN'T CHANGE ANYTHING ANYWAY

ENSURE THAT YOUR LIFE STAYS IN FLUX

EVEN YOUR FAMILY CAN BETRAY YOU

EVERY ACHIEVEMENT REQUIRES A SACRIFICE

EVERYONE'S WORK IS EQUALLY IMPORTANT

EVERYTHING THAT'S INTERESTING IS NEW

EXCEPTIONAL PEOPLE DESERVE SPECIAL CONCESSIONS

EXPIRING FOR LOVE IS BEAUTIFUL BUT STUPID

EXPRESSING ANGER IS NECESSARY

EXTREME BEHAVIOR HAS ITS BASIS IN PATHOLOGICAL PSYCHOLOGY

EXTREME SELF-CONSCIOUSNESS LEADS TO PERVERSION

FAITHFULNESS IS A SOCIAL NOT A BIOLOGICAL LAW

FAKE OR REAL INDIFFERENCE IS A POWERFUL PERSONAL WEAPON

FATHERS OFTEN USE TOO MUCH FORCE

FEAR IS THE GREATEST INCAPACITATOR

FREEDOM IS A LUXURY NOT A NECESSITY

GIVING FREE REIN TO YOUR EMOTIONS IS AN HONEST WAY TO LIVE

GO ALL OUT IN ROMANCE AND LET THE CHIPS FALL WHERE THEY MAY

GOING WITH THE FLOW IS SOOTHING BUT RISKY

GOOD DEEDS EVENTUALLY ARE REWARDED

GOVERNMENT IS A BURDEN ON THE PEOPLE

GRASS ROOTS AGITATION IS THE ONLY HOPE

GUILT AND SELF-LACERATION ARE INDULGENCES

HABITUAL CONTEMPT DOESN'T REFLECT A FINER SENSIBILITY

HIDING YOUR EMOTIONS IS DESPICABLE

HOLDING BACK PROTECTS YOUR VITAL ENERGIES

HUMANISM IS OBSOLETE

HUMOR IS A RELEASE

IDEALS ARE REPLACED BY CONVENTIONAL GOALS AT A CERTAIN AGE

From **Truisms**
1977–79
Double-sided silver photostats
243 × 91 cm each
Project, Marine Midland Bank
lobby, New York, 1982

IF YOU AREN'T POLITICAL YOUR PERSONAL LIFE SHOULD BE EXEMPLARY

IF YOU CAN'T LEAVE YOUR MARK GIVE UP

IF YOU HAVE MANY DESIRES YOUR LIFE WILL BE INTERESTING

IF YOU LIVE SIMPLY THERE IS NOTHING TO WORRY ABOUT

IGNORING ENEMIES IS THE BEST WAY TO FIGHT

ILLNESS IS A STATE OF MIND

IMPOSING ORDER IS MAN'S VOCATION FOR CHAOS IS HELL

IN SOME INSTANCES IT'S BETTER TO DIE THAN TO CONTINUE

INHERITANCE MUST BE ABOLISHED

IT CAN BE HELPFUL TO KEEP GOING NO MATTER WHAT

IT IS HEROIC TO TRY TO STOP TIME

IT IS MAN'S FATE TO OUTSMART HIMSELF

IT'S A GIFT TO THE WORLD NOT TO HAVE BABIES

IT'S BETTER TO BE A GOOD PERSON THAN A FAMOUS PERSON

IT'S BETTER TO BE LONELY THAN TO BE WITH INFERIOR PEOPLE

IT'S BETTER TO BE NAIVE THAN JADED

IT'S BETTER TO STUDY THE LIVING FACT THAN TO ANALYZE HISTORY

IT'S CRUCIAL TO HAVE AN ACTIVE FANTASY LIFE

IT'S GOOD TO GIVE EXTRA MONEY TO CHARITY

IT'S IMPORTANT TO STAY CLEAN ON ALL LEVELS

IT'S JUST AN ACCIDENT THAT YOUR PARENTS ARE YOUR PARENTS

IT'S NOT GOOD TO HOLD TOO MANY ABSOLUTES

IT'S NOT GOOD TO OPERATE ON CREDIT

IT'S VITAL TO LIVE IN HARMONY WITH NATURE

JUST BELIEVING SOMETHING CAN MAKE IT HAPPEN

KEEP SOMETHING IN RESERVE FOR EMERGENCIES

KILLING IS UNAVOIDABLE BUT IS NOTHING TO BE PROUD OF

KNOWING YOURSELF LETS YOU UNDERSTAND OTHERS

KNOWLEDGE SHOULD BE ADVANCED AT ALL COSTS

LABOR IS A LIFE-DESTROYING ACTIVITY

LACK OF CHARISMA CAN BE FATAL

LEISURE TIME IS A GIGANTIC SMOKE SCREEN

LISTEN WHEN YOUR BODY TALKS

LOOKING BACK IS THE FIRST SIGN OF AGING AND DECAY

LOVING ANIMALS IS A SUBSTITUTE ACTIVITY

LOW EXPECTATIONS ARE GOOD PROTECTION

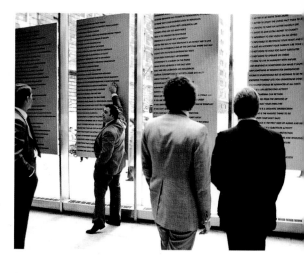

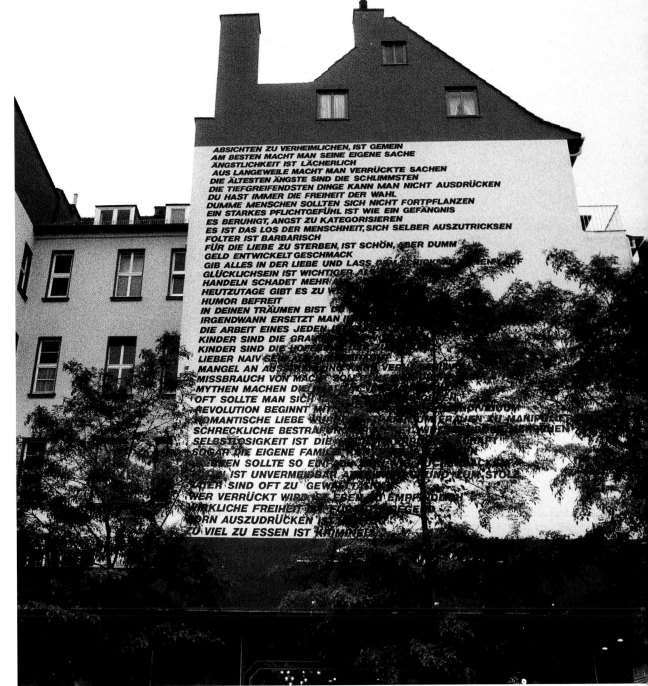

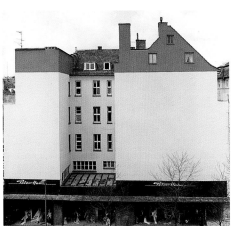

From **Truisms**
1977–79
Painted wall
Project, Haus Kranefüss,
Documenta 7, Kassel, 1982

MANUAL LABOR CAN BE REFRESHING AND WHOLESOME

MEN ARE NOT MONOGAMOUS BY NATURE

MODERATION KILLS THE SPIRIT

MONEY CREATES TASTE

MONOMANIA IS A PREREQUISITE OF SUCCESS

MORALS ARE FOR LITTLE PEOPLE

MOST PEOPLE ARE NOT FIT TO RULE THEMSELVES

MOSTLY YOU SHOULD MIND YOUR OWN BUSINESS

MOTHERS SHOULDN'T MAKE TOO MANY SACRIFICES

MUCH WAS DECIDED BEFORE YOU WERE BORN

MURDER HAS ITS SEXUAL SIDE

MYTHS CAN MAKE REALITY MORE INTELLIGIBLE

NOISE CAN BE HOSTILE

NOTHING UPSETS THE BALANCE OF GOOD AND EVIL

OCCASIONALLY PRINCIPLES ARE MORE VALUABLE THAN PEOPLE

OFFER VERY LITTLE INFORMATION ABOUT YOURSELF

OFTEN YOU SHOULD ACT LIKE YOU ARE SEXLESS

OLD FRIENDS ARE BETTER LEFT IN THE PAST

OPACITY IS AN IRRESISTIBLE CHALLENGE

PAIN CAN BE A VERY POSITIVE THING

PEOPLE ARE BORING UNLESS THEY'RE EXTREMISTS

PEOPLE ARE NUTS IF THEY THINK THEY ARE IMPORTANT

PEOPLE ARE RESPONSIBLE FOR WHAT THEY DO UNLESS THEY'RE INSANE

PEOPLE WHO DON'T WORK WITH THEIR HANDS ARE PARASITES

PEOPLE WHO GO CRAZY ARE TOO SENSITIVE

PEOPLE WON'T BEHAVE IF THEY HAVE NOTHING TO LOSE

PHYSICAL CULTURE IS SECOND BEST

PLANNING FOR THE FUTURE IS ESCAPISM

PLAYING IT SAFE CAN CAUSE A LOT OF DAMAGE IN THE LONG RUN

POLITICS IS USED FOR PERSONAL GAIN

POTENTIAL COUNTS FOR NOTHING UNTIL IT'S REALIZED

From **Truisms** and **Survival**
(detail)
14 Prairie Green granite benches
43 × 152 × 46 cm each
Permanent installation, US
Courthouse, Allentown,
Pennsylvania, 1995
Collection, US Courthouse,
Allentown, Pennsylvania

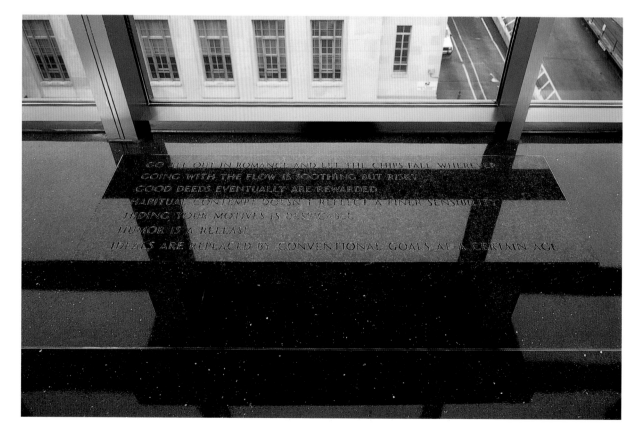

PRIVATE PROPERTY CREATED CRIME

PURSUING PLEASURE FOR THE SAKE OF PLEASURE WILL RUIN YOU

PUSH YOURSELF TO THE LIMIT AS OFTEN AS POSSIBLE

RAISE BOYS AND GIRLS THE SAME WAY

RANDOM MATING IS GOOD FOR DEBUNKING SEX MYTHS

RECHANNELING DESTRUCTIVE IMPULSES IS A SIGN OF MATURITY

RECLUSES ALWAYS GET WEAK

REDISTRIBUTING WEALTH IS IMPERATIVE

RELATIVITY IS NO BOON TO MANKIND

RELIGION CAUSES AS MANY PROBLEMS AS IT SOLVES

REMEMBER YOU ALWAYS HAVE FREEDOM OF CHOICE

REPETITION IS THE BEST WAY TO LEARN

RESOLUTIONS SERVE TO EASE YOUR CONSCIENCE

REVOLUTION BEGINS WITH CHANGES IN THE INDIVIDUAL

ROMANTIC LOVE WAS INVENTED TO MANIPULATE WOMEN

ROUTINE IS A LINK WITH THE PAST

ROUTINE SMALL EXCESSES ARE WORSE THAN THE OCCASIONAL DEBAUCH

SACRIFICING YOURSELF FOR A BAD CAUSE IS NOT A MORAL ACT

SALVATION CAN'T BE BOUGHT AND SOLD

SELF-AWARENESS CAN BE CRIPPLING

SELF-CONTEMPT CAN DO MORE HARM THAN GOOD

SELFISHNESS IS THE MOST BASIC MOTIVATION

SELFLESSNESS IS THE HIGHEST ACHIEVEMENT

SEPARATISM IS THE WAY TO A NEW BEGINNING

SEX DIFFERENCES ARE HERE TO STAY

SIN IS A MEANS OF SOCIAL CONTROL

SLIPPING INTO MADNESS IS GOOD FOR THE SAKE OF COMPARISON

SLOPPY THINKING GETS WORSE OVER TIME

SOLITUDE IS ENRICHING

SOMETIMES SCIENCE ADVANCES FASTER THAN IT SHOULD

SOMETIMES THINGS SEEM TO HAPPEN OF THEIR OWN ACCORD

SPENDING TOO MUCH TIME ON SELF-IMPROVEMENT IS ANTISOCIAL

STARVATION IS NATURE'S WAY

STASIS IS A DREAM STATE

STERILIZATION IS A WEAPON OF THE RULERS

STRONG EMOTIONAL ATTACHMENT STEMS FROM BASIC INSECURITY

From **Truisms**
1977–79
Daktronics double-sided
electronic sign
610 × 1220 cm
Project, Caesars Palace, Las
Vegas, 1986

STUPID PEOPLE SHOULDN'T BREED

SURVIVAL OF THE FITTEST APPLIES TO MEN AND ANIMALS

SYMBOLS ARE MORE MEANINGFUL THAN THINGS THEMSELVES

TAKING A STRONG STAND PUBLICIZES THE OPPOSITE POSITION

TALKING IS USED TO HIDE ONE'S INABILITY TO ACT

TEASING PEOPLE SEXUALLY CAN HAVE UGLY CONSEQUENCES

TECHNOLOGY WILL MAKE OR BREAK US

THE CRUELEST DISAPPOINTMENT IS WHEN YOU LET YOURSELF DOWN

THE DESIRE TO REPRODUCE IS A DEATH WISH

THE FAMILY IS LIVING ON BORROWED TIME

THE IDEA OF REVOLUTION IS AN ADOLESCENT FANTASY

THE IDEA OF TRANSCENDENCE IS USED TO OBSCURE OPPRESSION

THE IDIOSYNCRATIC HAS LOST ITS AUTHORITY

THE MOST PROFOUND THINGS ARE INEXPRESSIBLE

THE MUNDANE IS TO BE CHERISHED

THE NEW IS NOTHING BUT A RESTATEMENT OF THE OLD

THE ONLY WAY TO BE PURE IS TO STAY BY YOURSELF

THE SUM OF YOUR ACTIONS DETERMINES WHAT YOU ARE

THE UNATTAINABLE IS INVARIABLY ATTRACTIVE

THE WORLD OPERATES ACCORDING TO DISCOVERABLE LAWS

THERE ARE TOO FEW IMMUTABLE TRUTHS TODAY

THERE'S NOTHING EXCEPT WHAT YOU SENSE

THERE'S NOTHING REDEEMING IN TOIL

THINKING TOO MUCH CAN ONLY CAUSE PROBLEMS

THREATENING SOMEONE SEXUALLY IS A HORRIBLE ACT

TIMIDITY IS LAUGHABLE

TO DISAGREE PRESUPPOSES MORAL INTEGRITY

TO VOLUNTEER IS REACTIONARY

TORTURE IS BARBARIC

TRADING A LIFE FOR A LIFE IS FAIR ENOUGH

TRUE FREEDOM IS FRIGHTFUL

UNIQUE THINGS MUST BE THE MOST VALUABLE

UNQUESTIONING LOVE DEMONSTRATES LARGESSE OF SPIRIT

USING FORCE TO STOP FORCE IS ABSURD

VIOLENCE IS PERMISSIBLE EVEN DESIRABLE OCCASIONALLY

WAR IS A PURIFICATION RITE

WE MUST MAKE SACRIFICES TO MAINTAIN OUR QUALITY OF LIFE

WHEN SOMETHING TERRIBLE HAPPENS PEOPLE WAKE UP

WISHING THINGS AWAY IS NOT EFFECTIVE

WITH PERSEVERANCE YOU CAN DISCOVER ANY TRUTH

WORDS TEND TO BE INADEQUATE

WORRYING CAN HELP YOU PREPARE

YOU ARE A VICTIM OF THE RULES YOU LIVE BY

YOU ARE GUILELESS IN YOUR DREAMS

YOU ARE RESPONSIBLE FOR CONSTITUTING THE MEANING OF THINGS

YOU ARE THE PAST PRESENT AND FUTURE

YOU CAN LIVE ON THROUGH YOUR DESCENDANTS

YOU CAN'T EXPECT PEOPLE TO BE SOMETHING THEY'RE NOT

YOU CAN'T FOOL OTHERS IF YOU'RE FOOLING YOURSELF

YOU DON'T KNOW WHAT'S WHAT UNTIL YOU SUPPORT YOURSELF

YOU HAVE TO HURT OTHERS TO BE EXTRAORDINARY

YOU MUST BE INTIMATE WITH A TOKEN FEW

YOU MUST DISAGREE WITH AUTHORITY FIGURES

YOU MUST HAVE ONE GRAND PASSION

YOU MUST KNOW WHERE YOU STOP AND THE WORLD BEGINS

YOU ONLY CAN UNDERSTAND SOMEONE OF YOUR OWN SEX

YOU OWE THE WORLD NOT THE OTHER WAY AROUND

YOU SHOULD STUDY AS MUCH AS POSSIBLE

YOUR ACTIONS ARE POINTLESS IF NO ONE NOTICES

YOUR OLDEST FEARS ARE THE WORST ONES

A CRUEL BUT ANCIENT LAW
DEMANDS AN EYE FOR AN EYE.
MURDER MUST BE ANSWERED BY
EXECUTION. ONLY GOD HAS THE
RIGHT TO TAKE A LIFE AND
WHEN SOMEONE BREAKS THIS
LAW HE WILL BE PUNISHED. JUSTICE
MUST COME SWIFTLY. IT DOESN'T
HELP ANYONE TO STALL. THE
VICTIM'S FAMILY CRIES OUT FOR
SATISFACTION, THE COMMUNITY
BEGS FOR PROTECTION AND THE
DEPARTED CRAVES VENGEANCE SO
HE CAN REST. THE KILLER KNEW IN
ADVANCE THERE WAS NO EXCUSE
FOR HIS ACT. TRULY HE HAS
TAKEN HIS OWN LIFE. HE, NOT
SOCIETY, IS RESPONSIBLE FOR HIS
FATE. HE ALONE STANDS GUILTY
AND DAMNED.

BECAUSE THERE IS NO GOD SOMEONE
MUST TAKE RESPONSIBILITY FOR MEN.
A CHARISMATIC LEADER IS IMPERATIVE.
HE CAN SUBORDINATE THE SMALL
WILLS TO THE GREAT ONE. HIS
STRENGTH AND HIS VISION REDEEM
MEN. HIS PERFECTION MAKES THEM
GRATEFUL. LIFE ITSELF IS NOT SACRED,
THERE IS NO DIGNITY IN THE FLESH.
UNDIRECTED MEN ARE CONTENT WITH
RANDOM, SQUALID, POINTLESS LIVES.
THE LEADER GIVES DIRECTION AND
PURPOSE. THE LEADER FORCES GREAT
ACCOMPLISHMENTS, MANDATES PEACE
AND REPELS OUTSIDE AGGRESSORS.
HE IS THE ARCHITECT OF DESTINY. HE
DEMANDS ABSOLUTE LOYALTY. HE
MERITS UNQUESTIONING DEVOTION.
HE ASKS THE SUPREME SACRIFICE. HE IS
THE ONLY HOPE.

CHANGE IS THE BASIS OF ALL HISTORY,
THE PROOF OF VIGOR. THE OLD IS SOILED
AND DISGUSTING BY NATURE. STALE
FOOD IS REPELLENT, MONOGAMOUS LOVE
BREEDS CONTEMPT, SENILITY CRIPPLES
THE GOVERNMENT THAT IS TOO
POWERFUL TOO LONG. UPHEAVAL IS
DESIRABLE BECAUSE FRESH, UNTAINTED
GROUPS SEIZE OPPORTUNITY. VIOLENT
OVERTHROW IS APPROPRIATE WHEN THE
SITUATION IS INTOLERABLE. SLOW
MODIFICATION CAN BE EFFECTIVE;
MEN CHANGE BEFORE THEY NOTICE
AND RESIST. THE DECADENT AND THE
POWERFUL CHAMPION CONTINUITY.
'NOTHING ESSENTIAL CHANGES.' THAT
IS A MYTH. IT WILL BE REFUTED. THE
NECESSARY BIRTH CONVULSIONS WILL BE
TRIGGERED. ACTION WILL BRING THE
EVIDENCE TO YOUR DOORSTEP.

CHILD MOLESTATION IS ABHORRENT;
THIS DEVIATION IS UNIVERSALLY
CONDEMNED. ALL PEOPLE ARE SICKENED
AND ENRAGED BY THE ACT. IT IS TELLING
THAT PRISONERS, WHO ARE NOT KNOWN
FOR THEIR HIGH STANDARDS, OSTRACIZE
AND KILL CHILD MOLESTERS. NO PUNISHMENT
IS TOO SEVERE; CHILD MOLESTERS HAVE
ROBBED THE BABIES OF THEIR INNOCENCE,
THE MOST PRECIOUS POSSESSION OF
CHILDHOOD. MOLESTATION LEAVES
SPIRITUAL, EMOTIONAL AND PHYSICAL
WOUNDS THAT MAY NEVER HEAL. THE
FRIGHTENING ASPECT OF THE ABUSE IS
THAT MOLESTED CHILDREN OFTEN
BECOME CHILD MOLESTERS. THE AWFUL
CYCLE MUST BE STOPPED BEFORE ANY
MORE CHILDREN ARE DEFILED AND
RUINED. MOLESTERS SHOULD BE
RENDERED IMPOTENT.

From **Truisms**, **Inflammatory
Essays** and **Survival**
Offset posters
Truisms, 91.5 × 70 cm each
Inflammatory Essays, 43 × 43 cm
each
Survival, 96.5 × 68.5 cm
Installation, Centre for
Contemporary Art, Ujazdowski
Castle, Warsaw, Poland, 1993
Collections, The Museum of
Modern Art, New York; Walker Art
Center, Minneapolis

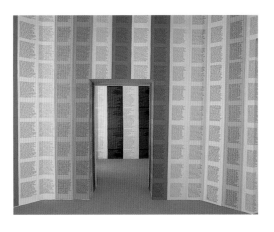

DESTROY SUPERABUNDANCE. STARVE THE
FLESH, SHAVE THE HAIR, EXPOSE THE BONE,
CLARIFY THE MIND, DEFINE THE WILL,
RESTRAIN THE SENSES, LEAVE THE FAMILY,
FLEE THE CHURCH, KILL THE VERMIN,
VOMIT THE HEART, FORGET THE DEAD.
LIMIT TIME, FORGO AMUSEMENT, DENY
NATURE, REJECT ACQUAINTANCES,
DISCARD OBJECTS, FORGET TRUTHS,
DISSECT MYTH, STOP MOTION, BLOCK
IMPULSE, CHOKE SOBS, SWALLOW CHATTER.
SCORN JOY, SCORN TOUCH, SCORN
TRAGEDY, SCORN LIBERTY, SCORN
CONSTANCY, SCORN HOPE, SCORN
EXALTATION, SCORN REPRODUCTION,
SCORN VARIETY, SCORN EMBELLISHMENT,
SCORN RELEASE, SCORN REST, SCORN
SWEETNESS, SCORN THE LIGHT. IT IS A
QUESTION OF FORM AND FUNCTION. IT IS A
MATTER OF REVULSION.

DON'T TALK DOWN TO ME.
DON'T BE POLITE TO ME. DON'T
TRY TO MAKE ME FEEL NICE.
DON'T RELAX. I'LL CUT THE
SMILE OFF YOUR FACE. YOU
THINK I DON'T KNOW WHAT'S
GOING ON. YOU THINK I'M
AFRAID TO REACT. THE JOKE'S
ON YOU. I'M BIDING MY TIME,
LOOKING FOR THE SPOT. YOU
THINK NO ONE CAN REACH
YOU, NO ONE CAN HAVE WHAT
YOU HAVE. I'VE BEEN PLANNING
WHILE YOU'RE PLAYING. I'VE
BEEN SAVING WHILE YOU'RE
SPENDING. THE GAME IS ALMOST
OVER SO IT'S TIME YOU
ACKNOWLEDGE ME. DO YOU
WANT TO FALL NOT EVER
KNOWING WHO TOOK YOU?

IT ALL HAS TO BURN, IT'S GOING
TO BLAZE. IT IS FILTHY AND CAN'T
BE SAVED. A COUPLE OF GOOD
THINGS WILL BURN WITH THE REST
BUT IT'S O.K., EVERY PIECE IS PART
OF THE UGLY WHOLE. EVERYTHING
CONSPIRES TO KEEP YOU HUNGRY
AND AFRAID FOR YOUR BABIES.
DON'T WAIT ANY LONGER.
WAITING IS WEAKNESS, WEAKNESS
IS SLAVERY. BURN DOWN THE
SYSTEM THAT HAS NO PLACE FOR
YOU, RISE TRIUMPHANT FROM THE
ASHES. FIRE PURIFIES AND
RELEASES ENERGY. FIRE GIVES
HEAT AND LIGHT. LET FIRE BE THE
CELEBRATION OF YOUR
DELIVERANCE. LET LIGHTNING
STRIKE, LET THE FLAMES DEVOUR
THE ENEMY!

PEOPLE MUST PAY FOR WHAT THEY
HOLD, FOR WHAT THEY STEAL. YOU
HAVE LIVED OFF THE FAT OF THE
LAND. NOW YOU ARE THE PIG WHO
IS READY FOR SLAUGHTER. YOU ARE
THE OLD ENEMY, THE NEW VICTIM.
WHEN YOU DO SOMETHING AWFUL
EXPECT RETRIBUTION IN KIND.
LOOK OVER YOUR SHOULDER.
SOMEONE IS FOLLOWING. THE POOR
YOU HAVE ROBBED AND IGNORED
ARE IMPATIENT. PLEAD INNOCENT;
YOUR SQUEALS INVITE TORTURE.
PROMISE TO BE GOOD; YOUR LIES
EXCITE AND INFLAME. YOU ARE
TOO DEPRAVED TO REFORM, TOO
TREACHEROUS TO SPARE, TOO
HIDEOUS FOR MERCY. RUN! JUMP!
HIDE! PROVIDE SPORT FOR THE
HUNTERS.

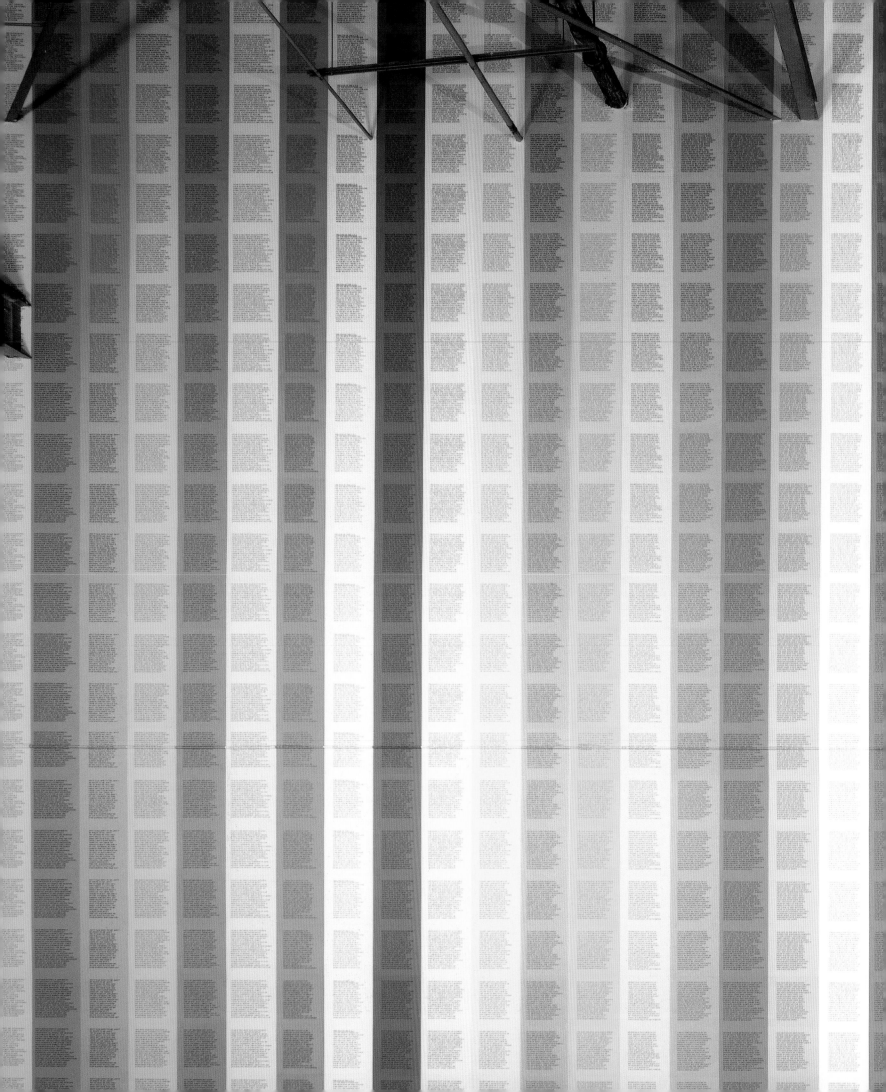

opposite, from **Inflammatory**
Essays
1979–82
Offset posters
43 × 43 cm each
Installation, Museum of
Contemporary Art, Los Angeles,
1989

below, from **Inflammatory Essays**
1979–82
Offset posters
43 × 43 cm each
Installation, Fundació Caixa de
Pensions, Barcelona, Spain, 1990
Collections, The Museum of
Modern Art, New York; Walker Art
Center, Minneapolis

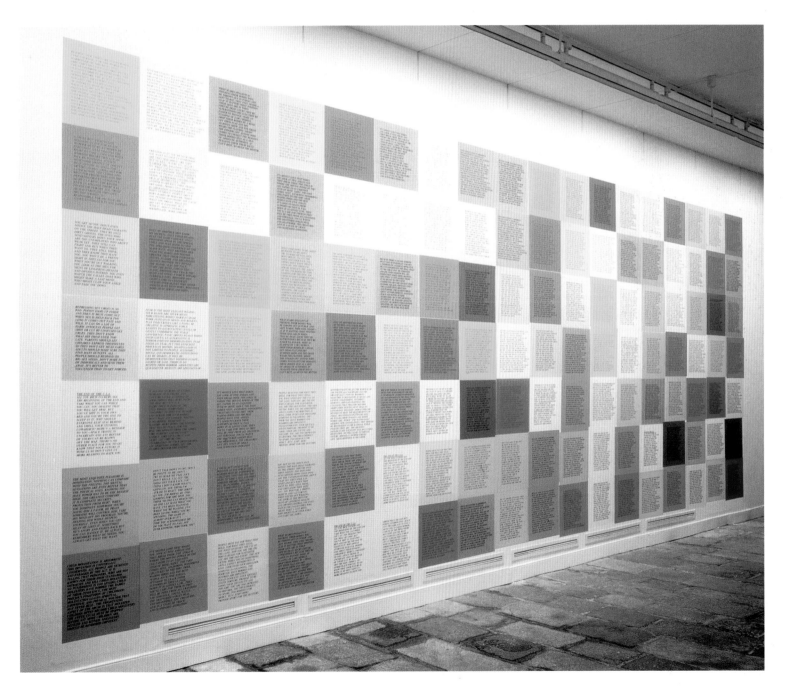

right and far right, from **Truisms**
and **Inflammatory Essays**
Offset posters
Truisms, 91.5 × 61 cm each
Inflammatory Essays, 43 × 43 cm
each
Project, Seattle, Washington,
1984

opposite, from **Inflammatory**
Essays
1979–82
Offset poster
43 × 43 cm

SENTIMENTALITY DELAYS THE REMOVAL OF
THE POLITICALLY BACKWARD AND THE
ORGANICALLY UNSOUND. RIGOROUS
SELECTION IS MANDATORY IN SOCIAL AND
GENETIC ENGINEERING. INCORRECT
MERCIFUL IMPULSES POSTPONE THE
CLEANSING THAT PRECEDES REFORM. SHORT-
TERM NICETIES MUST YIELD TO LONG-RANGE
NECESSITY. MORALS WILL BE REVISED TO
MEET THE REQUIREMENTS OF TODAY.
MEANINGLESS PLATITUDES WILL BE PULLED
FROM TONGUES AND MINDS. WORDS LIKE
"PURGE" AND "EUTHANASIA" DESERVE NEW
CONNOTATIONS. THEY SHOULD BE
RECOGNIZED AS THE RATIONAL PUBLIC
POLICIES THEY ARE. THE GREATEST DANGER
IS NOT EXCESSIVE ZEAL BUT UNDUE
HESITATION. WE WILL LEARN TO IMITATE
NATURE. HER KILLS NOURISH STRONG LIFE.
SQUEAMISHNESS IS THE CRIME.

SHRIEK WHEN THE PAIN HITS
DURING INTERROGATION. REACH
INTO THE DARK AGES TO FIND A
SOUND THAT IS LIQUID HORROR, A
SOUND OF THE BRINK WHERE MAN
STOPS AND THE BEAST AND
NAMELESS CRUEL FORCES BEGIN.
SCREAM WHEN YOUR LIFE IS
THREATENED. FORM A NOISE SO
TRUE THAT YOUR TORMENTOR
RECOGNIZES IT AS A VOICE THAT
LIVES IN HIS OWN THROAT. THE
TRUE SOUND TELLS HIM THAT HE
CUTS HIS FLESH WHEN HE CUTS
YOURS, THAT HE CANNOT THRIVE
AFTER HE TORTURES YOU. SCREAM
THAT HE DESTROYS ALL THE
KINDNESS IN YOU AND BLACKENS
EVERY VISION YOU COULD HAVE
SHOWN HIM.

YOU GET AMAZING SENSATIONS FROM
GUNS. YOU GET RESULTS FROM GUNS.
MAN IS AN AGGRESSIVE ANIMAL; YOU
HAVE TO HAVE A GOOD OFFENSE AND
A GOOD DEFENSE. TOO MANY
CITIZENS THINK THEY ARE HELPLESS.
THEY LEAVE EVERYTHING TO THE
AUTHORITIES AND THIS CAUSES
CORRUPTION. RESPONSIBILITY SHOULD
GO BACK WHERE IT BELONGS. IT IS
YOUR LIFE SO TAKE CONTROL AND
FEEL VITAL. THERE MAY BE SOME
ACCIDENTS ALONG THE PATH TO
SELF-EXPRESSION AND SELF-
DETERMINATION. SOME HARMLESS
PEOPLE WILL BE HURT. HOWEVER,
G-U-N SPELLS PRIDE TO THE STRONG,
SAFETY TO THE WEAK AND HOPE TO
THE HOPELESS. GUNS MAKE WRONG
RIGHT FAST.

YOU GET SO YOU DON'T EVEN
NOTICE THE HALF-DEAD
VAGRANTS ON THE STREET.
THEY'RE ONLY DIRTY GHOSTS.
THE ONES WHO SEND SHIVERS
DOWN YOUR SPINE ARE THE
UNEMPLOYED WHO AREN'T WEAK
YET. THEY STILL CAN FIGHT AND
RUN WHEN THEY WANT TO. THEY
STILL THINK, AND THEY KNOW
THEY HATE YOU. YOU WON'T BE
A PRETTY SIGHT IF THEY GO FOR
YOU. WHEN YOU'RE OUT
WALKING YOU LOOK AT THE MEN
FOR SIGNS OF LINGERING HEALTH
AND OBVIOUS HATRED. YOU
EVEN WATCH THE FALLEN ONES
WHO MIGHT MAKE A LAST MOVE,
WHO MIGHT CLAW YOUR ANKLE
AND TAKE YOU DOWN.

REJOICE! OUR TIMES ARE INTOLERABLE.
TAKE COURAGE FOR THE WORST IS A
HARBINGER OF THE BEST. ONLY
DIRE CIRCUMSTANCE CAN PRECIPITATE
THE OVERTHROW OF OPPRESSORS. THE
OLD AND CORRUPT MUST BE LAID TO
WASTE BEFORE THE JUST CAN TRIUMPH.
OPPOSITION IDENTIFIES AND
ISOLATES THE ENEMY. CONFLICT
OF INTEREST MUST BE SEEN FOR
WHAT IT IS. DO NOT SUPPORT
PALLIATIVE GESTURES; THEY CONFUSE
THE PEOPLE AND DELAY THE INEVITABLE
CONFRONTATION. DELAY IS NOT
TOLERATED FOR IT JEOPARDIZES THE
WELL-BEING OF THE MAJORITY.
CONTRADICTION WILL BE HEIGHTENED.
THE RECKONING WILL BE HASTENED
BY THE STAGING OF SEED DISTURBANCES.
THE APOCALYPSE WILL BLOSSOM.

Living (extract) 1980–82

AFFLUENT COLLEGE-BOUND STUDENTS FACE THE REAL PROSPECT OF
DOWNWARD MOBILITY. FEELINGS OF ENTITLEMENT CLASH WITH THE
AWARENESS OF IMMINENT SCARCITY. THERE IS RESENTMENT AT
GROWING UP AT THE END OF AN ERA OF PLENTY COUPLED WITH
REASSESSMENT OF CONVENTIONAL MEASURES OF SUCCESS.

AFTER DARK IT'S A RELIEF TO SEE A GIRL WALKING TOWARD OR
BEHIND YOU. THEN YOU'RE MUCH LESS LIKELY TO BE ASSAULTED.

EXERCISE BREAKS AT STRATEGIC POINTS DURING THE DAY ENHANCE
PRODUCTIVITY AND PROVIDE SIMULTANEOUS SENSATIONS OF RELIEF
AND REJUVENATION.

GIFTED CHILDREN, THOSE WITH AN IQ OF 125 OR ABOVE, ARE PRONE
TO FEELINGS OF ALIENATION, FRUSTRATION, AND BOREDOM. THESE
FEELINGS CAN CULMINATE IN VIOLENCE IF THE CHILDREN ARE NOT
ENCOURAGED AND CHALLENGED.

HOW DO YOU RESIGN YOURSELF TO SOMETHING THAT WILL NEVER BE?
YOU STOP WANTING THAT THING, YOU GO NUMB, OR YOU KILL
THE AGENT OF DESIRE.

IF YOU WISH TO LIVE ANONYMOUSLY, SUCCESS IS CONTINGENT ON
FORGOING THE MANY BENEFITS ATTACHED TO IDENTIFICATION, AND
YOU MUST NEVER BE SCRUTINIZED OR CAPTURED.

IN A PARADISAIC CLIMATE EVERYTHING IS CLEAR AND SIMPLE WHEN
YOU ARE PERFORMING BASIC ACTS NECESSARY FOR SURVIVAL.

IT CAN BE HELPFUL TO THINK OF THEM EATING THEIR FAVORITE FOODS
AND OCCASIONALLY THROWING UP AND GETTING BITS STUCK IN
THEIR NOSES.

IT'S AN ODD FEELING WHEN YOU TRIGGER INSTINCTIVE BEHAVIOR,
LIKE NURSING, IN SOMEONE. IT'S FUNNY TO BE IN HIS PRESENCE
WHILE A DIFFERENT PART OF THE NERVOUS SYSTEM TAKES OVER AND
HIS EYES GET STRANGE.

From **Living**
1980–82
Hand-painted enamel on metal
53.5 × 58.5 cm each
Installation, Cheim & Read, New
York, 1997
Collections, Museum of
Contemporary Art, Chicago;
Australian National Gallery,
Canberra

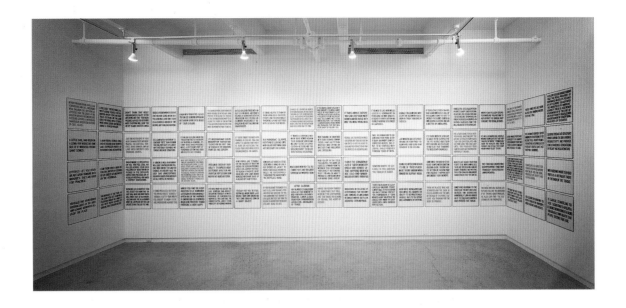

MORE THAN ONCE I'VE AWAKENED WITH TEARS RUNNING DOWN MY
CHEEKS. I HAVE TO THINK WHETHER I WAS CRYING OR WHETHER
IT IS INVOLUNTARY, LIKE DROOLING.

SOMETIMES YOU HAVE NO OTHER CHOICE BUT TO WATCH SOMETHING
GRUESOME OCCUR. YOU DON'T HAVE THE OPTION OF CLOSING YOUR
EYES BECAUSE IT HAPPENS FAST AND ENTERS YOUR MEMORY.

THE MOUTH IS INTERESTING BECAUSE IT'S ONE OF THOSE PLACES
WHERE THE DRY OUTSIDE MOVES TOWARD THE SLIPPERY INSIDE.

THE RICH KNIFING VICTIM CAN FLIP AND FEEL LIKE THE AGGRESSOR
IF HE THINKS ABOUT PRIVILEGE. HE ALSO CAN FIND THE CUT
SYMBOLIC OR PROPHETIC.

THE SMALLEST THING CAN MAKE SOMEBODY SEXUALLY UNAPPEALING.
A MISPLACED MOLE OR A PARTICULAR HAIR PATTERN CAN DO IT.
THERE'S NO REASON FOR THIS BUT IT'S JUST AS WELL.

THERE IS A PERIOD WHEN IT IS CLEAR THAT YOU HAVE GONE WRONG
BUT YOU CONTINUE. SOMETIMES THERE IS A LUXURIOUS AMOUNT OF
TIME BEFORE ANYTHING BAD HAPPENS.

THERE'S NO REASON TO SLEEP CURLED AND BENT. IT'S NOT
COMFORTABLE, IT'S NOT GOOD FOR YOU, AND IT DOESN'T PROTECT
YOU FROM DANGER. IF YOU'RE WORRIED ABOUT AN ATTACK YOU
SHOULD STAY AWAKE OR SLEEP LIGHTLY WITH LIMBS UNFURLED FOR
ACTION.

YOU CAN WATCH PEOPLE ALIGN THEMSELVES WHEN TROUBLE IS IN THE
AIR. SOME PREFER TO BE CLOSE TO THOSE AT THE TOP AND OTHERS
WANT TO BE CLOSE TO THOSE NEAR THE BOTTOM. IT'S A QUESTION OF
WHO FRIGHTENS THEM MORE AND WHOM THEY WANT TO BE LIKE.

IF YOU WERE A GOOD CHILD WITH FAIR PARENTS, YOU WOULD ALWAYS FREEZE IN YOUR TRACKS, GO LIMP AND TAKE A DESERVED BEATING. A HOLDOVER FROM THIS MIGHT HAVE YOU SUBMITTING TO REAL DANGER, BELIEVING THAT SOMEONE IS APPORTIONING PUNISHMENT AND THINKING THAT THEY WILL STOP SHORT OF KILLING YOU.

IT TAKES AWHILE BEFORE YOU CAN STEP OVER INERT BODIES AND GO AHEAD WITH WHAT YOU WERE TRYING TO DO.

IF YOU WISH TO LIVE ANONYMOUSLY, SUCCESS IS CONTINGENT ON FOREGOING THE MANY BENEFITS ATTACHED TO IDENTIFICATION. AND, YOU MUST NEVER BE SCRUTINIZED OR CAPTURED.

USUALLY YOU COME OUT WITH STUFF ON YOU WHEN YOU'VE BEEN IN THEIR THOUGHTS OR BODIES.

IF YOUR CLOTHES CATCH ON FIRE, DROP DOWN IMMEDIATELY, ROLL UP IN A BLANKET, COAT OR RUG TO SMOTHER THE FLAMES. REMOVE ALL SMOLDERING CLOTHING AND CALL A DOCTOR OR AMBULANCE.

HANDS-ON SOCIALIZATION PROMOTES HAPPY INTERPERSONAL RELATIONS. THE DESIRE FOR AND THE DEPENDENCE UPON FONDLING ENSURE REPEATED ATTEMPTS TO OBTAIN CARESSES AND THE WILLINGNESS TO RECIPROCATE.

WHEN YOUR FLESH STOPS RESEMBLING YOU, IT'S TIME TO ACT BEFORE THE UNREAL PART CONSUMES THE REGULAR PART.

THE SMALLEST THING CAN MAKE SOMEBODY SEXUALLY UNAPPEALING. A MISPLACED MOLE OR A PARTICULAR HAIR PATTERN CAN DO IT. THERE'S NO REASON FOR THIS BUT IT'S JUST AS WELL.

YOU'RE HOME FREE AS SOON AS NO ONE KNOWS WHERE TO FIND YOU.

AFFLUENT COLLEGE-BOUND STUDENTS FACE THE REAL PROSPECT OF DOWNWARD MOBILITY. FEELINGS OF ENTITLEMENT CLASH WITH THE AWARENESS OF IMMINENT SCARCITY. THERE IS RESENTMENT AT GROWING UP AT THE END OF AN ERA OF PLENTY COUPLED WITH REASSESSMENT OF CONVENTIONAL MEASURES OF SUCCESS.

MORE THAN ONCE I'VE AWAKENED WITH TEARS RUNNING DOWN MY CHEEKS. I HAVE HAD TO THINK WHETHER I WAS CRYING OR WHETHER IT WAS INVOLUNTARY, LIKE DROOLING.

PEOPLE LIKE TO BREED ANIMALS, DEVELOPING AND THEN REPLICATING NEW TRAITS IS VERY PLEASING. THE FEAR AND THE ATTRACTION IS THAT THE PROCESS IS UNCONTROLLABLE.

ONCE YOU KNOW HOW TO DO SOMETHING YOU'RE PRONE TO TRY IT AGAIN. AN UNHAPPY EXAMPLE IS COMPULSIVE MURDER. THIS IS NOT TO BE CONFUSED WITH USEFUL SKILLS ACQUIRED THROUGH YEARS OF WORK.

JUST WHEN THE BUG GETS READY TO LAND ON YOUR FACE YOU BLOW HARD AND SEND HIM STRAIGHT TO THE CEILING.

IT'S SCARY WHEN THE VEINS ARE SO CLOSE TO THE SURFACE THAT THEY'RE VISIBLE AND EVEN PROTUBERANT. ACCESS IS EASY TO THE FLUID THAT TRANSPORTS THE NECESSARY CHEMICALS.

IT'S A SAFE GAME TO PLAY WITH YOUR NOSE. SHUTTING OFF THE AIR AND LETTING IT FLOW AGAIN. THEN YOU CAN ESCALATE AND SEE HOW LONG YOU CAN LAST UNTIL YOU PASS OUT. YOUR HAND RELAXES AND YOU BREATHE NORMALLY AGAIN.

IT'S NO FUN WATCHING PEOPLE WOUND THEMSELVES SO THAT THEY CAN HOLE UP. NURSE THEMSELVES BACK TO HEALTH AND THEN REPEAT THE CYCLE. THEY DON'T KNOW WHAT ELSE TO DO.

GOING WHERE YOU'RE NOT SUPPOSED TO IS ALWAYS ENTERTAINING BUT SOMETIMES YOU'RE STUCK WITH SOMEBODY WHO REFUSES TO COME.

YOU CAN MAKE YOURSELF ENTER SOMEWHERE FRIGHTENING IF YOU BELIEVE YOU'LL PROFIT FROM IT. THE NATURAL RESPONSE IS TO FLEE BUT PEOPLE DON'T ACT THAT WAY ANYMORE.

EXERCISE BREAKS AT STRATEGIC POINTS DURING THE DAY ENHANCE PRODUCTIVITY AND PROVIDE SIMULTANEOUS SENSATIONS OF RELIEF AND REJUVENATION.

WHEN YOU SIT IN THE COLD, YOU CAN FEEL THE WARM AIR SQUEEZED UPWARD FROM THE MOTION OF YOUR CHEST AGAINST YOUR SHIRT. IF YOU CONTINUE TO SIT, YOU WILL BE ABLE TO PRODUCE A LIMITED AMOUNT OF HEAT BEFORE YOU'RE USED UP.

THERE'S THE SENSATION OF A LOT OF FLESH WHEN EVERY SINGLE HAIR STANDS UP. THIS HAPPENS WHEN YOU ARE COLD AND NAKED, AROUSED, OR SIMPLY TERRIFIED.

SOMEONE WANTS TO CUT A HOLE IN YOU AND FUCK YOU THROUGH IT, BUDDY.

THE MOUTH IS INTERESTING BECAUSE IT'S ONE OF THOSE PLACES WHERE THE DRY OUTSIDE MOVES TOWARD THE SLIPPERY INSIDE.

SOMETIMES YOU HAVE NO OTHER CHOICE THAN TO WATCH SOMETHING GRUESOME OCCUR. YOU DON'T HAVE THE OPTION OF CLOSING YOUR EYES BECAUSE IT HAPPENS FAST AND ENTERS YOUR MEMORY.

WHEN YOU GET OLDER, YOUR SKIN STARTS TO BE MORE COMPLICATED. THERE ARE PROTRUSIONS, HANGING SHAPES, SHADINGS, AND PATTERNS. THEN YOU CONSIDER ANALOGOUS CHANGES INSIDE THAT YOU CAN'T SEE.

THE FOND OLD COUPLE WAS DISAPPEARING TOGETHER THROUGH SUCCESSIVE AMPUTATIONS.

YOU HAVE TO MAKE THOUSANDS OF PRECISE AND RAPID MOVEMENTS TO PREPARE A MEAL. CHOPPING, STIRRING, AND TURNING PREDOMINATE. AFTERWARDS, YOU STACK AND MAKE CIRCULAR CLEANING AND RINSING MOTIONS. SOME PEOPLE NEVER COOK BECAUSE THEY DON'T LIKE IT. SOME NEVER COOK BECAUSE THEY HAVE NOTHING TO EAT. FOR SOME, COOKING IS A ROUTINE. FOR OTHERS, AN ART.

TUNNELING IS GOOD FOR TRANSPORTATION, CLANDESTINE MOVEMENT, AND THE DUAL PROSPECT OF SAFETY AND SUFFOCATION.

WITH BLEEDING INSIDE THE HEAD THERE IS A METALLIC TASTE AT THE BACK OF THE THROAT.

HOW DO YOU RESIGN YOURSELF TO SOMETHING THAT WILL NEVER BE? YOU STOP WANTING JUST THAT THING, YOU GO NUMB, OR YOU KILL THE AGENT OF DESIRE.

WHEN YOU'RE ON THE VERGE OF DETERMINING THAT YOU DON'T LIKE SOMEONE, IT'S AWFUL WHEN HE SMILES AND HIS TEETH LOOK ABSOLUTELY EVEN AND FALSE.

THERE'S NO REASON TO SLEEP CURLED UP AND BENT. IT'S NOT COMFORTABLE, IT'S NOT GOOD FOR YOU AND IT DOESN'T PROTECT YOU FROM DANGER. IF YOU'RE WORRIED ABOUT AN ATTACK YOU SHOULD STAY AWAKE OR SLEEP LIGHTLY WITH LIMBS UNFURLED FOR ACTION.

WHEN YOU'VE BEEN SOMEPLACE FOR A WHILE YOU ACQUIRE THE ABILITY TO BE PRACTICALLY INVISIBLE. THIS LETS YOU OPERATE WITH A MINIMUM OF INTERFERENCE.

THERE ARE PLACES THAT ARE SCARRED AND THE SKIN IS PULLED AROUND, LIKE THE NAVEL OR THE HEAD OF THE PENIS, THAT LEAVE YOU THINKING THAT THE BODY IS FRAGILE.

SOMETHING HAPPENS TO THE VOICES OF PEOPLE WHO LIVE OUTSIDE. THE SOUNDS ARE UNNATURALLY LOW AND HOARSE AS IF THE COLD AND DAMPNESS HAVE ENTERED THE THROAT.

THE RICH KNIFING VICTIM CAN FLIP AND FEEL LIKE THE AGGRESSOR IF HE THINKS ABOUT PRIVILEGE. HE ALSO CAN FIND THE CUT SYMBOLIC OR PROPHETIC.

YOUR BODY REFUSES TO OBEY WHEN YOU'RE VERY SICK. THE WORST IS WHEN YOU'RE ALERT BUT INCAPABLE OF WILLING YOURSELF ERECT.

YOU LEARN THE HARD WAY TO KEEP A FINGER ON YOUR NIPPLE WHEN SHAVING YOUR BREAST.

IT CAN BE STARTLING TO SEE SOMEONE'S BREATH, LET ALONE THE BREATHING OF A CROWD. YOU USUALLY DON'T BELIEVE THAT PEOPLE EXTEND THAT FAR.

YOU SHOULD LIMIT THE NUMBER OF TIMES YOU ACT AGAINST YOUR NATURE, LIKE SLEEPING WITH PEOPLE YOU HATE. IT'S INTERESTING TO TEST YOUR CAPABILITIES FOR A WHILE BUT TOO MUCH WILL CAUSE DAMAGE.

YOU HAVE TO MAKE THOUSANDS OF PRECISE AND RAPID MOVEMENTS TO PREPARE A MEAL. CHOPPING, STIRRING, AND TURNING PREDOMINATE. AFTERWARDS, YOU STACK AND MAKE CIRCULAR CLEANING AND RINSING MOTIONS. SOME PEOPLE NEVER COOK BECAUSE THEY DON'T LIKE IT, SOME NEVER COOK BECAUSE THEY HAVE NOTHING TO EAT. FOR SOME, COOKING IS A ROUTINE, FOR OTHERS, AN ART.

WHAT A SHOCK WHEN THEY TELL YOU IT WON'T HURT AND YOU ALMOST TURN INSIDE OUT WHEN THEY BEGIN.

WHEN YOU'RE ON THE VERGE OF DETERMINING THAT YOU DON'T LIKE SOMEONE IT'S AWFUL WHEN HE SMILES AND HIS TEETH LOOK ABSOLUTELY EVEN AND FALSE.

WITH BLEEDING INSIDE THE HEAD THERE IS A METALLIC TASTE AT THE BACK OF THE THROAT.

opposite, from **Living**
1980–82
Hand-painted enamel on metal
53.5 × 58.5 cm each
Installation, Cheim & Read, New
York, 1997

right, from **Living**
1980–82
Hand-painted enamel on metal
53.5 × 58.5 cm each
Collections, Museum of
Contemporary Art, Chicago;
Australian National Gallery,
Canberra

SOME DAYS YOU WAKE AND IMMEDIATELY START TO WORRY. NOTHING IN PARTICULAR IS WRONG, IT'S JUST THE SUSPICION THAT FORCES ARE ALIGNING QUIETLY AND THERE WILL BE TROUBLE.

TUNNELING IS GOOD FOR TRANSPORTATION, CLANDESTINE MOVEMENT, AND THE DUAL PROSPECT OF SAFETY AND SUFFOCATION.

LITTLE QUEENIE
ANY NUMBER OF ADOLESCENT GIRLS LIE FACE DOWN ON THE BED AND WORK ON ENERGY, HOUSING, LABOR, JUSTICE, EDUCATION, TRANSPORTATION, AGRICULTURE, AND BALANCE OF TRADE.

IT'S NO FUN WATCHING PEOPLE WOUND THEMSELVES SO THAT THEY CAN HOLE UP, NURSE THEMSELVES BACK TO HEALTH AND THEN REPEAT THE CYCLE. THEY DON'T KNOW WHAT ELSE TO DO.

IT'S EASY FOR YOU TO FEEL BETRAYED WHEN YOU'RE JUST WAVING YOUR ARMS AROUND AND THEY COME CRASHING DOWN ON A SHARP OBJECT.

IT TAKES AWHILE BEFORE YOU CAN STEP OVER INERT BODIES AND GO AHEAD WITH WHAT YOU WERE TRYING TO DO.

IF YOUR CLOTHES CATCH ON FIRE, DROP DOWN IMMEDIATELY, ROLL UP IN A BLANKET, COAT OR RUG TO SMOTHER THE FLAMES, REMOVE ALL SMOLDERING CLOTHING AND CALL A DOCTOR OR AMBULANCE.

HAVING TWO OR THREE PEOPLE IN LOVE WITH YOU IS LIKE MONEY IN THE BANK.

CRACK THE PELVIS SO SHE LIES RIGHT. THIS IS A MISTAKE. WHEN SHE DIES YOU CANNOT REPEAT THE ACT. THE BONES WILL NOT GROW TOGETHER AGAIN AND THE PERSONALITY WILL NOT COME BACK. SHE IS GOING TO SINK DEEP INTO THE MOSS TO GET WHITE AND LIGHTER. SHE IS UNRESPONSIVE TO BEGGING AND SELF-ABSORBED.

AN OPPOSITION MAN IS CHASED THROUGH HIS TOWN AND SHOT IN A SMELLING TRAP. PEOPLE COME TO POKE LIVE FINGERS THROUGH THE HOLES IN HIM. THEY LOOK AT THEIR FINGERS TO DIVINE WHETHER THEY WILL BE SHOT. THEY SHRINK AND SWELL AND RUN TO HUNT THE PRESIDENT OF THE NATION WHO IS THE TRAPPER.

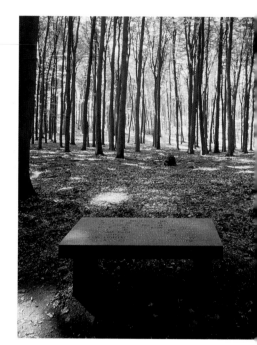

LIGHT GOES THROUGH BRANCHES TO SHOW TWO CHILDREN BORN AT ONCE WHO MIGHT LIVE. THE MOTHER RAN FROM EVERY HAZARD UNTIL THE BABIES EASED ONTO THE LEAVES. WITH BOTH HANDS SHE BRINGS THEM TO HER MOUTH, CALLING THEM TWICE THE USUAL ANSWER TO MORTAL QUESTIONS. SHE IS DELIGHTFUL AND MILKY SO THEY WILL WANT TO GROW.

BLOOD GOES IN THE TUBE BECAUSE YOU WANT TO FUCK. PUMPING DOES NOT MURDER BUT FEELS LIKE IT. YOU LOSE YOUR WORRYING MIND. YOU WANT TO DIE AND KILL AND WAKE LIKE SILK TO DO IT AGAIN.

PEOPLE GO TO THE RIVER WHERE IT IS LUSH AND MUDDY TO SHOOT CAPTIVES, TO FLOAT OR SINK THEM. SHOTS KILL MEN WHO ALWAYS WANT. SOMEONE IMAGINED OR SAW THEM LEAPING TO SAVAGE THE GOVERNMENT. NOW BODIES DIVE AND GLIDE IN THE WATER, SCARING FRIENDS OR MAKING THEM FURIOUS.

YOU SPIT ON THEM BECAUSE THE TASTE LEFT ON YOUR TEETH EXCITES. YOU SHOWED HOPE ALL OVER YOUR FACE FOR YEARS AND THEN KILLED THEM IN THE INTEREST OF TIME.

opposite, from **Under a Rock**
(detail)
1986
Misty Black granite benches
44 × 122 × 53 cm each
Installation, Sonsbeek '86,
Arnhem, The Netherlands

right, from **Under a Rock** (detail)
1986
10 Misty Black granite benches, 3
LED signs
44 × 122 × 53 cm each
Installation, Barbara Gladstone
Gallery, New York
Collections, Art Gallery of Ontario,
Toronto; The Museum of Modern
Art, New York

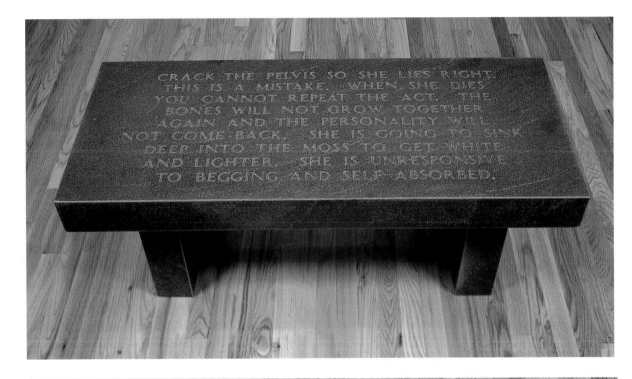

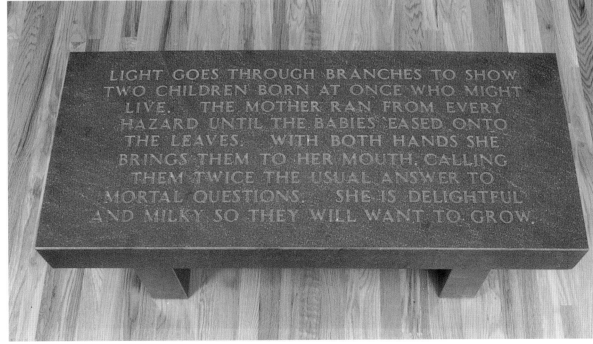

Mother and Child 1990

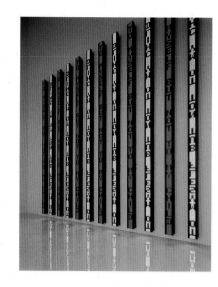

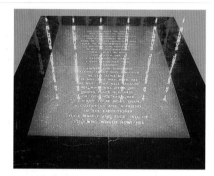

I AM INDIFFERENT TO MYSELF BUT NOT TO MY CHILD. I ALWAYS JUSTIFIED MY INACTIVITY AND CARELESSNESS IN THE FACE OF DANGER BECAUSE I WAS SURE TO BE SOMEONE'S VICTIM. I GRINNED AND LOITERED IN GUILTY ANTICIPATION. NOW I MUST BE HERE TO WATCH HER. I EXPERIMENT TO SEE IF I CAN STAND HER PAIN. I CANNOT. I AM SLY AND DISHONEST TALKING ABOUT WHY I SHOULD BE LEFT ALIVE, BUT IT IS NOT MY WAY WITH HER. SHE MUST STAY WELL BECAUSE HER MIND WILL OFFER NO HIDING PLACE IF ILLNESS OR VIOLENCE FINDS HER. I WANT TO BE MORE THAN HER CUSTODIAN AND A FRIEND OF THE EXECUTIONER. FUCK ME AND FUCK ALL OF YOU WHO WOULD HURT HER.

I DID NOT WANT MY CHILD BECAUSE I KNEW I COULD NOT LIKE THE FEELING WHEN SHE WAS THREATENED, BUT ONE MORNING IN A MOVEMENT OF INFINITE TENDERNESS I CALLED HER. I CANNOT PRECLUDE HER DEATH AND OUR DEPENDENCE LETS EVERY DANGER WORK UNCHALLENGED. THE IDEA THAT I AM CRIMINAL RECURS EACH TIME THERE IS REAL TROUBLE. I WOULD KILL HER RATHER THAN WATCH A DIRTY ENDING BUT THE KILLING WOULD SPOIL MY PITY. IF MY INSTINCT IS RUINED I WILL BE THE PERSON WHO CAN DO ANYTHING TO YOU.

I AM SULLEN AND THEN FRANTIC WHEN I CANNOT BE WHOLLY WITHIN THE ZONE OF MY INFANT. I AM CONSUMED BY HER. I AM AN ANIMAL WHO DOES ALL SHE SHOULD. I AM SURPRISED THAT I CARE WHAT HAPPENS TO HER. I WAS PAST FEELING MUCH BECAUSE I WAS TIRED OF MYSELF BUT I WANT HER TO LIVE. I HATE EACH OF YOU WHO MURDERS. NOW MY BEST SENSES ARE BACK AND WHAT I FEEL AFTER LOVE IS FEAR.

I FEAR FIVE THINGS AND MYSELF.

I FEAR THE NEW ILLNESS. I AM NOT SURE IF THE CHILD AND I ARE SICK. NOW THAT SHE IS BORN I AM AFRAID TO KNOW. I TOUCH HER NECK. I AM NOT CERTAIN I COULD CARE FOR HER.

I FEAR PEOPLE CRAZY MAD FROM NEED AND THE CONTEMPT OF EVERYONE WHO COULD HELP THEM. I GO WALKING AND I HOPE SOMEONE DOES NOT SEE MY FAT BABY AS AN INSULT.

I AM AFRAID OF THE ONES IN POWER WHO KILL PEOPLE AND DO NOT ADMIT GRIEF. THEY WILL NOT STAY IN A ROOM WITH A DYING BABY. THEY WILL NOT SPEND THE DAYS IT CAN TAKE.

I FEAR SUBSTANCES THAT CANNOT BE SENSED AND MUST NOT BE TOUCHED, THE RESIDUE OF GOOD AND BAD IDEAS. I TURN THE CHILD OVER AND OVER TO LOOK FOR SIGNS. CONTAMINATION MAKES THE NEW WEATHER AND THE STINKING HEAT. THE BABY IS RED AND TRIES TO PULL AWAY FROM ME. AFTER THIS IDIOT PERIOD OF SQUANDERING AND WAITING I FEAR EVERYONE WHO DOES NOT WELCOME CHANGE.

THE SHOCK OF A CUTTING BIRTH REMINDS ME THAT PAIN IS NOT THOUGHT. MY NEED TO PROTECT COMES WITH THE CHILD. IT MAY GIVE ME TIME.

War (extract) 1992

BURNED ALL OVER SO ONLY HIS TEETH ARE GOOD, HE SITS FUSED TO THE TANK. METAL HOLDS THE BLAST HEAT AND THE SUN. HIS DEATH IS FRESH AND THE SMELL PLEASANT. HE MUST BE PULLED AWAY SKIN SPLITTING. HE IS A SUGGESTION THAT AFFECTS PEOPLE DIFFERENTLY.

THE SHAPE IN THE BLANKET IS STUPID. A TORSO REMAINS. THE MOTHER RECALLS A CHILD'S LOGICAL AND ADEQUATE SHADOW. SHE RUNS HER HAND OVER AND REJECTS THE FLESH.

I GAG ON THE FOOD SHINY WITH OIL AND MUCUS. MY THROAT CLOSES WHEN I TRY TO EAT.

I STAB THE BOY. I CUT HOLES TO DRAIN HIM.

HE MOVES LEGLESS AFTER THE HIT. HE IS A PIECE OF SPIDER. HIS ELBOWS MAKE KNEES. HE LEAKS JUICE. HE FLIES NOT DREAMING.

THE OCEAN WASHES THE DEAD. THEY ARE FACE UP FACE DOWN IN FOAM. BODIES ROLL FROM SWELLS TO OPEN IN THE MARSH.

HIS NECK STRAINS AND PIVOTS. HE BITES IN A CIRCLE AROUND HIM. HE CANNOT RAISE HIS ARMS BECAUSE HE IS PACKED IN MEN. THE THING THAT IS ALL OF THEM BEGINS TO SCREAM.

IT IS THE WAR ZOO. IT IS A LANDMARK. PILOTS NAME IT. THE ANIMAL IS FOLDED IN THE LANDSCAPE. A BONE IS BROKEN SO IT CANNOT MOVE AWAY. INSTINCT MAKES IT WATCHFUL. IT EXPECTS THAT SOMEONE WILL TOUCH IT TO RESTORE THE PACT.

Erlauf (extract) 1995

ALWAYS POLITE TO OFFICERS

SMILING OFTEN TO DISARM

THE ENERGETICALLY CRUEL

BLOOD OUTSIDE FOR ANIMALS

A MEMORY OF DOMINANCE

THE SOLDIER BITES YOUR STOMACH

SNEAKING TO WASH

THE HORSE RUNNING INTO WALLS

NEW TEETH IN THE BABY'S MOUTH

THE BABY MOVES TO YOUR OTHER BREAST

ADDING WATER TO FOOD

FULL OF SWALLOWED BLOOD

SON OF A RAPIST

I RAISE MY ARMS TO HIM

THE CHILD WITH A HAND IN HER

BIRDS EATING THEM

PROPERTY SEIZED BY THE ZEALOUS

YOUR MOTHER WITH NO REAL POWER

THINKING WHILE HELD DOWN

AGREEING TO STAY STILL

WAITING TO BE TRANSPORTED

EYE CUT BY FLYING GLASS

THE CHILD WALKS ON A BROKEN LEG

BONE VISIBLE THROUGH THE FOREHEAD

BITING THE HELPER

CHEWING WOOD FOR COMFORT

DOCILE SO HE IS FAST

JEWS ROBBED

DYING FROM KNOWING

PARENTS QUIET WHEN YOU ARE TAKEN

WRITING ON THE WALLS AT NIGHT

KILLING EFFEMINATE MEN

THE BOY URINATES IN CLASS

THE LEGS OF YOUR MOTHER

USING GOD

EXPEDIENT POLICY

NO CHANCE TO EFFECT THE ENDING

STUPID SENTENCES EVERYWHERE

WHO GAVE MILK

WHO MADE BEDS

WHO LIVED IN THE WOODS

WHO RAN TO THE RIVER

WHO DIED LOOKING

WHOSE THOUGHTS ARE MISSING

Erlauf Peace Monument (detail)
1995
Bethel White granite paving stone
walkways
73 stones, 29 × 46 cm each
Searchlight set in Bethel White
granite column
Light, h. approx. 1.6 km
Permanent installation, Erlauf,
Austria

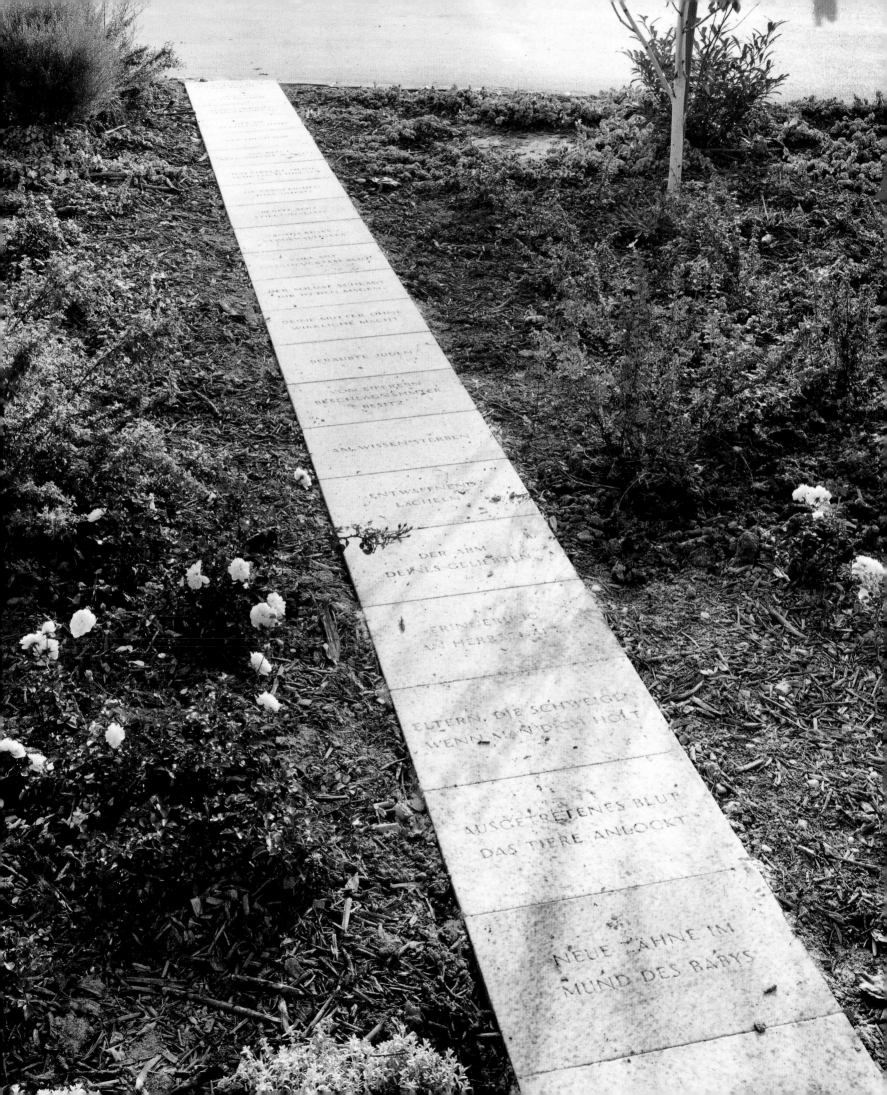

Contents

Selected exhibitions and projects
1972-80

1972-73
BFA, Ohio University, Athens, painting and printmaking

1975-77
MFA, Rhode Island School of Design, Providence, painting

1977
Whitney Independent Study Program, Whitney Museum of American Art, New York

Artist's book, *Diagrams*, edition the artist, New York

1978
'Jenny Holzer Painted Room: Special Project P.S. 1', **Institute for Art and Urban Resources at P. S. 1**, Long Island City, New York (project)

'Artwords and Bookworks', **Los Angeles Institute of Contemporary Art; Artists Space**, New York; **Herron School of Art**, Indianapolis; **Contemporary Arts Center**, New Orleans (group)
Cat. *Artwords and Bookworks*, Los Angeles Institute of Contemporary Art, texts Mike Crane, Judith Hoffberg, Joan Hugo

'Jenny Holzer Installation', **Franklin Furnace**, New York (project)

1979
'Manifesto Show', **5 Bleecker Street**, New York with Colen Fitzgibbon and Colab. (project)

'Fashion Moda Window', **Fashion Moda**, Bronx, New York with Stefan Eins (project)

'Printed Matter Window', **Printed Matter**, New York (project)

Artist's book, *A Little Knowledge*, edition the artist, New York

1980
'Textes Positions', **Onze Rue Clavel**, Paris with Peter Nadin (solo)

'Issue: Social Strategies by Women Artists', **Institute of Contemporary Arts**, London (group)
Cat. *Issue: Social Strategies by Women Artists*, Institute of Contemporary Arts, London, texts Margaret Harrison, Lucy R. Lippard, Sandy Nairne

'Living', **Rüdiger Schöttle Galerie**, Munich with Peter Nadin (solo)

'The Times Square Show', Abandoned building on Forty-first Street and Seventh Avenue, New York (group)

Artist's books, *Living*, with Peter Nadin, edition the artist, New York; *Black Book*, edition the artist, New York; *Hotel* with Peter Nadin, Tanam Press, New York

The subject-object make up an unanalyzable unit, in the midst of which the phenomenon takes place

MANIFESTO
5 BLEECKER ST
THRU APRIL
2-6 PM
THURS – FRI – SAT
OPENS APRIL 7 W/
FILMS AT 8 PM
SHOW

Selected articles and interviews
1972-80

1978

Larson, Susan C., 'A Booklover's Dream', *ArtNews*, New York, No 5, May

1979

1980

Deitch, Jeffrey, 'Report from Times Square', *Art in America*, New York, No 7, September

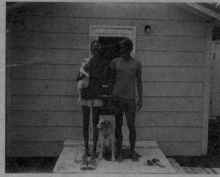

Jenny Holzer and Mike Glier c. 1978

Selected exhibitions and projects
1981-83

1981
'Eating Friends',
Artists Space, New York with Peter Nadin (group)

'Heute, Westkunst: Zeitgenössische Kunst seit 1939',
Museen der Stadt Köln; Messegelände Rheinhallen,
Cologne with Peter Nadin (group)
Cat. *Heute, Westkunst: Zeitgenössische Kunst seit 1939*,
Museen der Stadt Köln, texts Hugo Borger, Laszlo
Glozer, Kasper König, Karl Ruhrberg

'Living',
Le Nouveau Musée, Villeurbanne, France with Peter
Nadin (solo)

'Living',
Museum für (Sub) Kultur, Berlin with Peter
Nadin (solo)

Artist's books, *Eating Through Living*, with Peter Nadin,
Tanam Press, New York; *Eating Friends*, with Peter
Nadin, Top Stories, New York

1982
'Jenny Holzer - Peter Nadin: Living',
Galerie Chantal Crousel, Paris (solo)

'Art Lobby'
Marine Midland Bank, New York (project)

'Messages to the Public',
Times Square, New York (project)

'Thirty Texts from the Living Series',
Barbara Gladstone Gallery, New York with Peter Nadin
(solo)

'Documenta 7',
Museum Fridericianum, Kassel, Germany (group)
Cat. *Documenta 7*, Museum Fridericianum, Kassel, texts
Rudi Fuchs, the artists, et. al.
Outdoor installation, Haus Kranefuss, Kassel (project)

1983
'Présence Discrète',
Musée des Beaux-Arts de Dijon, Dijon, France (group)

'The Revolutionary Power of Women's Laughter',
Protetch/McNeil, New York; **Arts Cultural Resource
Center**, Toronto (group)

'1983 Biennial Exhibition',
Whitney Museum of American Art, New York (group)
Cat. *1983 Biennial Exhibition*, Whitney Museum of
American Art, New York, texts Tom Armstrong, John G.
Hanhardt, Barbara Haskell, Richard Marshall,
Patterson Sims

Selected articles and interviews
1981-83

1981

Armstrong, Richard, 'Reviews: 'Heute, Westkunst',
Artforum, New York, No 1, September

Graham, Dan, 'Signs', *Artforum*, New York, No 8, April

Foster, Hal, 'Critical Spaces', *Art in America*, New York,
No 3, March
Buchloh, Benjamin H.D., 'Allegorical Procedures:
Appropriation and Montage in Contemporary Art',
Artforum, New York, No 10, September
Foster, Hal, 'Subversive Signs', *Art in America*, New
York, No 10, November

1983

Weinstock, Jane, 'A Lass, a Laugh and a Lad', *Art in
America*, New York, No 6, Summer

Messages to the Public, Times Square, New York

Fashion Moda Store, collaboration with Stefan Eins, et. al., Documenta 7,
1982

Selected exhibitions and projects

1983-84

'Art and Social Change, USA',
Allen Memorial Art Museum, Oberlin College, Ohio
(group)
Cat. *Art and Social Change*, USA, Allen Memorial Art
Museum, texts David Deitcher, Lucy R. Lippard, et. al.

'Jenny Holzer: With A-One, Mike Glier and Lady Pink:
Survival Series',
Lisson Gallery, London (solo)

'Jenny Holzer',
Barbara Gladstone Gallery, New York (solo)

Artist's book, *Truisms and Essays*, Nova Scotia College
of Art and Design Press, Nova Scotia

1984
'Poster Project',
Seattle Art Museum (project)

'The Fifth Biennale of Sydney: Private Symbol, Social
Metaphor',
Art Gallery of New South Wales, Sydney; **Ivan
Dougherty Gallery**, Paddington, Australia (group)
Cat. *The Fifth Biennale of Sydney: Private Symbol, Social
Metaphor*, Art Gallery of New South Wales, Sydney,
texts Stuart Morgan, Annelie Pohlen, Carter Ratcliff,
Nelly Richard et al.

Marries Mike Glier, 21 May

'Jenny Holzer',
Kunsthalle Basel; **Le Nouveau Musée**, Villeurbanne,
France (solo)
Cat. *Jenny Holzer*, Kunsthalle Basel, Le Nouveau Musée,
Villeurbanne, text Jean-Christophe Ammann

'The Human Condition: Biennial III',
San Francisco Museum of Modern Art (group)
Cat. *The Human Condition: Biennial III*, San Francisco
Museum of Modern Art, texts Achille Bonito Oliva et al.

'Content: A Contemporary Focus 1974–1984',
Hirshhorn Museum and Sculpture Garden,
Smithsonian Institution, Washington, DC, (group)
Cat. *Content: A Contemporary Focus 1974–1984*,
Hirshhorn Museum and Sculpture Garden, Smithsonian
Institution, Washington, DC, texts Howard N. Fox,
Abram Lerner, Miranda McClintick, Phyllis Rosenzweig

'Jenny Holzer',
Dallas Museum of Art (solo)
Pamphlet, *Jenny Holzer*, Dallas Museum of Art, text Sue
Graze

'Sign on a Truck: A Program by Artists and Many Others
on the Occasion of the Presidential Election' (project)
Grand Army Plaza; **Bowling Green Plaza**, New York
Artist's pages, 'Sign on a Truck', *Artforum*, New York,
November (project)

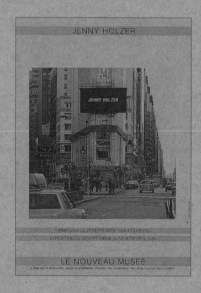

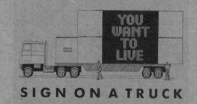

Selected articles and interviews

1983-84

Handy, Ellen, 'Emergence: New from the Lower East
Side', *Arts Magazine*, New York, No 5, January
Zelevansky, Lynn, 'New York Reviews: Jenny Holzer',
ArtNews, New York, No 1, January
Armstrong, Richard, 'Reviews: Jenny Holzer', *Artforum*,
New York, No 6, February

1984

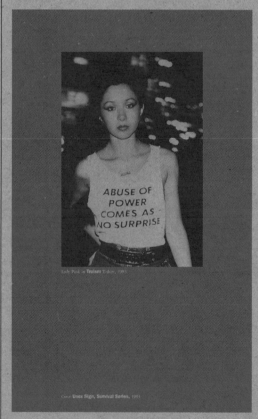

Lady Pink in *Truism* T-shirt, 1983

Cover: Unex Sign, *Survival Series*, 1983

Kutner, Janet, 'The Writing's on the Wall', *The Dallas
Morning News*, 15 November
Marvel, Bill, 'Electronic Sign Art Is Illuminating', *Dallas
Times Herald*, 2 December

Selected exhibitions and projects
1983-84

'Holzer Kruger Prince',
Knight Gallery, Spirit Square Art Center, Charlotte,
North Carolina (group)
Cat. *Holzer Kruger Prince*, Knight Gallery, Charlotte,
North Carolina, texts William Olander, Ann Shengold

'Ailleurs et Autrement'
Musée d'Art Moderne de la Ville de Paris (group)

1985
Moves to Hoosick, New York

'Signs',
The New Museum of Contemporary Art, New York (group)
Cat. *Signs*, The New Museum of Contemporary Art, New
York, text Ned Rifkin

'Carnegie International'
Museum of Art, Carnegie Institute, Pittsburgh
(group).
Cat. *1985 Carnegie International*, Museum of Art,
Carnegie Institute, Pittsburgh, texts Achille Bonito
Oliva, Bazon Brock, Benjamin H.D. Buchloh, John
Caldwell, Germano Celant, Hal Foster, Rudi Fuchs,
Johannes Gachnang, Per Kirkeby, Jannis Kounellis,
Hilton Kramer, Donald Kuspit, John Lane, Thomas
McEvilley, Mark Rosenthal, Peter Schjeldahl, Nicholas
Serota

'Selection from the Survival Series',
Times Square Spectacolor Board, New York (project)

'Technics and Civilization – Laurie Anderson, Jenny
Holzer, Cindy Sherman',
Thomas Segal Gallery, Boston (group)

1986
'Jenny Holzer, Cindy Sherman: Personae',
The Contemporary Arts Center, Cincinnati, Ohio (solo)
Cat. *Jenny Holzer, Cindy Sherman: Personae*, The
Contemporary Arts Center, Cincinnati, Ohio, texts
Dennis Barrie, Sarah Rogers-Lafferty

'Ein anderes Klima: Künstlerinnen gebrauchen Neue
Medien/A Different Climate: Women Artists Use New
Media',
Städtische Kunsthalle, Düsseldorf (group)

'Jenny Holzer',
Galerie Monika Sprüth, Cologne (solo)

'In Other Words',
The Corcoran Gallery of Art, Washington, DC (group)
Cat. *In Other Words*, The Corcoran Gallery of Art,
Washington DC, text Ned Rifkin. Outdoor installation,
Dupont Circle, Washington, DC (project)

Selected articles and interviews
1983-84

Ammann, Jean-Christophe, 'A Plea for New Art in
Public Spaces', *Parkett*, Zurich, No 2

1985

Bowman, Russell, 'Words and Images: A Persistent
Paradox', *Art Journal*, New York, No 4, Winter
Siegel, Jeanne, 'Jenny Holzer's Language Games', *Arts
Magazine*, New York, No 4, December

1986

NEW YORK ■ AILLEURS ET AUTREMENT
■ ■ ■ ■ JENNY HOLZER ■ ■ ■ ■ BARBARA
KRUGER ■ ■ ■ ■ LOUISE LAWLER ■ ■ ■ ■
SHERRIE LEVINE ■ ■ ALAN MC COLLUM
■ ■ ■ RICHARD PRINCE ■ ■ ■ ■ MARTHA
ROSLER ■ ■ ■ ■ JAMES WELLING ■ ■ ■ ■ ■
ARC ■ ■ MUSÉE D'ART MODERNE DE LA
VILLE DE PARIS ■ ■ ■ ■ ■ ■ 21 DECEMBRE
1984 ■ ■ 17 FEVRIER 1985 ■ ■ ■ ■ ■ ■ ■

MONIKA SPRÜTH GALERIE
Köln
Wormser Straße 23

EAU DE COLOGNE 83–93

Eröffnung: 5. Juni 1993 - 11 – 15 Uhr
Öffnungszeiten: Di. - Fr. 11 – 13 und 15 – 18 Uhr - Sa. 11 – 14 Uhr

Selected exhibitions and projects
1986-87

'Keith Haring – Jenny Holzer',
Am Hof, Vienna
Cat. *Protect Me From What I Want*, text Hubert Klocker,
Peter Pakesch (project)

'Electronic Sign Project',
Palladium, New York (project)

'Jenny Holzer',
Galerie Crousel-Hussenot, Paris (solo)

'Jenny Holzer/Barbara Kruger',
The Israel Museum, Jerusalem (solo)
Cat. *Jenny Holzer/Barbara Kruger*, The Israel Museum,
Jerusalem, text Suzanne Landau

'Protect Me From What I Want',
**Caesars Palace; Fashion Show Mall; Thomas & Mack
Center; Regency Plaza; McCarran International
Airport**, Las Vegas (project)

'Prospekt 86: Eine internationale Austellung aktueller
Kunst',
Frankfurter Kunstverein; Kunsthalle Schirn (group)
Cat. *Prospekt 86: Eine internationale Austellung
aktueller Kunst*, Frankfurter Kunstverein, texts Hillmar
Hoffmann, Peter Weiermair, the artists

'Jenny Holzer: Under a Rock',
Barbara Gladstone Gallery, New York (solo)

'Jenny Holzer: Signs',
Des Moines Art Center; Aspen Art Museum; Artspace,
San Francisco; **Museum of Contemporary Art**,
Chicago; **The List Visual Arts Center**, Massachusetts
Institute of Technology, Cambridge (solo)
Cat. *Signs*, Des Moines Art Center, texts Joan Simon,
Bruce Ferguson. Outdoor installation, 'Jenny Holzer:
Signs', Showplace Square, Candlestick Park, San
Francisco (project)

'Art and Its Double',
Centro Cultural de la Fundació Caixa de Pensions,
Barcelona (group)

1987
'Jenny Holzer: Under a Rock',
Rhona Hoffman Gallery, Chicago (solo)

'Social Engagement: Women's Video in the 80s',
Whitney Museum of American Art, New York (group)

Selected articles and interviews
1986-87

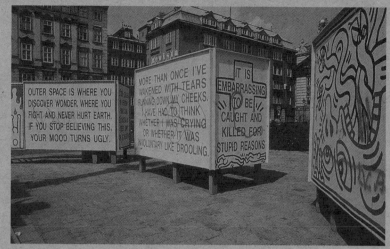

Protect Me From What I Want (project), Jenny Holzer with Keith Haring, Am Hof, Vienna, 1986

Cotter, Holland, 'Jenny Holzer at Barbara Gladstone
Gallery', *Art in America*, New York, No 12, December
Jones, Ronald, 'Jenny Holzer's 'Under a Rock'', *Arts
Magazine*, New York, No 5, January

Weisang, Myriam, 'Getting What She Wants: Jenny
Holzer Signs On in San Francisco', *San Francisco
Examiner Image*, 3 May 1987
Baker, Kenneth, 'Artist's Electronic Signs Flash Around
Town', *San Francisco Chronicle*, 14 May 1987

Grimes, Nancy, 'New York Reviews: Jenny Holzer',
ArtNews, New York, No 2, February
Indiana, Gary, 'Writing in Public', *The Village Voice*, New
York, 28 October
Handy, Ellen, 'Notes on Criticism: Art and Transac-
tionalism', *Arts Magazine*, New York, No 2, October
Ferguson, Bruce, 'Wordsmith: An Interview with Jenny
Holzer', *Art in America*, New York, No 12, December

1987
Artner, Alan, 'Surprising View from Jenny Holzer',
Chicago Tribune, 27 February
Hawkins, Margaret, 'Jenny Holzer's Abstract Messages
Are Signs of the Times', *Chicago Sunday Times*, 27
February

Selected exhibitions and projects

1987-88

'L'Époque, la Mode, la Morale, la Passion',
Centre Georges Pompidou, Paris (group)
Cat. *L'Époque, la Mode, la Morale, la Passion*, Centre
Georges Pompidou, Paris, texts Bernard Ceysson,
Kenneth Baker, Benjamin H.D. Buchloh, Germano
Celant, Hal Foster, Fredric Jameson, Rosalind Krauss et
al.

'Documenta 8',
Museum Fridericianum, Kassel, Germany (group)
Cat. *Documenta 8*, Museum Fridericianum, Kassel, texts
Manfred Schneckenburger et al.

'Skulptur Projekte in Münster',
**Westfälisches Landesmuseum für Kunst und
Kulturgeschichte**, Münster, Germany (group)
Cat. *Skulptur Projekte in Münster*, Westfälisches
Landesmuseum für Kunst und Kulturgeschichte,
Münster, Germany, texts Carl Andre, Klaus Bussmann,
Georg Jappe, Kasper König, Ludwig Wittgenstein

'Jenny Holzer, Louise Lawler, Ken Lum',
Galerie Crousel-Robelin, Paris (group)

'Zwei spektakuläre Kunstaktionen der New Yorker
Künstlerin Jenny Holzer im Oktober in Hamburg',
Hamburg (project)

1988

'Committed to Print: An Exhibition of Recent American
Printed Art with Social and Political Themes',
The Museum of Modern Art, New York (group)
Cat. *Committed to Print: An Exhibition of Recent
American Printed Art with Social and Political Themes*,
The Museum of Modern Art, New York, text Deborah
Wye

'Jenny Holzer',
HoffmanBorman Gallery, Santa Monica (solo)

'Jenny Holzer: Signs and Benches',
The Brooklyn Museum, New York (solo)

'Australian Biennale: From the Southern Cross, A View
of World Art *c.* 1940–1988',
Art Gallery of New South Wales, Sydney; **Pier 2/3**,
Walsh Bay, Sydney (group)
Cat. *Australian Biennale: From the Southern Cross, A View
of World Art c. 1940–1988*, Art Gallery of South Wales,
Sydney, texts Franco Belgiorno-Nettis, Bernard
Blistène, Jürgen Habermas, Diane Waldman, Nick
Waterlow, et. al.

Daughter Lili born

'Nelson Mandela Seventieth Birthday Tribute',
Wembley Stadium, London (project)

Selected articles and interviews

1987-88

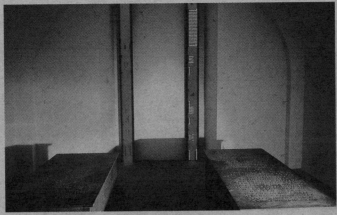

Installation, Documenta 8, Museum Fridericianum, Kassel, Germany, 1987

Westerbeck, Colin, 'Reviews: Jenny Holzer', *Artforum*,
New York, No 9, May

Kuspit, Donald, 'Regressive Reproduction and
Throwaway Conscience', *Artscribe International*,
London, No 61, January/February
Cameron, Dan, 'Post-Feminism', *Flash Art*, Milan, No
132, February/March
Independent Curators Incorporated, 'Jenny Holzer',
ICI Newsletter, New York, Spring/Summer
Bordaz, Jean-Pierre, 'Jenny Holzer and the Spectacle
of Communication', *Parkett*, No 13, Zurich

1988

Knight, Christopher, 'Words to the Wise, Spoken to the
Eyes', *Los Angeles Herald Examiner*, 23 March

Selected exhibitions and projects
1988-89

'Art Breaks',
MTV, New York (project)

'Plaques: The Living Series 1980–1982, The Survival
Series 1983–1985',
Interim Art, London (solo)

'Jenny Holzer: Signs/Under a Rock',
Institute of Contemporary Arts, London (solo)
Cat. *Signs/Under a Rock*, Institute of Contemporary
Arts, London, texts Iwona Blazwick, Joan Simon,
Bruce Ferguson. Outdoor installation, Piccadilly Circus
(project)

Artist's book, *Black Book*, edition the artist, New York

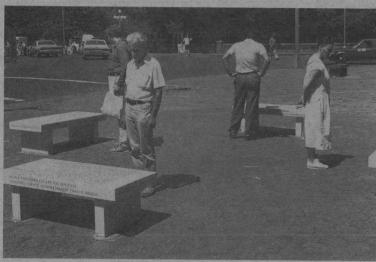

Installation, **Doris C. Freedman Plaza**, New York, 1989

1989

'Jenny Holzer'
Ydessa Hendeles Art Foundation, Toronto (solo)

'Jenny Holzer: Laments 1989',
Dia Art Foundation, New York (solo)
Cat. *Laments 1989*, Dia Art Foundation, New York

'A Forest of Signs: Art in the Crisis of Representation',
The Museum of Contemporary Art, Los Angeles (group)
Cat. *A Forest of Signs: Art in the Crisis of Representation*,
The Museum of Contemporary Art, Los Angeles, texts
Ann Goldstein, Mary Jane Jacob, Anne Rorimer,
Howard Singerman

'Benches',
Doris C. Freedman Plaza, New York (project)

'Image World: Art and Media Culture',
Whitney Museum of American Art, New York (group)
Cat. *Image World: Art and Media Culture*, Whitney
Museum of American Art, New York, texts John G.
Hanhardt, Marvin Heiferman, Lisa Phillips

Selected articles and interviews
1988-89

Carpenter, Merlin, 'Reviews: Jenny Holzer', *Artscribe
International,* London, No 74, March/April, 1989
Watson, Gray, 'Reviews: Jenny Holzer: ICA and
Elsewhere, London', *Flash Art*, Milan, No 145
March/April, 1989

Esman, Abigail R., 'Jenny Holzer', *New Art
International*, Paris, February/March
Howell, John, 'Jenny Holzer: The Message is the
Medium', *ArtNews*, New York, No 6, Summer
MacPherson, Rory, 'Jenny Holzer', *Splash*, Summer
Handy, Ellen, 'Jenny Holzer', *Arts Magazine*, New York,
No 1, September
Larson, Kay, 'Signs of the Times: Jenny Holzer's Art
Words Catch On', *New York Magazine*, 5 September
Chua, Lawrence, 'Jenny Holzer: Holzer, Like
Burroughs, Couches Subversion in Seeming Nonsense',
Flash Art, Milan, No 14, October
Taylor, Paul, 'Holzer Sees Aphorism as Art', *Vogue*, New
York, November
Staniszewski, Mary Anne, 'Jenny Holzer: Language
Communicates', *Flash Art*, Milan, No 143,
November/December
Buck, Louisa, 'Word Play', *The Face*, London, December
Danziger, James, 'American Graffiti', *The Sunday Times
Magazine*, London, 4 December
Buck, Louisa, 'Clean and Keen, Clean and Mean', *The
Guardian*, London, 14 December

1989

Smith, Roberta, 'Flashing Aphorisms by Jenny Holzer
at Dia', *The New York Times*, 10 March
Princenthal, Nancy, 'The Quick and the Dead: Jenny
Holzer's "Laments" at Dia', *The Village Voice*, New York,
14 March
Larson, Kay, 'In the Beginning Was the Word', *New York
Magazine*, 3 April

ELECTRONIC COMMUNICATIONS

Brenson, Michael, 'Bold Sculpture for Wide-Open
Spaces', *The New York Times*, 21 July

Selected exhibitions and projects

1989-90

'Jenny Holzer',
Solomon R. Guggenheim Museum, New York (solo)
Cat. *Jenny Holzer*, Solomon R. Guggenheim Museum,
New York, text Diane Waldman

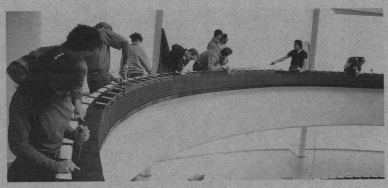

Solomon R. Guggenheim Museum installation, in progress, 1989

1990

'Time Span: Jenny Holzer, On Kawara, Bruce Nauman,
Lawrence Weiner',
Centro Cultural de la Fundació Caixa de Pensions,
Barcelona (group)

'Culture and Commentary: An Eighties Perspective',
**Hirshhorn Museum and Sculpture Garden,
Smithsonian Institution**, Washington, DC (group)
Cat. *Culture and Commentary: An Eighties Perspective*,
Hirshhorn Museum and Sculpture Garden, Smithsonian
Institution, Washington DC, texts Maurice Culot, Kathy
Halbreich, Simon Watney et al.

'The Decade Show: Frameworks of Identity in the 1980s',
The New Museum of Contemporary Art, New York; **The
Studio Museum in Harlem**, New York; **Museum of
Contemporary Hispanic Art**, New York (group)
Cat. *The Decade Show: Frameworks of Identity in the
1980s*, The New Museum of Contemporary Art, New
York, texts Kinshasa Holman Conwill, Eunice Lipton,
Nilda Peraza et al.

'XLIV Biennale di Venezia',
United States Pavilion, Venice; **Städtische
Kunsthalle**, Düsseldorf; **Louisiana Museum**,
Humlebaek, Denmark; **Albright-Knox Art Gallery**,
Buffalo; **Walker Art Center**, Minneapolis (solo)
Cat. *XLIV Esposizione Internazionale d'Arte La Biennale
di Venezia*, Gruppo Editoriale Fabbri, Venice, ed.
Simonetta Rasponi
Cat. *The Venice Installation*, Albright-Knox Art Gallery,
Buffalo, New York, text Michael Auping

Award, Leone d'Oro, XLIV Biennale di Venezia

'Life-Size: A Sense of the Real in Recent Art',
The Israel Museum, Jerusalem (group)
Cat. *Life-Size: A Sense of the Real in Recent Art*, The
Israel Museum, Jerusalem, text Suzanne Landau

Selected articles and interviews

1989-90

Smith, Roberta, 'Holzer Makes the Guggenheim a
Museum of Many Messages', *The New York Times*, 13
December
Larson, Kay, 'Jenny Be Good', *New York Magazine*, 8
January 1990
Schjeldahl, Peter, 'Says Who?', *7 Days*, New York, 17
January 1990
Heartney, Eleanor, 'Jenny Holzer: Guggenheim
Museum', *ArtNews*, New York, No 3, March 1990
Miller, John, 'Jenny Holzer: Guggenheim Museum',
Artscribe International, London, No 80, March/April 1990

Craddock, Sacha, 'In the End Was the Word', *Weekend
Guardian*, London, 14 January
Evans, Steven, 'Not All About Death: Jenny Holzer',
Artscribe International, London, No 76, Summer
Heartney, Eleanor, 'The New Social Sculpture',
Sculpture, Washington, No 4, July/August

1990

Brenson, Michael, 'Media Artist Named to Represent the
US at '90 Venice Biennale', *The New York Times*, 27 July,
1988
Kimmelman, Michael, 'Venice Biennale Opens with
Surprises', *The New York Times*, 28 May
Sischy, Ingrid and Maria, Karen, 'Art in Venice: Holzer
Has Words for America', *Interview*, New York, No 6, June
Plagens, Peter, 'The Venice Artfest', *Newsweek*, New
York, 11 June
Als, Hilton, 'Def in Venice: Fear and Loathing at the
Biennale', *The Village Voice*, New York, 17 July
Flam, Jack, 'Mixed-Up-Media: The Same New Thing',
The Wall Street Journal, New York, 25 July
Hughes, Robert, 'A Sampler of Witless Truisms', *Time*,
New York, 30 July
Joselit, David, 'Holzer: Speaking of Power', *Art in
America*, New York, No 10, October

l. to r., Patricia Contreras Auping, Michael Auping, Mike Glier, Jenny
Holzer, XLIV Biennale di Venezia, 1990

Selected exhibitions and projects
1990-92

'High & Low: Modern Art and Popular Culture',
The Museum of Modern Art, New York; **The Art Institute of Chicago**; **Museum of Contemporary Art**, Los Angeles (group)
Cat. *High and Low: Modern Art and Popular Culture*, The Museum of Modern Art, New York, texts Adam Gopnik, Kirk Varnedoe

1991
'Metropolis',
Martin-Gropius-Bau, Berlin (group)
Cat. *Metropolis*, Martin-Gropius-Bau, Berlin, texts Christos M. Joachimides, Norman Rosenthal

'Nachtregels/Night Lines: Words Without Thoughts Never to Heaven Go',
Centraal Museum, Utrecht, The Netherlands (group)
Cat. *Nachtregels/Night Lines: Words Without Thoughts Never to Heaven Go*, Centraal Museum, Utrecht, The Netherlands, texts Sjarel Ex, Bert Jansen

'Compassion and Protest: Recent Social and Political Art from the Eli Broad Family Foundation Collection',
San Jose Museum of Art (project)

'Beyond the Frame: American Art 1960–1990',
Setagaya Museum, Tokyo; **National Museum of Art**, Osaka, **Fukuoka Art Museum**, Fukuoka (group)

'Speechless Text/Image Video',
International Center of Photography, New York (group)

'Selections from The Living Series: 1980–1982',
Laura Carpenter Fine Art, Santa Fe and tour (solo)
Cat. *Jenny Holzer: The Living Series*, Tallgrass Press, Sante Fe, text Rhonda Lieberman

'Devil on the Stairs: Looking Back on the Eighties',
Institute of Contemporary Art, University of Pennsylvania, Philadelphia; **Newport Harbor Art Museum**, Newport Beach, California (group)
Cat. *Devil on the Stairs: Looking Back on the Eighties*, Institute of Contemporary Art, University of Pennsylvania, texts Peter Schjeldahl, Robert Storr

1992
'Allegories of Modernism: Contemporary Drawing',
The Museum of Modern Art, New York (group)
Cat. *Allegories of Modernism: Contemporary Drawing*, The Museum of Modern Art, New York, text Bernice Rose

'Doubletake: Collective Memory and Current Art',
Hayward Gallery, London; **Kunsthalle Wien** (group)
Cat. *Doubletake: Collective Memory and Current Art*, Hayward Gallery, London, texts Lynne Cooke, Bice Curiger, Greg Hilty

Selected articles and interviews
1990-92

Lewis, James, 'Powers of Disingenuousness', *Art Issues*, Los Angeles, No 11, May 1990
Mantegna, Gianfranco, 'Parole per la vita', *Chorus*, Milan, No 5, June
Gomez, Edward M., 'Quarrelling over Quality', *Time*, New York, Fall

1991

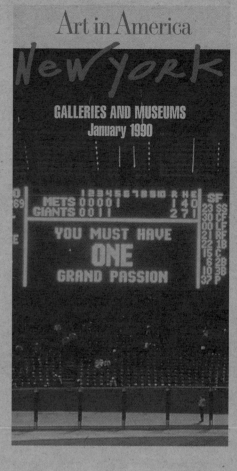

Zurbrugg, Nicholas, 'Jenny Holzer', *Eyeline: East Coast Contemporary Visual Arts*, Brisbane, No 16, Spring
Howell, John, 'Contemporary Art in Pursuit of Perfection in the House of Asher', *Elle Decor*, New York, No 6, August

1992

Selected exhibitions and projects

1992-93

'Jenny Holzer',
Ydessa Hendeles Art Foundation, Toronto (solo)

'TransForm: BildObjektSkulptur im 20. Jahrhundert',
Kunstmuseum und Kunsthalle Basel (group)
Cat. *TransForm: BildObjektSkulptur im 20. Jahrhundert*,
Kunstmuseum und Kunsthalle Basel, texts Gottfied
Boehm, Eva Keller, Franz Meyer et al.

'Territorium Artis',
**Kunst-und Ausstellungshalle der Bundesrepublik
Deutschland**, Bonn (group)
Cat. *Territorium Artis*, Kunst-und Ausstellungshalle der
Bundesrepublik Deutschland, Bonn, text Pontus Hulten

Book, *Universe Series on Women Artists*, Universe
Publishing, New York, text Michael Auping

1993
Permanent installation, 'Green Table',
University of California, San Diego

'Street Art: Jenny Holzer',
Centre for Contemporary Art, Ujazdowski Castle,
Warsaw (solo)
Outdoor installation, electronic signs, Warsaw
(project)

'American Art in the 20th Century',
Martin-Gropius-Bau, Berlin; **Royal Academy of Arts**,
London (group)

Permanent installation, 'The Empire Style and
Biedermeier Collection',
Österreichisches Museum für Angewandte Kunst,
Vienna

'42nd Street Art Project', **Times Square**, New York
(project)

'Virtual Reality: An Emerging Medium',
Guggenheim Museum SoHo, New York (group)

'War', **Church of St. Peter**, Cologne (project)

Artist's pages, 'Lustmord', *Süddeutsche Zeitung
Magazin*, No 46

Permanent installation, 'From the Living Series',
Walker Art Center, Minneapolis

'The Living Series',
Barry Whistler Gallery, Dallas (solo)

Selected articles and interviews

1992-93

Dyer, Susan, 'The Sibyl Cave Revisited: Jenny Holzer',
Women's Art Magazine, London, No 46, May-June

1993

Ciesielska, Jolanta, 'Jenny Holzer: Centrum Sztuki
Wspólczesnej, Zamek Ujazdowski, Warsawa', *Artelier*,
Poznan, No 2

Central Station, Warsaw, 1993 (project)

Witt-Dorring, Christian, 'Designing Artist: Jenny
Holzer', ed. Peter Noever, MAK: Austrian Museum of
Applied Arts, Vienna (second ed: Prestel, Munich,
1995)

Whitehouse, Karen, 'The Museum of the Future', *IEEE
Computer Graphics and Applications*, Los Alamitos,
California, May 1994
Ippolito, Jon, 'Will Virtual Reality Open Doors or Close
Them?', *Guggenheim Magazine*, Spring/Summer 1994

Weskott, Hanne, 'Editorial Power and Blood Feuds',
World Art, Melbourne, No 1, January
Anon., 'Drucken mit Blut: Künstlerin vergeudet 90 Liter
Lebenssaft', *Berliner Zeitung*, 12 November
Janda, Fritz; Kettenbach, Vera; Neumann, Sieglinde,
'Blut: Druck: Der Schock sitzt', *Express Düsseldorf*, 12
November
Stankiewitz, Karl, 'Was darf die Kunst?', *Stuttgarter
Nachrichten*, 13 November
Chandler, David, 'Lustmord', *Creative Camera*, London,
No 336, October/November 1995

Press conference for *Süddeutsche Zeitung Magazin*, Munich

Selected exhibitions and projects
1994-95

1994
'Lystmord: Jeg Er Våken På Stedet Hvor Kvinner Dør',
Bergen Billedgalleri, Norway (solo)
Cat. *Lystmord*, Bergen Billedgalleri, texts Per Bjarne
Boym, Christian Kämmerling

'Lustmord',
Barbara Gladstone Gallery, New York (solo)

'Jenny Holzer',
Contemporary Art Center, Art Tower Mito, Mito,
Japan; **Art Gallery Atrium**, Fukuoka, Japan (solo)
Cat. *Lustmord*, Contemporary Art Center, Art Tower
Mito, Mito, texts Eriko Osaka, Toshio Shimizu

Permanent installation, 'Black Garden',
Nordhorn, Germany
Cat. *Black Garden*, Städtische Galerie, Nordhorn, texts
Sabine Dylla, Justin Hoffmann

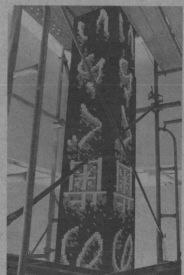

Screensaver, 'Truisms', to celebrate 200 years of Darier
Hentsch & CIE, programmed by Antenna Tool & Die Co.,
New York, text Jenny Holzer

1995
'Lustmord',
Monika Sprüth Galerie, Cologne (solo)

Permanent installation, 'Erlauf Peace Monument',
Erlauf, Austria
Cat. *Erlauf Peace Monument*, Niederosterreichischen
Landesmuseum, Vienna, texts Katharina Blaas-
Pratscher, Siegwald Ganglmair, Susanne Neuburger

Installation, Toyota Municipal Museum of Art, Toyota Aichi,
Japan, 1994

'Please Change Beliefs'
On-line project, 'äda'web, http://adaweb.com/cgi-
bin/jfsjr/truism'

'Man and Machine: Technology Art',
Dong-Ah Gallery, Seoul (group)
Cat. *Man and Machine: Technology Art*, Dong Ah Gallery,
Seoul, text In Soon Pae

'Longing and Belonging: From the Faraway Nearby',
SITE Santa Fe, Santa Fe (group)
Cat. *Longing and Belonging: From the Faraway Nearby*,
SITE Santa Fe, Santa Fe, text Lon Dubinsky

Erlauf Peace Monument, inauguration, Erlauf, Austria,
1995

Selected articles and interviews
1994-95

1994

Schwartzman, Allan, 'After Four Years, the Message is
Murder', *The New York Times*, 8 May
Filipovna, Valerie, 'Truth and Truisms', *Paper*, New York,
No 6, June
Princenthal, Nancy, 'Jenny Holzer at Barbara
Gladstone', *Art in America*, New York, No 11, November
Simon, Joan, 'No Ladders; Snakes: Jenny Holzer's
Lustmord', *Parkett*, Zurich, Nos 40-41, June

Kurabayashi, Yasushi, 'Jenny Holzer', *GQ*, Tokyo, No 20,
October
Nakamata, Akio, 'I Enjoy Real and Unreal', *Wired*,
Tokyo, No 2, March 1995

Grudin, Eva Ungar, 'Sichbare Dunkelheit: Jenny
Holzer's Gegen-Denkmal in Nordhorn', Nordhorn
Kulturbeitrage 4: Vom Langemarckplatz zum
Schwarzen Garten (Nordhorn: Stadt Nordhorn,
Kulturdezernat, 1996
Sachs, Angeli, 'Black Garden: War Memorial in Nordhorn,
Germany', *Domus*, Milan, No 775, October 1995
Franzen, Brigitte, 'Jenny Holzer's Schwarzer Garten in
Nordhorn', *Kritische Berichte*, Jonas Verlag, Germany,
No 24
Weisz, Peter, 'GRÜNderzeit', *Ahead*, Vienna, July-
September

Snider, Burr, 'Jenny Holzer: Multidisciplinary Dweeb',
Wired, San Francisco, No 2, February

Diamonstein, Barbaralee, 'Jenny Holzer: Artist', *Inside
the Art World: Artists, Directors, Curators, Collectors,
Dealers: Conversations with Barbaralee Diamonstein*,
Rizzoli, New York
Lingemann, Susanne, '7 starke Frauen in New York',
Art, Hamburg, No 12, December

1995

Metzger, Rainer, 'Ein Kalter Krieg mit anderen Mitteln',
Der Standard, Vienna, 6-7 May
Götz, Thomas, 'Ein Mädchen, zwei Soldaten und das
Licht', *Die Presse*, Vienna, 8 May

Helfand, Glen, 'WEBReviews', *The Web Magazine*,
October/November 1996
Sand, Michael, 'Who's Afraid of Cyberspace', *Tate: The
Art Magazine*, London, No 6, Summer

Villani, John, 'Art Space Colossal Santa Fe',
Albuquerque Journal, 16 July

Permanent installation, **Toyota Municipal Museum of Art**, Japan

'Jenny Holzer: From the Laments Series, 1989',
Williams College Museum of Art, Williamstown (solo)

'Laughter Ten Years After',
Center for the Arts, Wesleyan University, Middletown, Connecticut; **Houghton House Gallery**, Hobart and William Smith Colleges, Geneva, New York; **Spruance Art Center**, Beaver College Art Gallery, Glenside, Pennsylvania (group)
Cat. *Laughter Ten Years After*, Center for the Arts, Wesleyan University, Middletown, Connecticut, texts Jo Anna Isaak, Jeanne Silverthorn, Marcia Tucker

Permanent installation, 'Allentown Benches: Selections from the Truisms and Survival Series',
United States Courthouse, Allentown, Pennsylvania

1996
'Everything That's Interesting Is New: The Dakis Joannou Collection',
Athens School of Fine Arts; **Museum of Modern Art**, Copenhagen (group)
Cat. *Everything That's Interesting Is New: The Dakis Joannou Collection*, DESTE Foundation for Contemporary Art, Athens, texts Jeffrey Deitch, Stuart Morgan

'KriegsZustand', **Völkerschlachtdenkmal**, Leipzig (project)
Cat. *KriegsZustand*, Leipziger Galerie für Zeitgenössische Kunst, texts Anne-Marie Bonnet, Eva Ungar Grudin, Klaus Werner

'Mediascape',
Guggenheim Museum SoHo, New York (group)
Cat. *Mediascape*, Guggenheim Museum SoHo, New York, texts Annika Blunck, Matthew Drutt, Ursula Frohne, Heinrich Klotz, Oliver Seifert

'Thinking Print: Books to Billboards, 1980-95',
The Museum of Modern Art, New York (group)
Cat. *Thinking Print: Books to Billboards, 1980-95*, The Museum of Modern Art, New York, text Deborah Wye

Project for *Slate*,
Online magazine,
http://www.antennaco.com/holzer/holzer.html

Permanent installation, **Schiphol Airport**, Amsterdam

'Biennale di Firenze: Il Tempo e la Moda',
Florence; **Achenbach Kunsthandel**, Dusseldorf;
Guggenheim Museum SoHo, New York (project)
Cat. *Biennale di Firenze: Il Tempo e la Moda*, texts Germano Celant, Luigi Settembrini, Ingrid Sischy.
Outdoor installation: Xenon projection, Arno river, Florence; and texts on taxi hoods throughout the city (project)

Virtual Reality installation, Contemporary Art Center, Art Tower Mito, Mito, Japan, 1994

Mike Glier, Lili Holzer-Glier, Squeeze, Jenny Holzer, 1995

Irmer, Thomas, 'KriegsZustand: Jenny Holzer Laser Installation in Leipzig', *Tagesspregal*, Berlin, 17 June

Hirschberg, Lynn, 'The Little Rubber Dress, Among Others', *The New York Times Magazine*, New York, 2 February
Turner, Jonathan, 'Transporting Truisms', *ArtNews*, New York, No 1, January

'Biennale di Firenze: Il Tempo e la Moda', Florence, 1996

Selected exhibitions and projects

1996-98

'Jenny Holzer: Lustmord',
Kunstmuseum des Kantons Thurgau, Kartause
Ittingen, Warth (solo)
Cat. *Jenny Holzer: Lustmord*, Kunstmuseum des
Kantons Thurgau, Kartause Ittingen, Warth, texts
Christian Kämmerling, Markus Landert, Beatrix Ruf,
Noemi Smolik, Yvonne Volkart

'Views from Abroad: European Perspectives on
American Art 2',
Whitney Museum of American Art, New York; **Museum
für Moderne Kunst**, Frankfurt, Germany (group)
Cat. *Views from Abroad: European Perspectives on
American Art 2*, Whitney Museum of American Art, New
York, texts Jean-Christophe Ammann, Mario Kramer,
Rolf Lauter, Adam Weinberg

Permanent installation, 'Ceiling Snake',
Hamburger Kunsthalle

Book, *Jenny Holzer: Writing/Schriften*, Cantz,
Ostfildern-Ruit, Germany, ed. Noemi Smolik

1997
Permanent installation, 'Oskar Maria Graf Memorial',
Literaturhaus, Munich

'Jenny Holzer: Lustmord',
Contemporary Arts Museum, Houston (solo)
Cat. *Jenny Holzer: Lustmord*, Contemporary Arts
Museum, Houston, text Lynn M. Herbert

Permanent installation, **Museo Guggenheim Bilbao**,
Spain

Jenny Holzer, Museo Guggenheim Bilbao, 1997

Permanent installation, **Kunsthalle Zürich**

Screensaver, 'Use What is Dominant ... ', programmed
by Antenna Tool & Die Co., New York, text Jenny Holzer

1998
Permanent installation, 'First Amendment Memorial',
University of Southern California, Los Angeles

Selected articles and interviews

1996-98

Zwez, Anneliese, 'Lust und Grauen in der Psyche', *Berner
Rundschau*, 29 October
Gürtler, Carole, 'Der Schock und seine Inszenierung',
Basler Zeitung, 7 January, Section 4
Mack, Gerhard, 'Mit dir in mir beginne ich den Tod zu
ahnen', *Extra Cash*, Switzerland, No 38, 20 September
Beil, Ralf, 'Psychopathologie im Klosterkeller', *Neue
Zürcher Zeitung*, Zurich, 31 October
Vachtova, Ludmila, 'Von der Haut bis auf die Knochen',
Die Weltwoche, Zurich, 26 September

Spayde, Jon, 'What the World Needs Now', *Utne Reader*,
Minneapolis, No 3, March
Hacke, Azel, 'Kleinkunst', *Süddeutsche Zeitung Magazin*,
Munich, 22 November

1997
Freisinger, Gisela M., 'Ich mache hier ein Denkmal über
ihre Arbeit am Oskar-Maria-Graf-Denkmal', *Das
München der Münchner: 50 Jahre Kulturbaugeschichte*,
Bruckmann, Munich
Grasberger, Thomas, 'OMG Zum Fressen, Saufen und
Sitzen', *Abendzeitung*, Munich, 11 March

Johnson, Patricia C., 'Lustmord Horrifies But Intrigues',
Houston Chronicle, 11 July
Aspon, Catherine D., 'Unsettling and Powerful Lustmord:
Jenny Holzer at the CAM', *Public News*, 23 July

Riding, Alan, 'The Basques Get Modern', *The New York
Times*, New York, 24 June
Kimmelman, Michael, 'A Giant Guggenheim Outpost in
Spain May Upstage its Contents', *The New York Times*,
New York, 20 October
Plagens, Peter, 'Another Tale of Two Cities', *Newsweek*,
New York, 3 November

Museo Guggenheim Bilbao installation, pre-production drawing

1998
Muchnic, Suzanne, 'A Sculpture to Put Some Light on
Dark Days', *Los Angeles Times*, 12 March 1997
Klady, Leonard, 'Hollywood's Blacklisted Launch
Memorial', *Daily Variety*, Los Angeles, 13 March 1997
Robb, David, 'USC Art Honors the Blacklisted', *The
Hollywood Reporter*, 13 March 1997

Ammann, Jean-Christophe, *Jenny Holzer*, Kunsthalle Basel, Basel; Le Nouveau Musée, Villeurbanne, 1984

Ammann, Jean-Christophe, 'A Plea for New Art in Public Spaces', *Parkett*, Zurich No 2, 1984

Armstrong, Richard, 'Reviews: Jenny Holzer', *Artforum*, New York, No 6, February 1983

Aspon, Catherine D., 'Unsettling and Powerful Lustmord: Jenny Holzer at the CAM', *Public News*, 23 July 1997

Avgikos, Jan, 'Jenny Holzer', *Artforum*, New York, September 1994

Baker, Kenneth, 'Artist's Electronic Signs Flash Around Town', *San Francisco Chronicle*, 14 May 1987

Barrie, Dennis, *Jenny Holzer, Cindy Sherman: Personnae*, The Contemporary Arts Centre, Cincinnati, Ohio, 1986

Blaas-Pratscher, Katharina, *Erlauf Peace Monument*, Niederosterreichischen Landesmuseums, Vienna, 1995

Blazwick, Iwona, *Signs/Under a Rock*, Institute of Contemporary Arts, London; Orchard Gallery, Belfast, 1988

Bonetti, David, 'What's in a Word? Jenny Holzer's Message Is the Medium', *The Boston Phoenix*, 16 October 1987

Bonnet, Anne-Marie, *KriegsZustand*, Leipziger Galerie für Zeitgenossische Kunst, 1996

Boym, Bjarne, *Lystmord*, Bergen Billedgallerie, 1994

Bordaz, Jean-Pierre, 'Jenny Holzer and the Spectacle of Communication', *Parkett*, Zurich No 13, 1987

Bowman, Russell, 'Words and Images: A Persistent Paradox', *Art Journal*, New York, No 4, Winter, 1985

Brenson, Michael, 'Bold Sculpture for Wide-Open Spaces', *The New York Times*, 21 July 1989

Buchloh, Benjamin H.D., 'Allegorical Procedures: Appropriation and Montage in Contemporary Art', *Artforum*, New York, No 10, September 1982

Buck, Louisa, 'Word Play', *The Face*, London, December 1988

Cameron, Dan, 'Post-Feminism', *Flash Art*, Milan, No 132, February/March 1987

Carpenter, Merlin, 'Reviews: Jenny Holzer', *Artscribe International*, London, No 74, March/April 1989

Castellucci, Pier Paolo; Luciano Marucci, 'Jenny Holzer', *Juliet Art Magazine*, Trieste, February/ March 1996

Chandler, David, 'Lustmord', *Creative Camera*, London, No 336, October/November 1995

Chua, Lawrence, 'Jenny Holzer: Holzer, Like Burroughs, Couches Subversion in Seeming Nonsense', *Flash Art*, Milan, No 14, October 1988

Ciesielska, Jolanta, 'Jenny Holzer: Centrum Sztuki Wspólczesnej, Zamek Ujazdowski, Warsawa', *Artelier*, Poznan, No 2, 1993

Cirincione, Janine, 'Jenny Holzer Unplugged', *A Gathering of Tribes*, New York, No 2, Fall/Winter, 1994

Cotter, Holland, 'Jenny Holzer at Barbara Gladstone Gallery', *Art in America*, New York, No 12, December 1986

Cotter, Holland, 'Lustmord', *The New York Times*, 13 May 1994

Craddock, Sacha, 'In the End Was the Word', *Weekend Guardian*, London, 14 January 1989

Danziger, James, 'American Graffiti', *The Sunday Times Magazine*, London, 4 December 1988

Deitch, Jeffrey, 'Report from Times Square', *Art in America*, New York, No 7, September 1980

Deitcher, David, *Art and Social Change*, Allen Memorial Art Museum, 1983

Dylla, Sabine, *Black Garden*, Galerie der Stadt Nordhorn, Nordhorn, ed. Sabine Dylla, 1994.

Esman, Abigail R., 'Jenny Holzer', *New Art International*, Paris, February/March 1988

Evans, Steven, 'Not All About Death: Jenny Holzer', *Artscribe International*, London, No 76, Summer, 1989

Fagotti, Laura, 'Una Spirale di LED al Guggenheim', *Allestire*, Milan, No 11, 1989

Ferguson, Bruce, 'Wordsmith: An Interview with Jenny Holzer', *Art in America*, No 12, December 1986

Ferguson, Bruce, *Signs/Under a Rock*, Institute of Contemporary Arts, London; Orchard Gallery, Belfast, 1988

Flam, Jack, 'Mixed-Up-Media: The Same New Thing', *The Wall Street Journal*, New York, 25 July 1990

Foster, Hal, 'Subversive Signs', *Art in America*, New York, No 10, November 1982

Franzen, Brigitte, 'Jenny Holzer's Schwarzer Garten in Nordhorn', *Kritische Berichte*, Jonas Verlag, Germany, No 24, 1994

Ganglmair, Siegwald, *Erlauf Peace Monument*, Niederosterreichischen Landesmuseum, Vienna, 1995

Grimes, Nancy, 'New York Reviews: Jenny Holzer', *ArtNews*, New York, No 2, February 1986

Grudin, Eva Ungar, *KriegsZustand*, Leipziger Galerie für Zeitgenossische Kunst, 1996

Handy, Ellen, 'Emergence: New from the Lower East Side', *Arts Magazine*, New York, No 5, January 1983

Handy, Ellen, 'Jenny Holzer', *Arts Magazine*, New York, No 1, September 1988

Harrison, Margaret, *Issue: Social Strategies by Women Artists*, Institute of Contemporary Arts, London, 1980

Hawkins, Margaret, 'Jenny Holzer's Abstract Messages Are Signs of the Times', *Chicago Sunday Times*, 27 February 1987

Heartney, Eleanor, 'Jenny Holzer: Guggenheim Museum', *ArtNews*, New York, No 3, March 1990

Heartney, Eleanor, 'The New Social Sculpture', *Sculpture*, Washington, DC, No 4, July-August 1989

Helfand, Glen, 'WEBReviews', *The Web Magazine*, October/November 1996

Herbert, Lynn M., *Jenny Holzer: Lustmord*, Contemporary Arts Museum, Houston, 1997

Hirschberg, Lynn, 'The Little Rubber Dress, Among Others', *The New York Times Magazine*, New York, 2 February 1996

Hoffmann, Justin, *Black Garden*, Galerie der Stadt Nordhorn, Nordhorn, ed. Sabine Dylla, 1994

Hofmann, Andrea, 'Lustmord: Radikal und direct', *Bodensee-Zeitung*, Arbon, Switzerland, 18 September 1996

Holzer, Jenny, *A Little Knowledge*, edition the artist, New York, 1979

Holzer, Jenny, *Signs*, Des Moines Art Center, Des Moines, 1986

Holzer, Jenny, 'Why Jane Can't Draw…', *Newsweek Special Edition*, New York, Fall/Winter, 1990

Holzer, Jenny, *The Living Series*, Tallgrass Press, New York, 1991

Holzer, Jenny, *Jenny Holzer: Writing/Schriften*, Cantz, Ostfildern-Ruit, ed. Noemi Smolik, 1996

Howell, John, 'Jenny Holzer: The Message is the Medium', *ArtNews*, New York, No 6, Summer 1988

Howell, John, 'Contemporary Art in the Pursuit of Perfection in the House of Asher', *Elle Decor*, New York, No 6, August 1991

Hughes, Robert, 'A Sampler of Witless Truisms', *Time*, New York, 30 July 1990

Independent Curators Incorporated, 'Jenny Holzer', *ICI Newsletter*, New York, Spring/Summer 1987

Indiana, Gary, 'Writing in Public', *The Village Voice*, New York, 28 October 1986

Ippolito, Jon, 'Will Virtual Reality Open Doors or Close Them?', *Guggenheim Magazine*, Spring/Summer 1994

Irmer, Thomas, 'Deutsche Denmaler: Ein Gesprach mit Jenny Holzer', *Neue Bildende Kunst: Zeitschrift für Kunst und Kritik*, August/September 1996

Johnson, Patricia C., 'Lustmord Horrifies But Intrigues', *Houston Chronicle*, 11 July 1997

Jones, Ronald, 'Jenny Holzer's 'Under a Rock'', *Arts Magazine*, New York, No 5, January 1986

Joselit, David, 'Holzer: Speaking of Power', *Art in America*, New York, No 10, October 1990

Kachur, Lewis, 'Venice Preview: Jenny Holzer', *Art International*, Paris, No 11, Summer, 1990

Kämmerling, Christian, *Jenny Holzer: Lustmord*, Kunstmuseum des Kantons Thurgau, Kartause Ittingen, Warth, 1996

Kämmerling, Christian, *Lystmord*, Bergen Billedgallerie, 1994

Kimmelman, Michael, 'Venice Biennale Opens with Surprises', *The New York Times*, 28 May 1990

Klady, Leonard, 'Hollywood's Blacklisted Launch Memorial', *Daily Variety*, Los Angeles, 13 March 1997

Kurabayashi, Yasushi, 'Jenny Holzer', *GQ*, Tokyo, No 20, October 1994

Kuspit, Donald, 'Regressive Reproduction and Throwaway Conscience', *Artscribe International*, London, No 61, January-February 1987

Lynch, Florence, 'Jenny Holzer', *Virus*, Milan, No 10, June 1997

Landau, Suzanne, *Jenny Holzer/Barbara Kruger*, The Israel Museum, Jerusalem, 1986

Landert, Markus, *Jenny Holzer: Lustmord*, Kunstmuseum des Kantons Thurgau, Kartause Ittingen, Warth, 1996

Larson, Susan C., 'A Booklover's Dream', *ArtNews*, New York, No 5, May 1978

Larson, Kay, 'Signs of the Times: Jenny Holzer's Art Words Catch On', *New York Magazine*, 5 September 1988

Larson, Kay, 'In the Beginning Was the Word', *New York Magazine*, 3 April 1989

Larson, Kay, 'Jenny Be Good', *New York Magazine*, 8 January 1990

Lewis, James, 'Powers of Disingenuousness', *Art Issues*, Los Angeles, No 11, May 1990

Lippard, Lucy R., *Issue: Social Strategies by Women Artists*, Institute of Contemporary Arts, London, 1980

Miller, John, 'Jenny Holzer: Guggenheim Museum', *Artscribe International*, London, No 80, March/April 1990

Muchnic, Suzanne, 'A Sculpture to Put Some Light on Dark Days', *Los Angeles Times*, 12 March 1997

Nakamata, Akio, 'I Enjoy Real and Unreal', *Wired*, Tokyo, No 2, March 1995

Nairne, Sandy, *Issue: Social Strategies by Women Artists*, Institute of Contemporary Arts, London, 1980

Nemiroff, Diana, 'Personae and Politics: Jenny Holzer', *Vanguard*, Vancouver, No 9, November 1983

Neuburger, Susanne, *Erlauf Peace Monument*, Niederosterreichischen Landesmuseums, Vienna, 1995

Odling-Smee, James, 'Jenny Holzer: Bradbury Place and Shaftesbury Square, Belfast', *Circa*, Belfast, March/April, 1989

Olander, William, *Holzer Kruger Prince*, Knight Gallery, Charlotteville, North Carolina, 1984

Osaka, Eriko, *Lustmord*, Contemporary Art Centre, Art Tower Mito, 1994

Polak, Maralyn Lois 'Jenny Holzer: Messages are her Medium', *Philadelphia Inquirer Magazine*, 27 September 1987

Princenthal, Nancy, 'The Quick and the Dead: Jenny Holzer's "Laments" at Dia', *The Village Voice*, New York, 14 March 1989

Princenthal, Nancy, 'Jenny Holzer at Barbara Gladstone', *Art in America*, New York, No 11, November 1994

Rifkin, Ned, *Signs*, The New Museum of Contemporary Art, New York, 1985

Robb, David, 'USC Art Honors the Blacklisted', *The Hollywood Reporter*, 13 March 1997

Rogers-Lafferty, Sarah, *Jenny Holzer, Cindy Sherman: Personae*, The Contemporary Arts Centre, Cincinnati, Ohio, 1986

Ruf, Beatrix, *Jenny Holzer: Lustmord*, Kunstmuseum des Kantons Thurgau, Kartause Ittingen, Warth, 1996

Sachs, Angeli, 'Black Garden: War Memorial in Nordhorn, Germany', *Domus*, Milan, No 775, October 1995

Schwartzman, Allan, 'After Four Years, the Message is Murder', *The New York Times*, 8 May 1994

Shengold, Ann, *Holzer Kruger Prince*, Knight Gallery, Charlotte, North Carolina, 1984

Shimizu, Toshio, *Lustmord*, Contemporary Art Centre, Art Tower Mito, 1994

Siegel, Jeanne, 'Jenny Holzer's Language Games', *Arts Magazine*, New York, No 4, December 1985

Simon, Joan, *Signs/Under a Rock*, Institute of Contemporary Arts, London; Orchard Gallery, Belfast, 1988

Simon, Joan, 'No Ladders; Snakes: Jenny Holzer's Lustmord', *Parkett*, Zurich Nos 40-41, June 1994

Smith, Roberta, 'Holzer Makes the Guggenheim a Museum of Many Messages', *The New York Times*, 13 December 1989

Smith, Roberta, 'Flashing Aphorisms by Jenny Holzer at Dia', *The New York Times*, 10 March 1989

Smolik, Noemi, *Jenny Holzer: Lustmord*, Kunstmuseum des Kantons Thurgau, Kartause Ittingen, Warth, 1996

Snider, Burr, 'Jenny Holzer: Multidisciplinary Dweeb', *Wired*, San Francisco, No 2, February 1994

Sischy, Ingrid; Karen Marta, 'Art in Venice: Holzer Has Words for America', *Interview*, New York, No 6, June 1990

Staniszewski, Mary Anne, 'Jenny Holzer: Language Communicates', *Flash Art*, Milan, No 143, November/December 1988

Svitil, Torene, 'Jenny Holzer', *Exposure*, Los Angeles, September-October 1988

Taylor, Paul, 'Jenny Holzer Sees Aphorism as Art', *Vogue*, New York, November 1988

Turner, Jonathan, 'Transporting Truisms', *Artnews*, New York, No 1, January 1996

Volkart, Yvonne, *Jenny Holzer: Lustmord*, Kunstmuseum des Kantons Thurgau, Kartause Ittingen, Warth, 1996

Waldman, Diane, interview with Jenny Holzer, The Solomon R. Guggenheim Museum, New York, 1989

Watson, Gray, 'Reviews: Jenny Holzer: ICA and Elsewhere, London', *Flash Art*, Milan, No 145 March/April, 1989

Weinstock, Jane, 'A Lass, a Laugh and a Lad', *Art in America*, New York, No 6, Summer, 1983

Weisang, Myriam, 'Getting What She Wants: Jenny Holzer Signs On in San Francisco', *San Francisco Examiner Image*, 3 May 1987

Werner, Klaus, *KriegsZustand*, Leipziger Galerie für Zeitgenossische Kunst, 1996

Westerbeck, Colin, 'Reviews: Jenny Holzer', *Artforum*, New York, No 9, May 1987

Zelevansky, Lynn, 'New York Reviews: Jenny Holzer', *ArtNews*, New York, No 1, January 1983

Zurbrugg, Nicholas, 'Jenny Holzer', *Eyeline: East Coast Contemporary Visual Arts*, Brisbane, No 16, Spring 1991

Zwez, Anneliese, 'Lust und Grauen in der Psyche', *Berner Rundschau*, 29 October 1996